IMAGES
of America

ITALIANS *in*
NEW ORLEANS

(*on the cover*) The walking nuns, pictured in 1982, make a pleasing contrast with the arches and steps of the recently installed Piazza D'Italia. (Photo by Art Hutchinson.)

IMAGES

of America

ITALIANS *in* NEW ORLEANS

Joseph Maselli and Dominic Candeloro

ARCADIA
PUBLISHING

Published by Arcadia Publishing
Charleston, South Carolina

Library of Congress Catalog Card Number: 2004110479

For all general information contact Arcadia Publishing at:
Telephone 843-853-2070
Fax 843-853-0044
E-mail sales@arcadiapublishing.com
For customer service and orders:
Toll-Free 1-888-313-2665

Visit us on the Internet at www.arcadiapublishing.com

CONTENTS

ACKNOWLEDGMENTS

Since history is cumulative, we must first acknowledge the contributions of Giovanni Schiavo, the pioneering author of dozens of books on Italian Americans. His *Four Centuries of Italian American History* and *The American Italians Before the Civil War* are classics. Schiavo's research and his collected papers constitute the core of the holdings of the American Italian Museum collections. Exhibitions and publications produced by the museum have been informed by the rich legacy that Schiavo has left us.

We thank the many groups and individuals who have donated materials to the museum. We cannot preserve Italian-American culture without the active participation of the descendants of the immigrants. Thanks to their generosity and co-operation, the museum and library are the major resources in the South for students of Italian Americana.

Bette Cadwell did a heroic job in assembling and identifying all the images in this volume. This book could not have been produced without Bette's hard work. Karen Quaglino Daray worked tirelessly to scan the photos. Both the authors and the readers of *Images of America: Italians in New Orleans* owe a debt of gratitude to Bette and Karen.

The Arcadia *Images of America* Series has had great success in stimulating interest in local ethnic histories, and we are sure that this volume will spark enthusiasm for the rich Italian heritage in New Orleans. All of the notes and other materials used in preparation of this book will be placed on file at the American Italian Museum. We hope that readers will pursue their family and community histories and contribute additional materials to the museum, so that we can produce additional exhibits and books that preserve the fragile immigrant and ethnic heritage.

We have benefited from the scholarly work of Richard Gambino (*Vendetta*, 1977, and the 1999 HBO film *Vendetta* on the 1891 lynching), Vincenza Scarpaci ("Italian Immigrants in Louisiana's Sugar Parishes," 1977), Anthony Margavio and Jerome Salamone (*Bread and Respect*, 2002), Evans Casso (*Staying in Step: A Continuing Italian Renaissance*, 1984), and many others.

Dominic Candeloro
Joseph Maselli

INTRODUCTION

Although New Orleans was settled first by the French and then the Spanish, by the 19th century the city had become a mecca for Italian immigrants. Between 1850 and 1870, the U.S. Census Bureau estimates that there were more Italians in New Orleans than in any other American city. By 1910, following the mass migrations from Sicily, the population of the city's French Quarter was 80 percent Italian. The earlier Italian pioneers who arrived in New Orleans before the Louisiana Purchase came as explorers, soldiers, merchants, and builders who braved the seas and paved the way to the Louisiana Territory. Today there are approximately 250,000 Americans of Italian descent living in the Greater New Orleans area, making Italian Americans the largest ethnic group in the city.

The history and culture of local Italian Americans, most of Sicilian heritage, is preserved in the American Italian Renaissance Foundation (AIRF) Museum and Research Library, located in the heart of New Orleans. The museum records Italy's troubled history following unification in 1870 and the closing decades of the 19th century, when the country's severe economic and social problems forced millions of Italians to emigrate to the United States. Most of the Italian immigrants headed for New York and other cities along the eastern seaboard. Many Sicilians, however, sailed from Palermo directly to New Orleans. During their month-long voyage they suffered from many illnesses, including dysentery, and some died along the way.

An unforgettable event in the history of Italians in New Orleans was the 1891 lynching of 11 Sicilians. Discrimination against Italian Americans was still evident in the 1920s and 1930s when they, along with Jews and African Americans, were excluded from membership in the city's famous Carnival "Krewes," the Mardi Gras organizations. Italian Americans formed their own organization called the Krewe of Virgilians. The Metropolitan Opera diva Marguerite Piazza reigned as their first queen in 1936.

Despite their hardships, most Sicilian immigrants were able to build better lives for themselves and their families in New Orleans. Here they found land they could afford to buy, a familiar religious community, and a natural climate similar to the one they left behind in Sicily. To help each other in the new land, Italian immigrants founded mutual-aid societies. The first one in the U.S. was the *Società Italiana di Mutua Beneficenza*, formed in New Orleans in 1843. The oldest still in existence is the San Bartolomeo Society, founded in 1879 by immigrants from the tiny island of Ustica off the coast of Palermo. In 1972, the author of this introduction founded the first statewide federation of Italian American organizations.

When the Sicilians settled in New Orleans, they brought with them their culture, music, and food. Sicilian cultural artifacts in the museum include a colorful, hand-painted Sicilian cart and a traditional Sicilian St. Joseph's Day altar laden with the specialties that Sicilian women prepare on March 19 to feed the homeless and the poor.

Italian Americans helped build New Orleans, putting up more than 50 percent of the city's high-rise buildings. Local Italian Americans also contributed to the city's music. Nick LaRocca wrote "Tiger Rag" and as leader of the Original Dixieland Jazz Band made the first jazz recording in 1917. He was followed by the Dukes of Dixieland—Frank, Freddie and Papa Assunto— and by Louis Prima and Sam Butera. As Italians entered New Orleans's business and artistic communities, they gained much deserved visibility and status. In 1971, the Italian-American Marching Club was organized to parade annually on March 19th, St. Joseph's Day. Today, the club has more than 1,500 members and is open to all people of Italian descent.

Joseph Maselli
New Orleans, Louisiana

One

IN THE BEGINNING
Italians Have Always Been Here

New Orleans is an old city, and Italians have been prominent here from the very beginning. Historians Giovanni Schiavo, Russell Magnaghi, and Mike Bacarella have counted many notable explorers, missionaries, soldiers, planters, merchants, and artists. Four Italians accompanied De Soto in his explorations in the 1540s. Enrico de Tonti (1682) and Rene-Robert de la Salle reached the mouth of the Mississippi River. Tonti stayed on to help build up the French colony. Records show that many Italian settlers arrived in New Orleans aboard the Chameau on August 11, 1718, the same year the French established the city. It has been difficult to recognize all of them since their names were changed to French spellings. Francesco Maria de Reggio, a native of Alba, Piedmont, became a member of the cabildo (town council) in 1781 and a year later was alcalde ordinario (ordinary mayor). The de Reggios became a prominent New Orleans family, and Francesco was the great-grandfather of Civil War Gen. Pierre Beauregard. Jerome Chiapella of Genoa also emigrated to New Orleans during the Spanish regime. Francesco Vigo, a notable American patriot during the Revolutionary War, first settled in New Orleans in 1774.

Reflecting Italian interest in trade and cultural relations with New Orleans, the various independent states of Italy established consular offices here beginning in the 1830s. P.A. Frigerio was a noted pianist and composer in 1850s. In the 1820s, M. (J.B.) Fogliardi decorated and painted the French Theater and Orleans Theater. Philip Achille Perelli (1822–1891), an artist, sculptor, and teacher, executed a bust of Dante for the Italian Masons' mausoleum in 1865. Adelina Patti (1843–1919) performed at the Opera House and lived and worked in New Orleans in 1861. Her apartment on Royal Street is known as Patti's Court. Louis Frigerio opened a nautical instrument business at 80 Customhouse in 1851. In the 1850s, Pietro Gualdi, a painter and architect, designed residences and a magnificent tomb for the Italian Benevolent Society. Fr. John M. Cambiaso, principal of the Jesuit College at Baronne and Common Streets, designed the Church of the Immaculate Conception and the St. Maurice Church.

Milanese Angelo Socola, the "Father of the Rice Industry," operated the largest rice mill in the United States in the 1850s. J.B. Solari, secretary of the Società Italiana di Mutua Beneficenza in Nuova Orleans, founded a grocery and imported wines and liquors. Santo Oteri established in 1868 the import business that eventually became United Fruit. A prominent insurance man, Giuseppe A. Barelli (1801–1858) also served as Consul to New Orleans for the Kingdom of the Two Sicilies.

The Civil War call to organize the Garibaldi Legion in January 1861 netted more than 170 Italian-American volunteers. Another Italian guard battalion also became part of the Louisiana Militia. Dr. Felix Formento Jr. (1837–1907) was chief surgeon at the Louisiana Confederate Hospital in Richmond. During the yellow fever epidemics of 1867–1878 he served the community, dealing mostly with needy Italians.

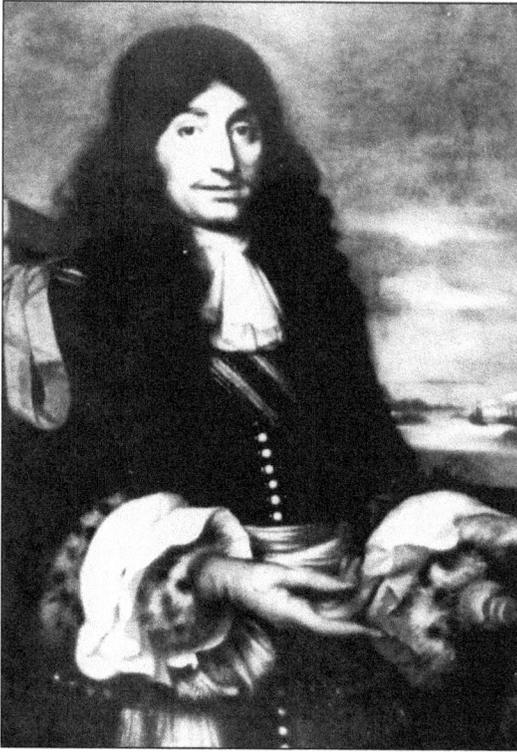

Enrico de Tonti (1650–1730), a Neapolitan in the service of France, joined forces with explorer La Salle to reach the mouth of the Mississippi on April 9, 1682. Sporting a crude prosthesis and known as the "man with the iron hand," Tonti was the first white man to reach the Gulf of Mexico by way of the Mississippi. In 1698 Louis XIV enlisted Tonti to settle the area and play an important role in the development of New Orleans.

Pierre Maspero (1771–1822), from Milan, opened a restaurant in New Orleans in 1795; Andrew Jackson and privateers Jean and Pierre Lafitte supposedly planned the Battle of New Orleans there. After the battle, Jackson was carried to Maspero's in triumph. Italians associated with Jean Lafitte in the battle included Louis Chighizola and Vincent Gambi. According to the 1822 *New Orleans Directory and Register*, Maspero also ran the Looking Glass & Gilding Manufactory on Chartres Street.

Giacomo Costantino Beltrami (1779–1855) explored the source of the Mississippi River and traveled 3,000 miles to the mouth of Big Muddy. He lived briefly in New Orleans, then moved to a quiet plantation in St. James Parish, where he wrote the story of his discovery, *La Decouverte des Sources du Mississippi*, which was published on January 29, 1824, the first work written and published by an Italian in New Orleans.

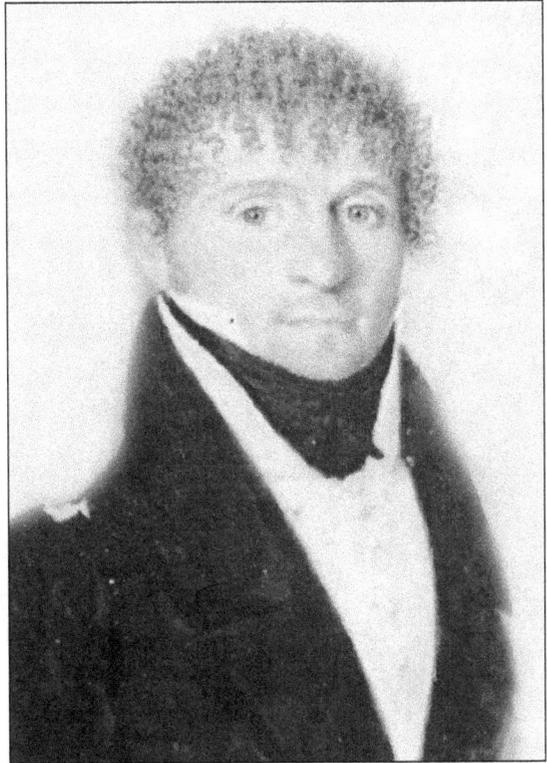

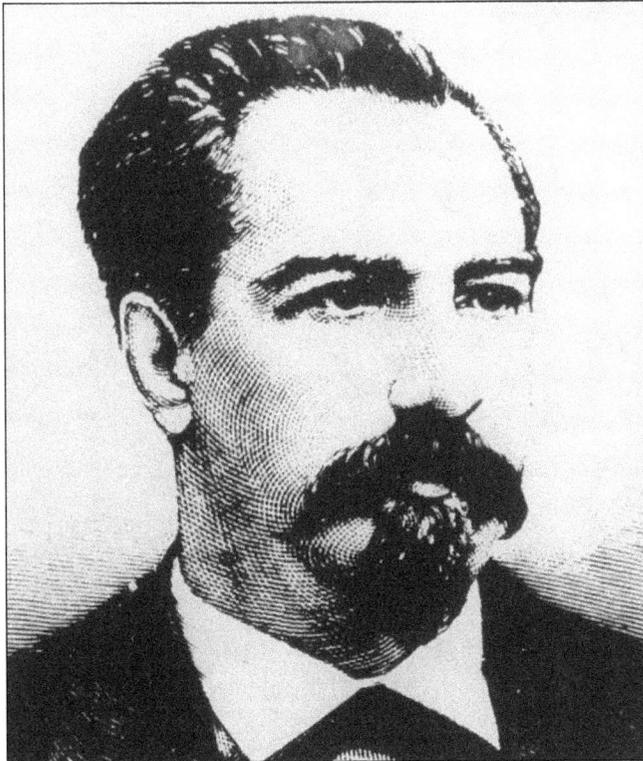

Angelo Socolo, considered the "Father of the Rice Industry," operated the largest rice mill in the United States in the 1850s. Arriving in New Orleans in 1849 from San Remo, he became a partner in A. Gandolfo & Company, importing Italian and Mexican produce. He experimented with new types of rice, introduced steam-powered threshing machines and mills, and increased Louisiana's annual production 30 times. He became known as the world's leading authority on rice cultivation and production.

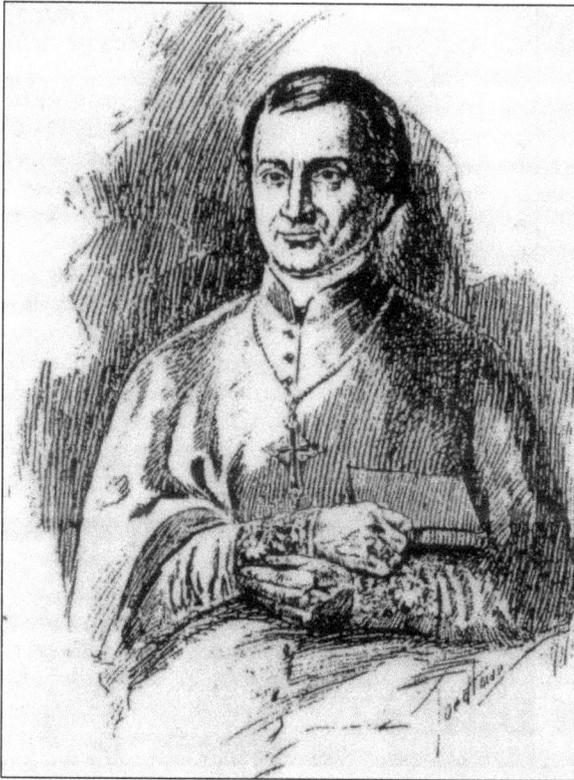

Another example of their pioneering presence in New Orleans was Bishop Joseph Rosati. He was the first Italian bishop in the South, administrator of the Diocese of New Orleans, and Bishop of the St. Louis Cathedral from 1826 to 1830. He was known as prudent financially and a strong spiritual leader.

Achille Perelli (1829–1891) was a noted artist, sculptor, and teacher. Born in Milan, he served with Garibaldi in the ill-fated 1848 Italian Revolution, then fled to New Orleans, where he settled on Iberville Street. In 1865, the Italian Masons commissioned Perelli to make a life-size bust of Dante for their mausoleum; Perelli refused payment for his work. Perelli helped to organize the Southern Art Union and taught at the Artists' Association of New Orleans.

Two

MASS MIGRATION AFTER THE CIVIL WAR
From Sicily to New Orleans

After the Civil War the numbers and the character of Italian migration to New Orleans changed dramatically. The relatively well-established Italian community in the French Quarter was involved in a wide variety of enterprises. When Sicilian peasants from places like Ustica, Cefaù, Contessa Entillina, and Palermo arrived, they found employment in those businesses, in the food industry, and on the docks of New Orleans. In contrast to Italian colonies in the United States, more than half of the Sicilian immigrants arrived prior to 1900. Most moved into the French Quarter, parts of which soon became known as "Little Palermo."

There was a strong demand for labor in New Orleans and the sugar parishes. Labor agents in Sicily, family and clan chain-migration patterns, and the influence of labor bureaus and padroni in America facilitated the transplantation of the Sicilian workforce to Louisiana.

The development of direct import-export trade between New Orleans and Sicily in citrus fruit, figs, olives, and seafood further enhanced the growth and economic power of Italians in the Crescent City. The Sicilian migration was so intense—and successful—that it triggered racial and ethnic prejudices in newspaper articles and cartoons and, ultimately, violence against the Sicilians.

The Census bureau estimates that there were more Italians in New Orleans than in any other U.S. city during the period 1850–1970. Unofficial sources cite about 30,000 Italians in New Orleans in the 1890s. By the end of the 1890s, more than 2,000 Italians were arriving in the city each year; about 90 percent were Sicilian. Many of the immigrants were "birds of passage" who returned to Italy after a season or two of hard work. Likely, many of these reimpatriati became involved as trading partners with Sicilian merchants in Louisiana.

By 1910, following the mass migrations from Sicily, the population of the city's French Quarter was 80 percent Sicilian. Other sources claim that nearly 100,000 Sicilian immigrants came in New Orleans between 1898 and 1929. Despite everything, the Sicilian colony grew and prospered, fulfilling the dreams of the immigrant generation.

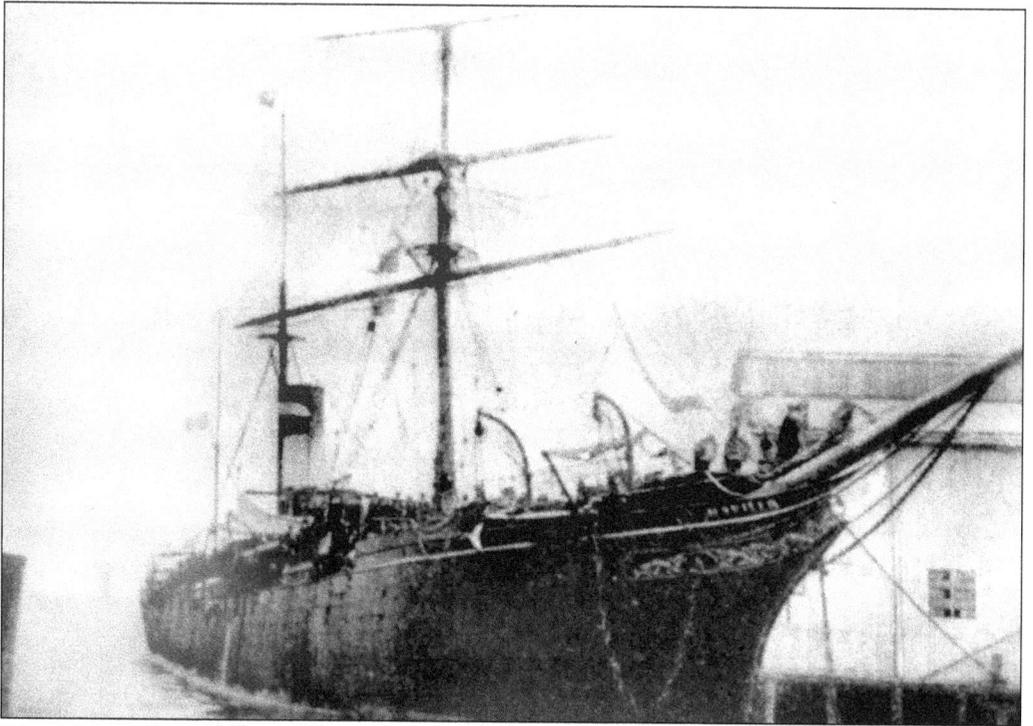

The SS *Manilla* was one of the many ships that brought Sicilian immigrants from Genoa and Palermo up the Mississippi River to New Orleans between 1901 and 1905. Mary Guzzardi and her family were among the many immigrants that came to New Orleans aboard this ship.

Dr. Felix Formento Jr. (1837–1907) played an important medical role during the Civil War. Born in New Orleans and educated at Jefferson College in Louisiana, he studied medicine at the Royal University at Torino. During the war he became chief surgeon at the Louisiana Confederate Hospital in Richmond, Virginia, where he pioneered skin grafting. Formento was one of the most prominent surgeons in the South, a member of the Louisiana State Board of Health, and president of the American Public Health Association.

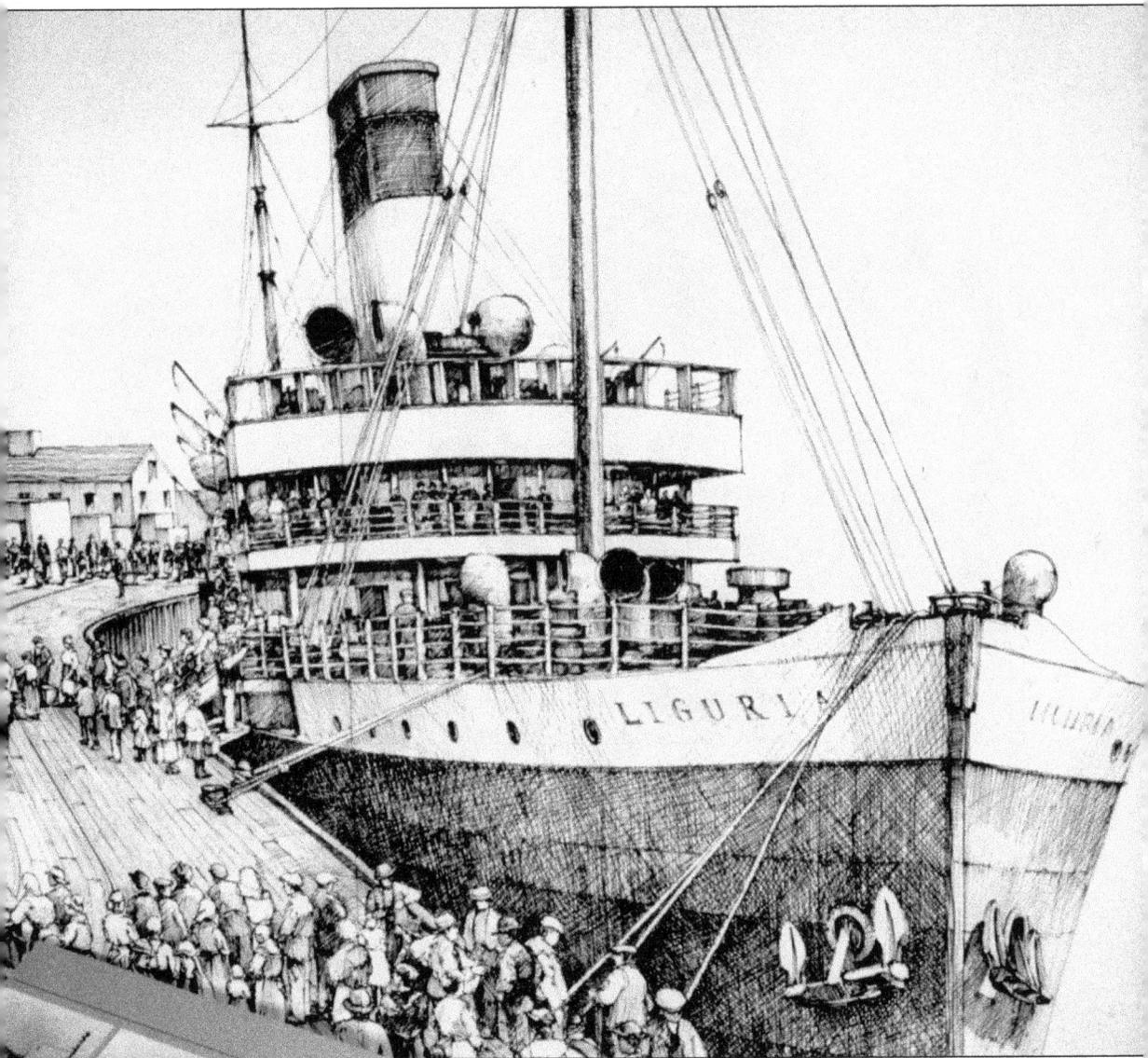

This drawing shows the SS *Liguria* bringing immigrant Sicilians to New Orleans *c.* 1900. Among the passengers from Palermo arriving on October 7, 1910, was Nicolo Pircoco. Research into passenger records reveals that he was 52, married, a merchant, and literate. He purchased his own ticket and had $1,000 in his possession. He was to join his brother Giuseppe in New Orleans; he had never been in prison, an almshouse, or supported by charity; he was not a polygamist or anarchist. He was in good health, 5 feet, 4 inches, of rosy complexion with chestnut hair and eyes, and he was born in Contessa Entellina, Province of Palermo.

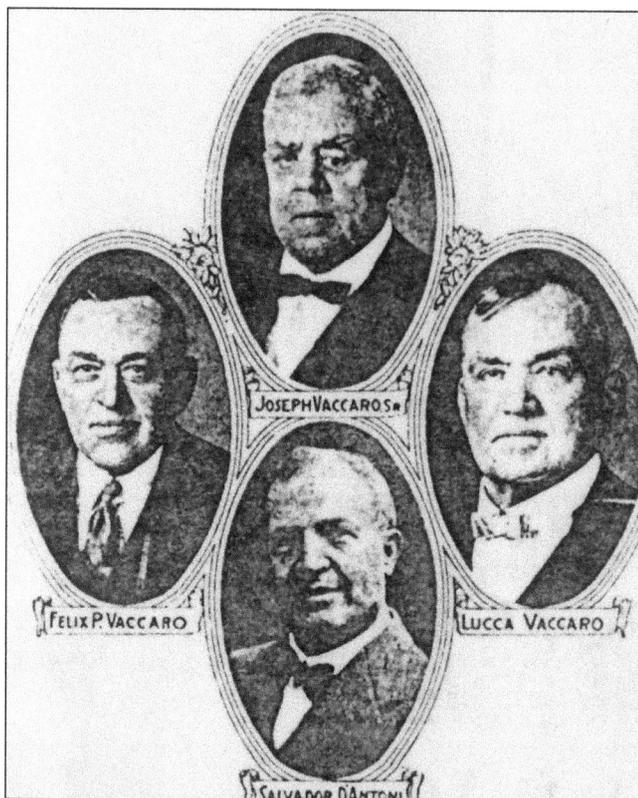

Like so many other New Orleans companies, the Standard Fruit & Steamship Company evolved from an Italian immigrant family's meager fruit stand. After emigrating from Contessa Entellina in the late 1800s, the Vaccaro brothers—Joseph, Felix, and Lucca—began peddling fruit from baskets. Soon after, the Vaccaros, along with Salvador, Vincent, and Carmelo D'Antoni, went into business together, importing bananas from Central America and purchasing their own ships for importing. This Vaccaro-D'Antoni enterprise later became the Standard Fruit and Steamship Company, which owned banana plantations in Central America and the ships that transported the bananas to market.

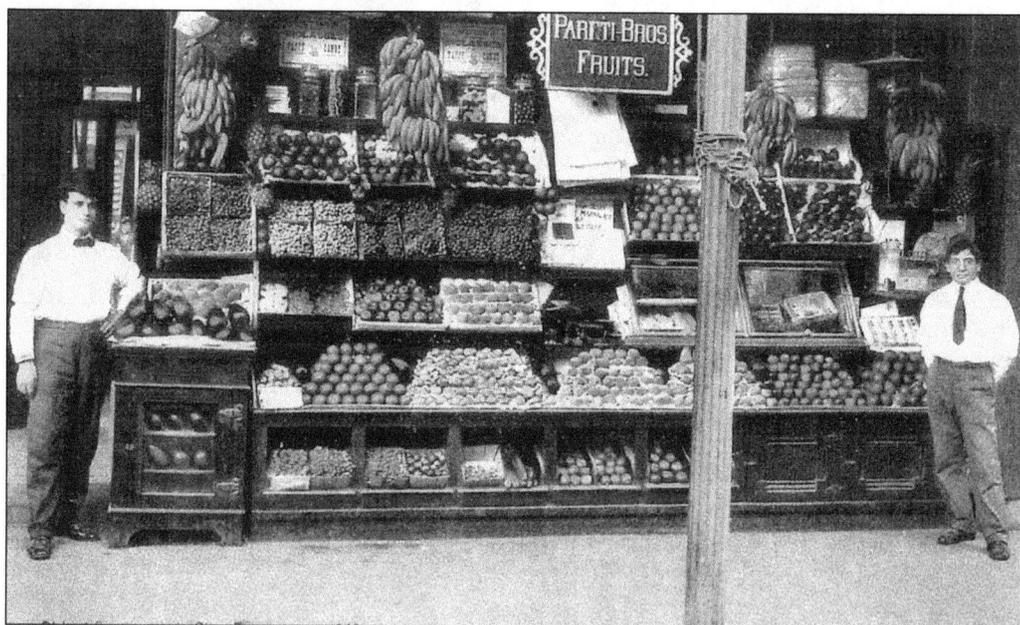

Pareti Brothers Fruit Stand was established in 1852. The card reads: "Oldest fruit stand in the City, Established 1852, Handles finest line of Fruits—Royal & Canal Streets, New Orleans, Louisiana." The Pareti family traces its roots back to Sicily.

Antonio Monteleone was a nobleman who operated a shoe factory in Sicily. He set out for New Orleans in 1880 and opened a cobbler shop on Royal Street. By 1886, he bought the 64-room Commercial Hotel at Royal and Iberville. Even in Depression years, the Monteleone was ranked as one the few hotels in America to show a profit. Four generations of Monteleones have made their hotel a jewel in the heart of the French Quarter. This landmark is one of the last great family-owned and operated hotels in the city today.

This 1891 advertisement gives us a glimpse into the wholesale labor market for Italian laborers. In some places there were three scales of pay—the highest for white workers, less for African Americans, and even less for Italians. It was not long, however, before railroad and construction bosses came to appreciate the dogged work ethic of immigrant Italian gang-laborers.

L'ITALO - AMERICANO LABOR BUREAU !

For the past ten years there has been a large influx of Italians into the State of Louisiana. In this decade there disembarked at the part of New Orleans, 4500 ITALIANS. These emmigrants are mostly STRONG, HEALTHY, ABLE BODIED INDUSTRIOUS MEN. AS LABORERS THEY HAVE NO SUPERIORS. Attracted by our temperate climate and the fertile resource of our State, they have come here in search of homes. CAPITALISTS, PLANTATION OWNERS, RAILROAD CONTRACTORS, AND, IN FACT, ALL PERSONS WHO WORK LABORERS IN GREAT NUMBERS, FIND THE ITALIAN IMMIGRANT A VALUABLE ACQUISITION, BECAUSE OF HIS WILLINGNESS AND HIS PECULIAR ADAPTABILITY TO HARD WORK. A WELL EQUIPPED AND RELIABLE LABOR BUREAU IS WANTED.

This want L'ITALO AMERICANO PURPOSES TO SUPPLY.

We will furnish Laborers to Proprietors, and employment to Laborers. One position is one which eminently qualifies us for the office we have elected to fill. Our circulation is not confined within narrow limits. It embraces nearly the entire United States, and our acquaintences with the Rail Road Authorities, Plantation Owners and Contractors gives us special facilities for serving satisfactorily and justly both employer and laborer.

L'ITALO AMERICANO LABOR BUREAU

Will be in charge of a thoroughly competent person, who will devote to it his constant and undivided attention. Our charges will be moderate whilst our services will be found to be of great value.

CORRESPONDENCE SOLICITED.

ADDRESS:

L'ITALO AMERICANO,
23 POYDRAS STREET,
NEW ORLEANS, LA.

17

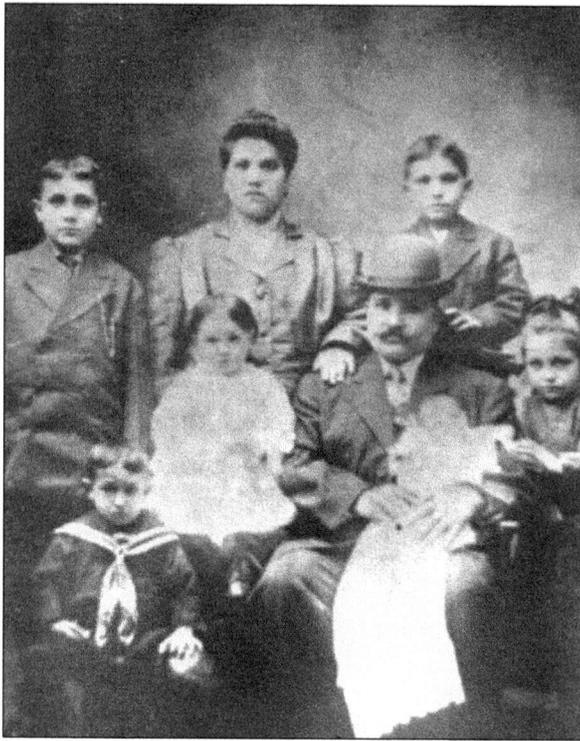

The Piazza family was a typical family of the early 20th century. In this portrait, standing from left to right are Anthony Piazza (brother of Paul Piazza Sr.), Mrs. Paul (Antonia Bonfanti) Piazza, and their son Anthony; in the middle row are Paul Piazza Sr. holding baby Frances and children Mary on his right and Dorothy on his left; seated on the floor is little Sam Piazza. The Piazza family is known for their success in the seafood business. They trace their origins to the Province of Palermo.

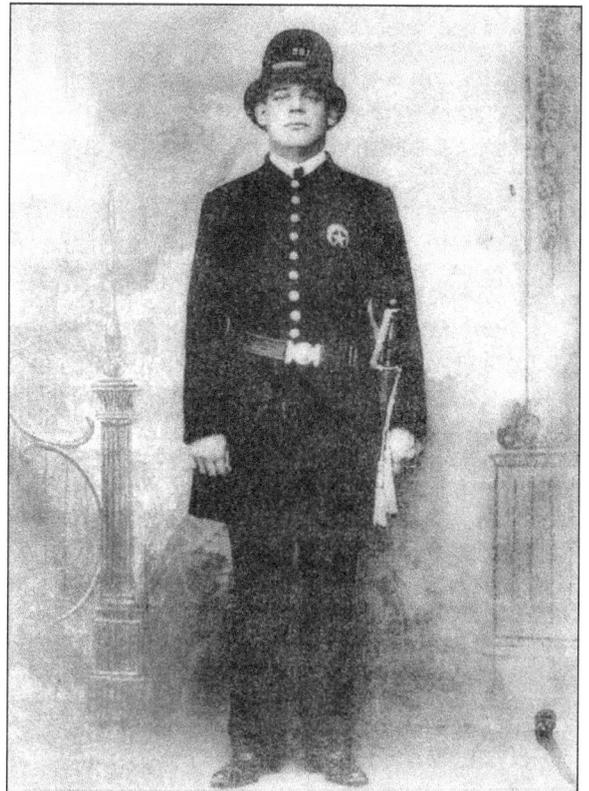

Frank Battaglia (Badge 581), pictured in 1909, was one of the first of many to serve on the New Orleans Police Force. The uniform of the day included an English bobby-style hat, a nightstick, and a crescent badge.

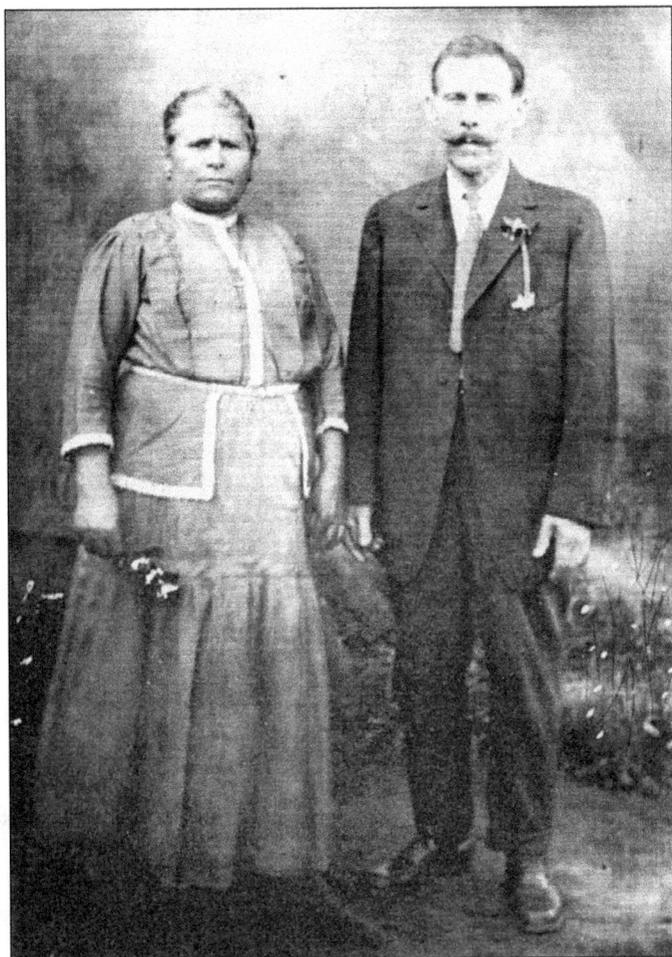

Agostino and Giuseppina Taormina Guzzardi, immigrant grandparents of Antoinette Cammarata Maselli, arrived in New Orleans in the late 1890s from the Province of Palermo.

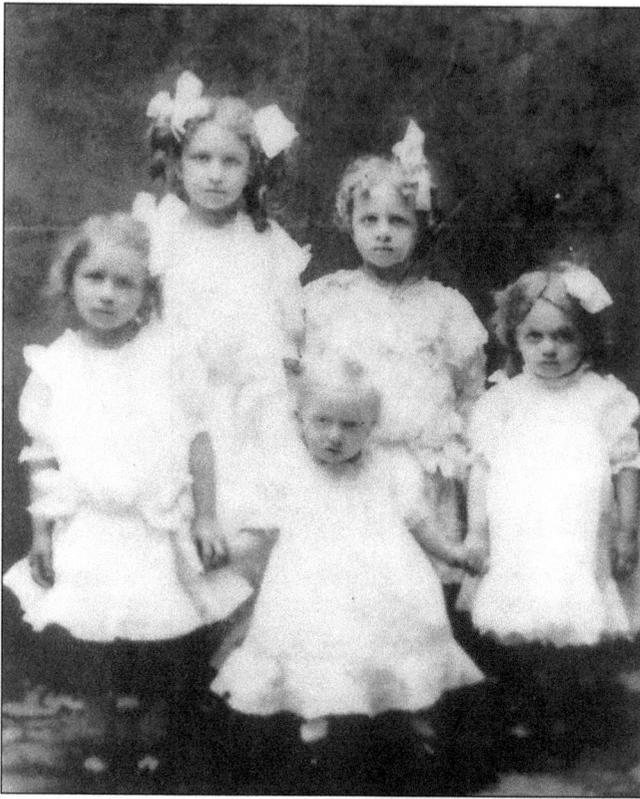

The Clesi children are, from left to right, Mamie Clesi Marino, Rita Clesi Ciaccio, Tony Clesi, Phyl Clesi Palermo, and Ana Clesi Tipery, in 1902. *Famiglie numerose* (large families) were the norm in that era, as was the high rate of infant mortality.

The children of Joseph David and Caroline Corrado Russo are, from left to right (front row) William C., Raymond "Kotchie," and Robert; (back row) JoAnn, David, Theresa Bourgeois Russo, and Peter S. Russo. They trace their origins back to Sicily.

This is the Certificate of Baptism of Biagia Maria Catarinoto, daughter of Arcoangelo and Vinciensa Ferrara, baptized on July 20, 1901, at St. Alphonsus Church. Her sponsors were John and Angelina Pinneno. *Comparaggio* (godparenthood) was an important element in creating the extended family groups that sustained Italians under the stress of migration to a new land.

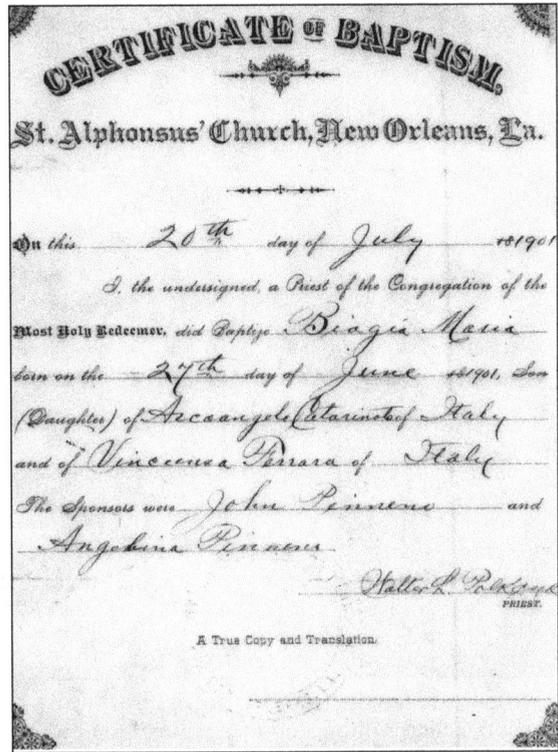

Calogero (1882–1957) and Josephine Barcelona Taravella (1884–1954) were both born in Alia, Sicily, arrived in New Orleans around 1898 as young children, they met, married, and raised 11 children. He was a barber and later delivered milk by horse and buggy in the New Orleans suburbs of Harvey and Marrero.

The Falcone family, from left to right are (first row) Rosalie Falcone Rotolo, Joseph Falcone (father), Felice Salito Falcone (mother), and Lucille Falcone (grandmother); (back row) Virginia Falcone Lemoine, Josephine Falcone Sentra, Vincent Falcone, Stella Falcone Miceli, and Annie Falcone Zara. Children missing from photo are Joseph, Peter, and Sam Falcone.

The Vincent and Rosalia Sclafani family settled in the French Quarter around 1900. Vincent worked in the Mangano Macaroni Factory in the 500 block of St. Philip Street. This photo was taken in 1912. The family originated in Chiusa, Sclafani, Sicily.

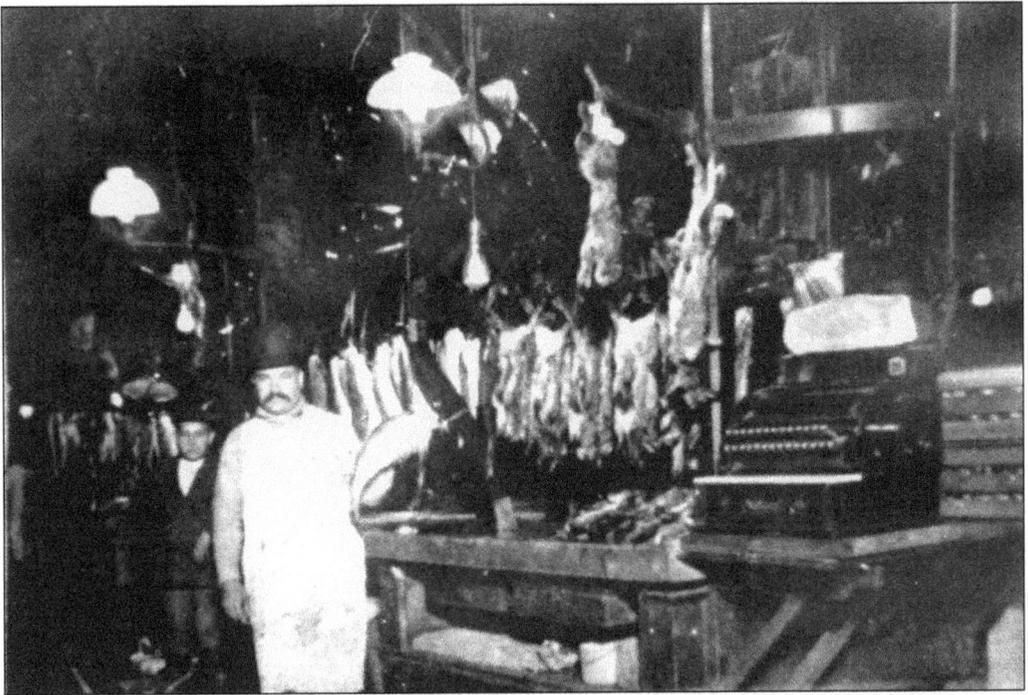

Paul Piazza Sr. and son Anthony stand in front of Paul's Fish Stall in the French Market's wholesale section in the early 1900s. The French Market consisted primarily of Italian merchants from 1880 until 1950.

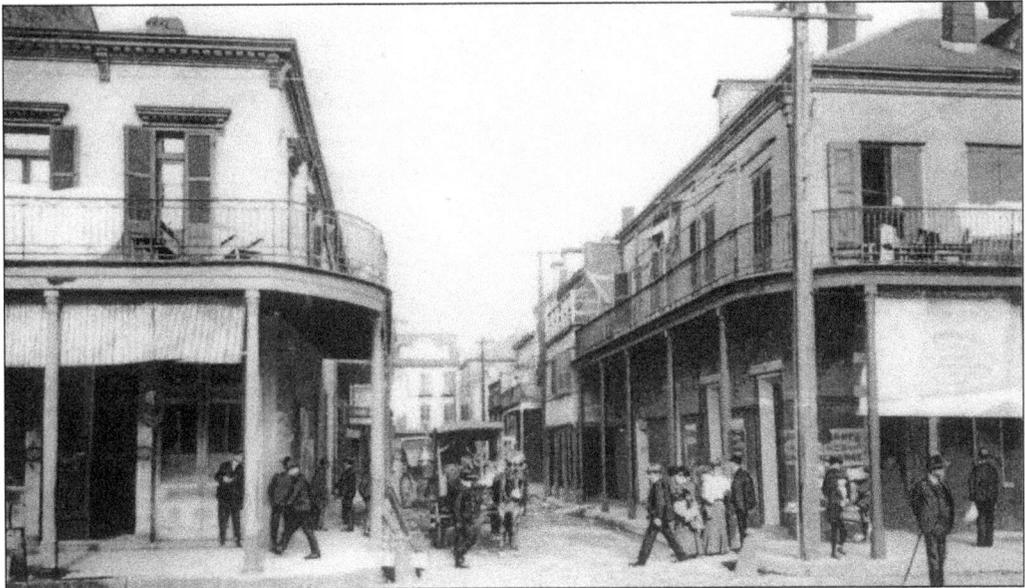

This postcard, originally printed in color, depicted the hustle and bustle of street life around the Italian headquarters on Madison Street in the Italian section of the French Quarter *c.* 1906.

L.A. Guglielmo's 1911 letter to Frank Vatter, ordering two bottles of Napa Hill claret for $75, illustrates business practices of that era.

The 1911 letterhead and notes of Lucas Cashio of Lutcher reveal that he was engaged in the importation and sale of produce, wines, liquor, passenger steamer tickets, and international banking services. In this document Eddie Wilson signed with his "x" to pay $4 monthly on his $17 account.

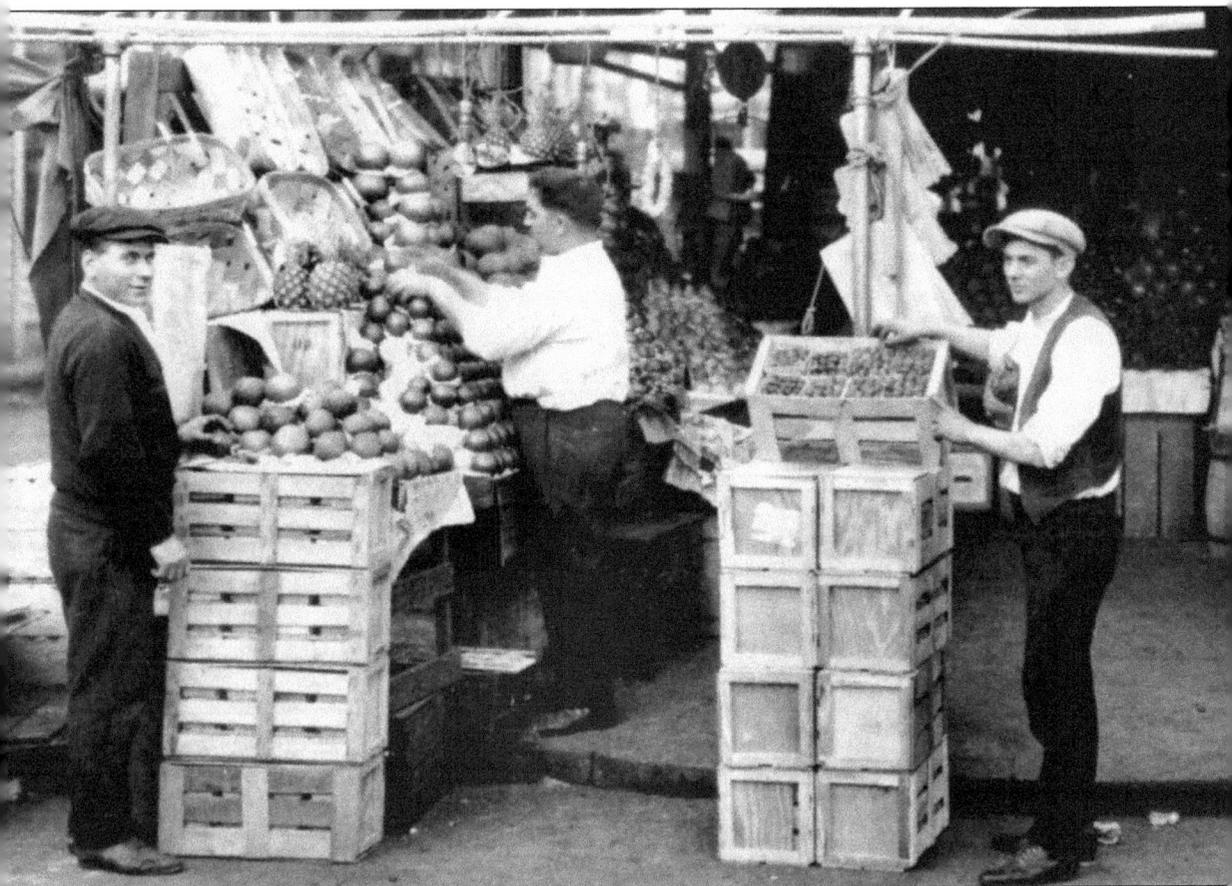

This Italian vegetable and fruit stand at the French Market in the French Quarter in 1919 is typical of the small ventures of generations of Sicilian and Italians in this city. Joseph P. Tedesco is second from left, putting fruit on shelf. Though the hours were long and the shelf-life of the produce complicated business decisions, such occupations offered many opportunities to interact with the public and fraternize with colleagues and relatives in the produce business. (Courtesy of The Historic New Orleans Collection Acc. No. 1979.325.)

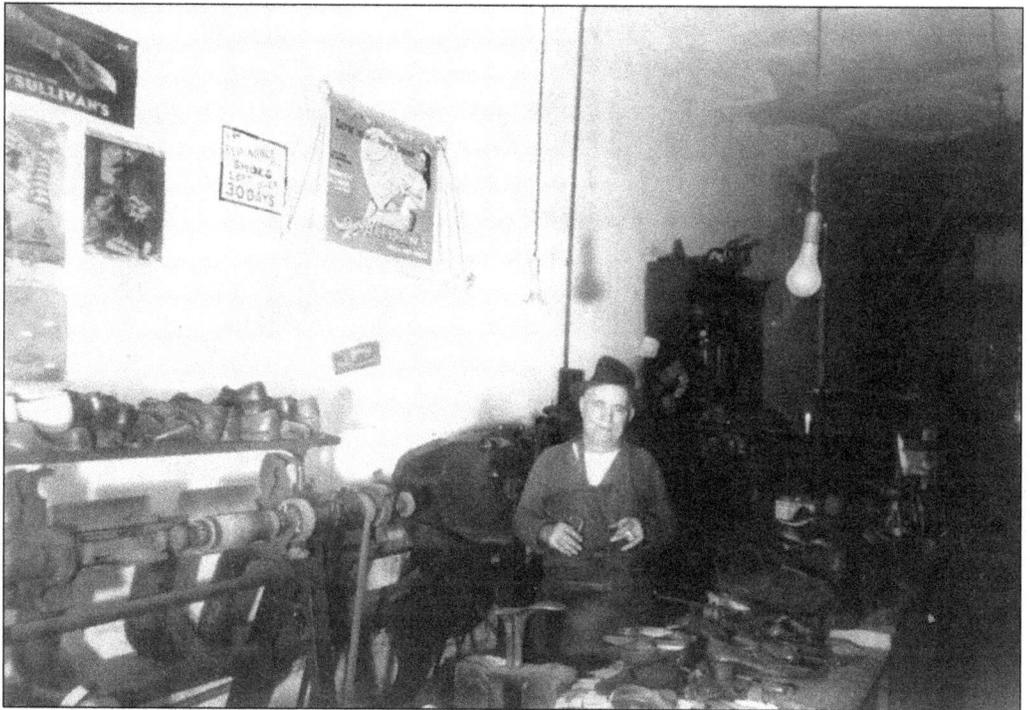

Sam Alongi's Shoe Repair shop is pictured *c.* 1920. Before the advent of the "throw-away" society, neighborhoods were dotted with one-man shoemaker shops. The rural backgrounds of many Italians had given them the skills to start these small businesses. A number of Sicilian immigrants who started off in such humble circumstances became millionaires.

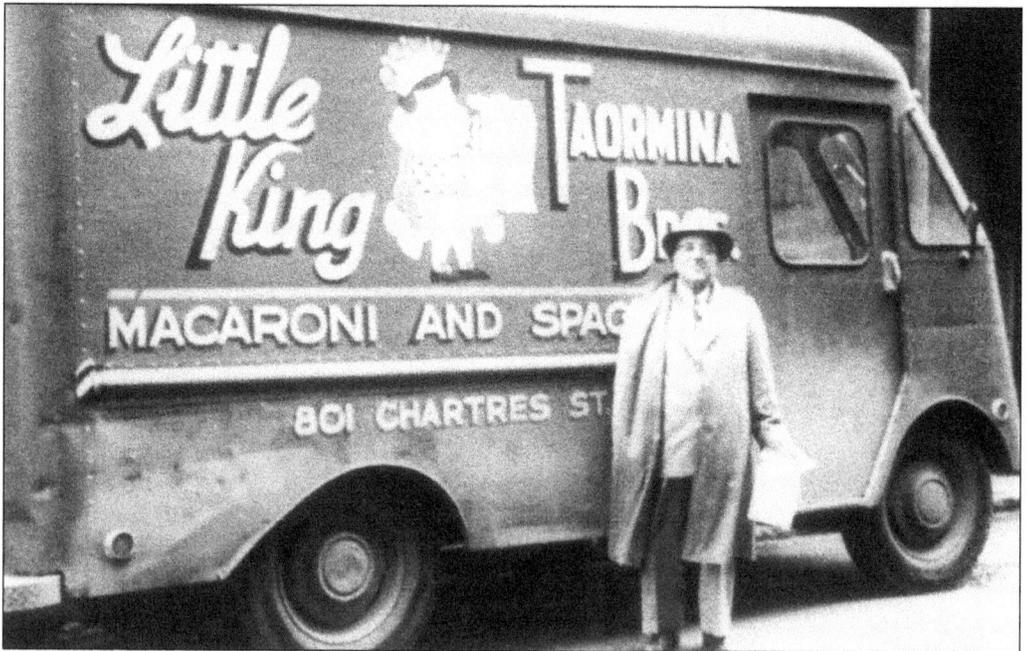

The Little King grocery at 801 Chartres Street in the French Quarter was owned by Frank Taormina. They specialized in macaroni, spaghetti, and other pastas. This view is *c.* 1920.

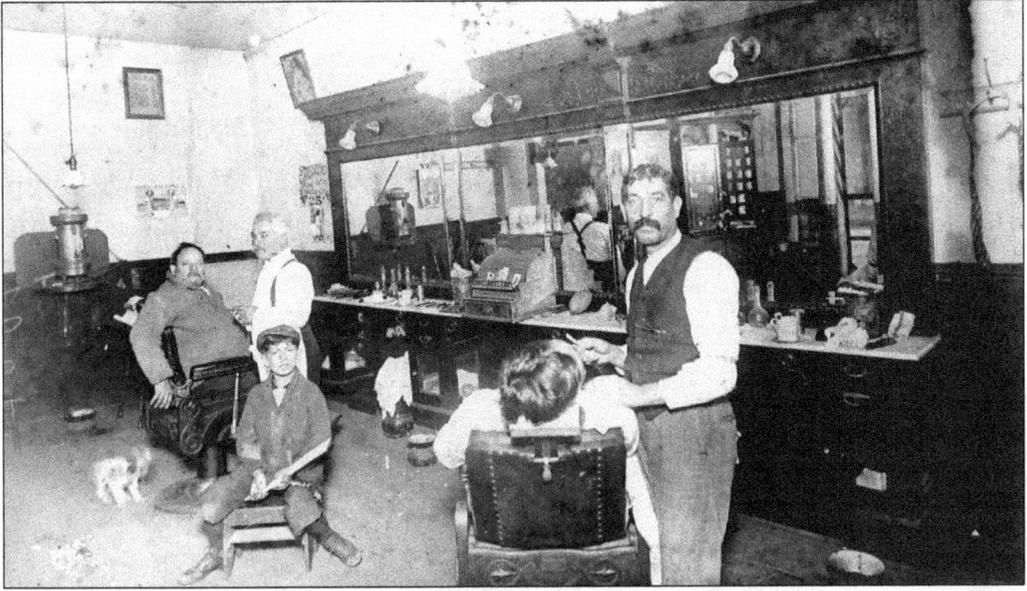

The Johnson Crofalo barbershop, seen c. 1920, was typical of the era. It featured a massive mirror, straight razor, a boy, a dog, a poster for the Italian Lines, and a price list for tonsorial services. Barbering was an easy start-up business, involving only a small initial investment, and shops could be located in the front parlor of a family home.

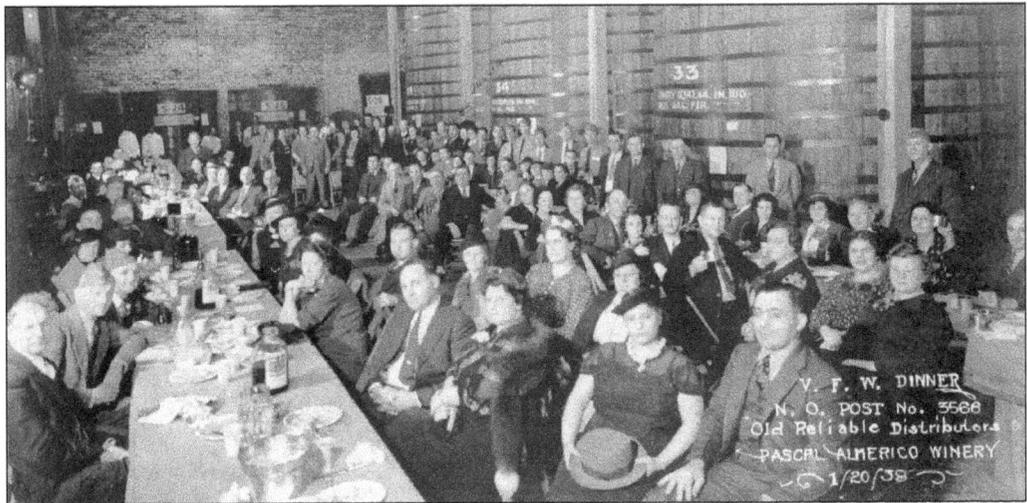

Old Reliable Distributors of Italian Girl Wine held their annual dinner at the VFW Post No. 3566 located at 2231 Decatur Street. The photo was taken on January 20, 1938.

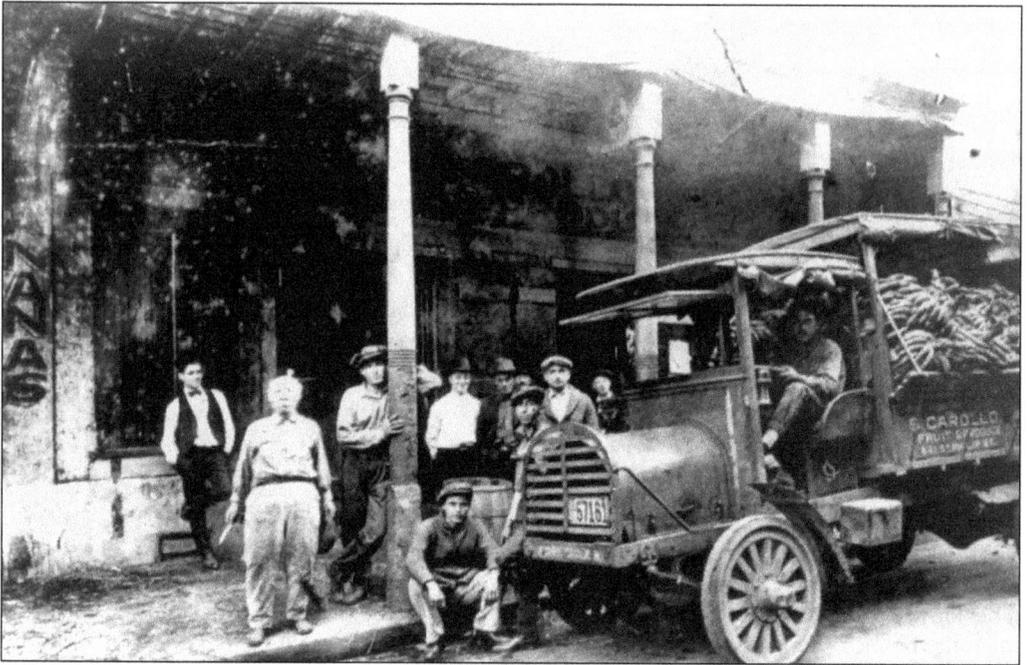

Fruit and produce was the family business of Sam Carollo at 621 St. Philip Street in the French Quarter back in 1921. The truck is loaded for the day's journey in this photo submitted by Sam's son Anthony Corollo, former owner of Venezia's Restaurant on North Carrollton Avenue.

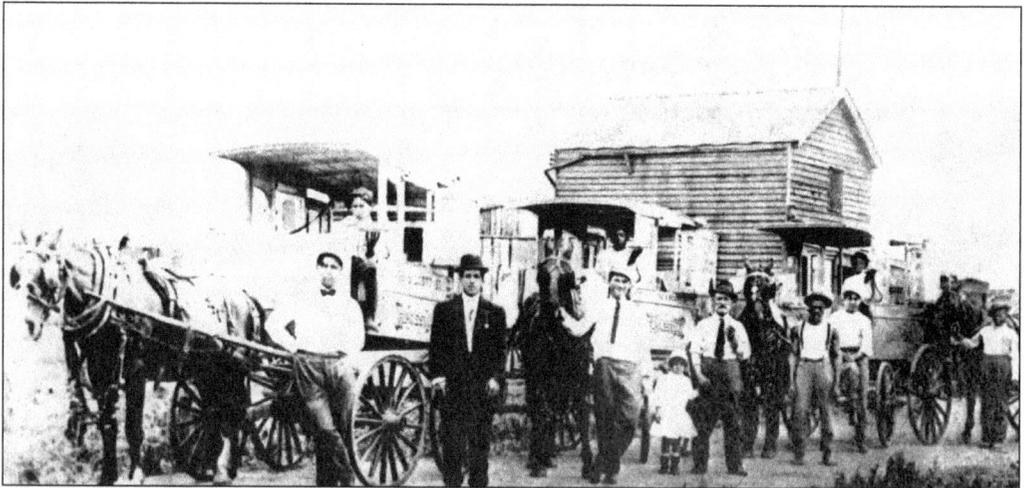

Francesco "Frank" Prestia (in the dark suit), owner of the White Rose Ice Cream company, poses proudly with horse-drawn wagons, the first to deliver hand-made ice cream to New Orleanians. He started the company in 1908, making all the ice cream by hand and selling from a pushcart. A carpenter by trade, Prestia designed and built his own ice-cream freezer and used a bell to announce his wares. As business began to prosper, he built a factory at 229 South Rocheblave Street in 1920.

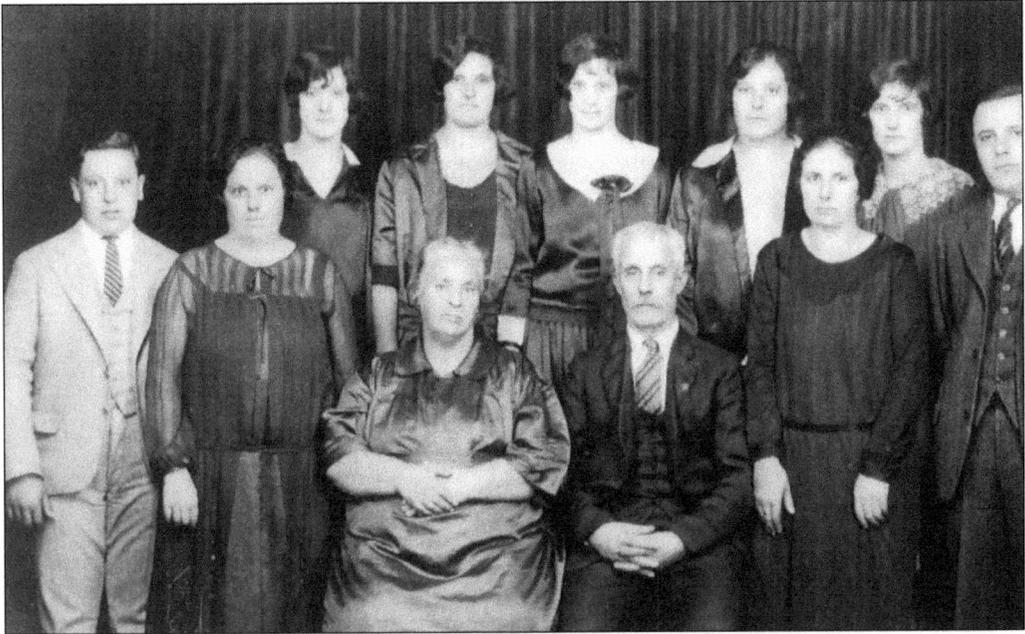

Andrew Messina came to American in 1892 from Sambuca, Sicily. He met and married Maria Campesi, and they had two boys and seven girls. The success of their restaurant ventures over 59 years is yet another example of the families who have combined Italian cuisine, hard work, and family solidarity to achieve status. Pictured here are, from left to right, (front row) George Messina, Louise Messina, Maria Campesi Messina, Andrew Messina, Pauline Messina Roussa and Dominick Messina; (back row) Kate Messina, Margaret Messina Grisaffi, Mary Messina Rafferti, Nancy Messina, and Tina Messina Grisaffi.

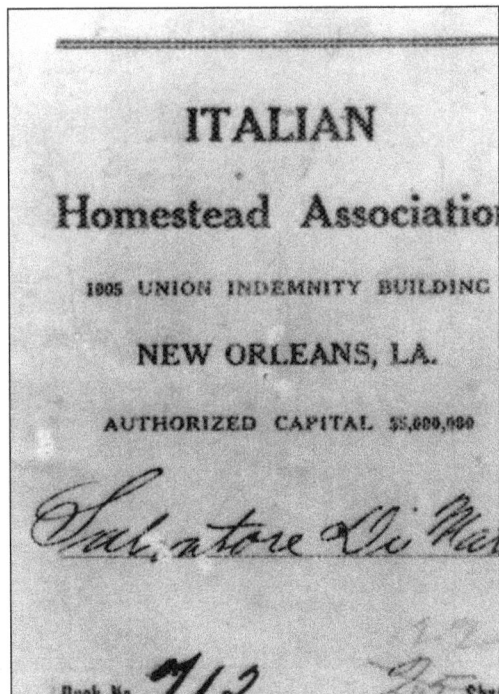

As the holder of deposit book #712, Salvatore Di Matteo owned 22 shares in the Italian Homestead Association, c. 1925. Organizations such as the IHA provided opportunities for Italians in New Orleans to accumulate real estate, a major component in the economic success of Italians in the city. DiMatteo came from Monreale, and his wife from San Giuseppe, Sicily.

LUIGI DELL'ORTO,
Banca Italiana,

P. O. Box 1285. 17 DECATUR STREET,

NEW · ORLEANS · LA.

Il vapore.........................della Navigazione..............

.................partirà da New Orleans direttamente per l'Italia verso

..

Il vapore prenderà un numero limitato di passeggieri, e sin da ora si

accettano caparre per assicurarne il posto.

Prezzo del biglietto da Nuova Orleans a Palermo · $40.00.
" " " Messina · 40.00.
" " " Napoli · 38.00.
" " " Livorno · 38.00.
" " " Genova · 35.00.
Ragazzi da 7 a 12 anni non compiti · · · · · 20.00.
Ragazzi da 3 a 7 anni non compiti · · · · · 10.00.
Sotto 3 anni, uno per famiglia gratis.

I biglietti si vendono alla Banca Italiana Luigi Dell'Orto.

In the early 1900s, the Luigi Dell'Orto *Banca Italiana* (Italian Bank), located at 17 Decatur Street, offered passage to Palermo and Messina to adults for $40, children 7–12 for $20, 3–7 for $10, and children under 3 were free (one to a family).

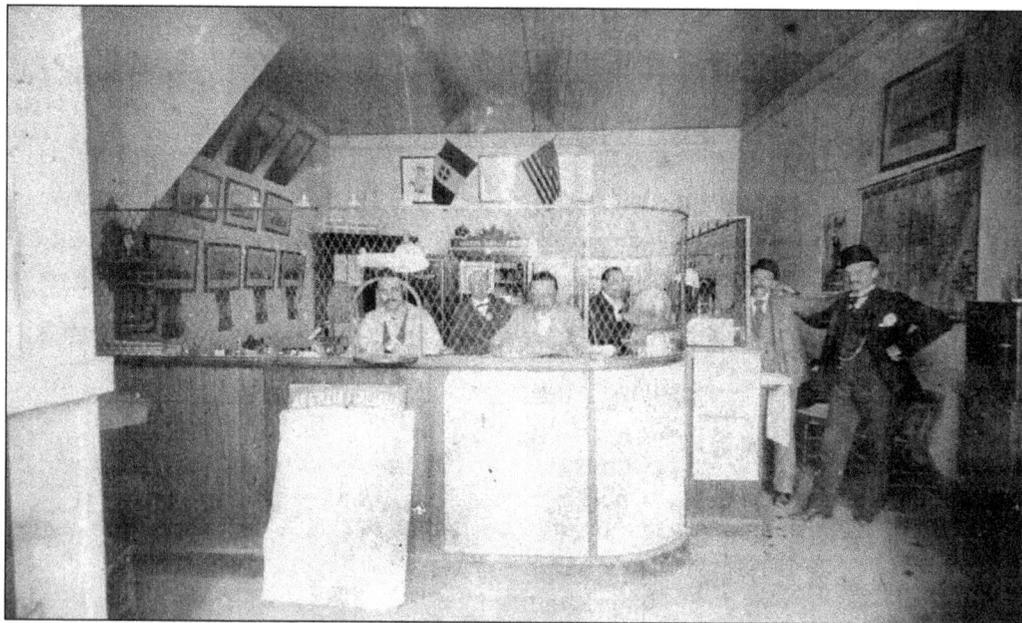

The interior of the Luigi Dell Orto *Banca Italiana* is pictured here c. 1900.

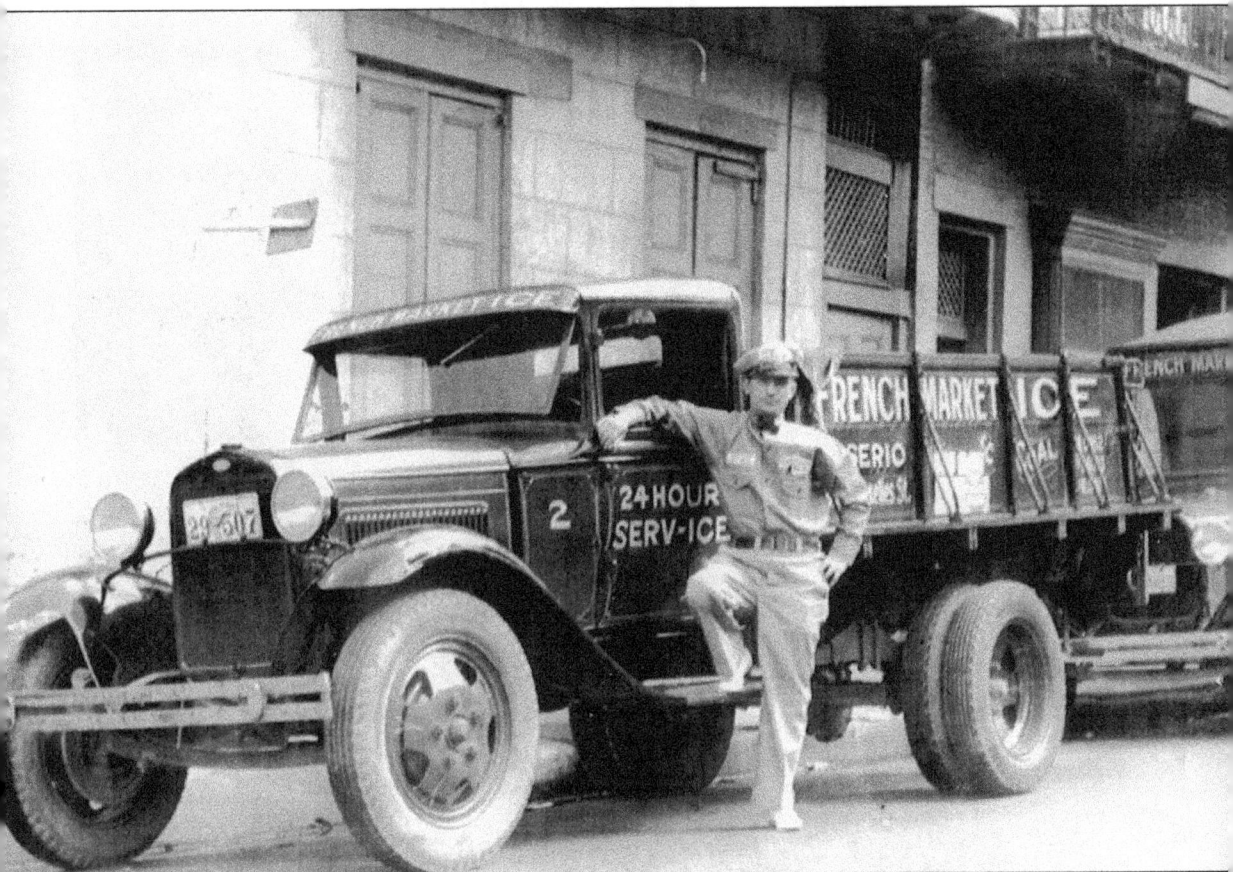

"Iceman" Anthony Serio proudly poses with his French Market Ice Company truck in 1936. Before the days of electric home refrigerators, the iceman visited neighborhoods several times a week. The French Market Ice Company was located at 1020 Chartres Street. The photograph is courtesy of his son, Salvadore J. Serio.

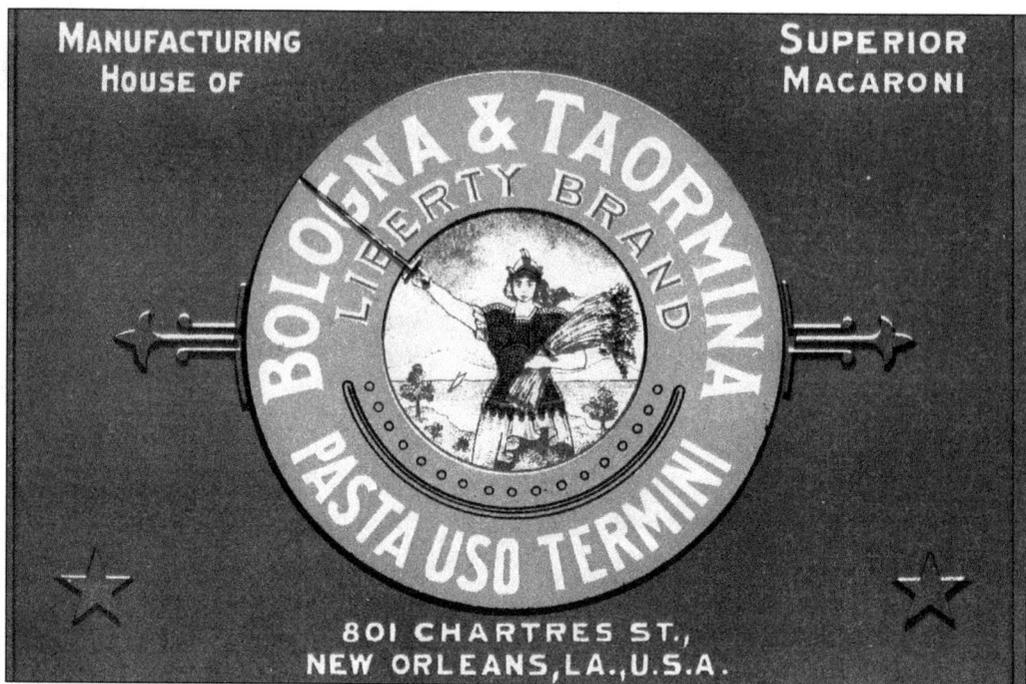

Bologna & Taormina Liberty Brand Pasta's label indicates the ways in which entrepreneurs were able to weave together Italian and American images to brand and sell their products. Bologna & Taormina was a small company, but the families eventually branched out to other successful businesses.

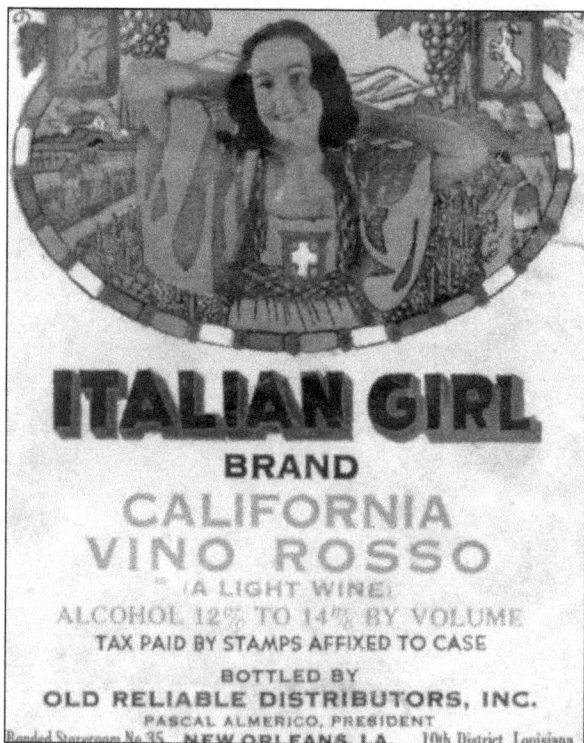

Old Reliable Distributor's label for "Italian Girl" CaliforniaVino Rosso, owned by Pascal Almerico, projected an idyllic image of rural Italy. "Italian Girl" must have packed quite a punch, with a rating of up to 14 percent alcohol by volume.

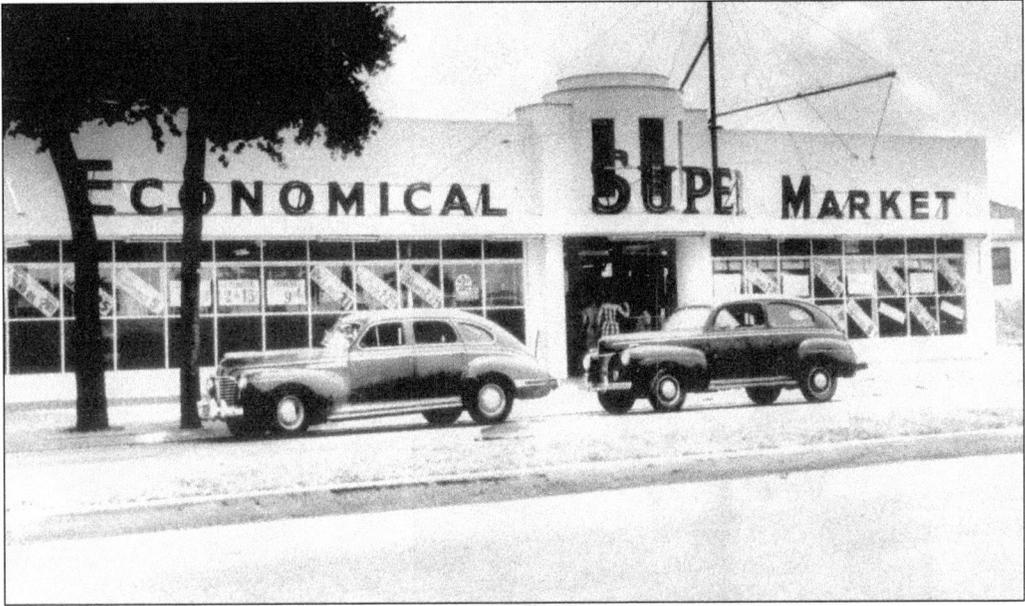

Anthony Zuppardo sold imported bananas, and by the late 1920s owned a fruit stand in the Gentilly section. By 1940, it became a two-story building where Anthony lived with his wife, Frances Carraci. His brother Joseph joined the business about the same time. The brothers changed the name to Economical Grocery. They opened a store in Metairie in the 1960s. Today, the Zuppardos continue to operate the supermarkets, and "Tony," at 90, is there daily to oversee the operations. The secret to their continued growth is in their motto, "It makes a difference when the owners are there." The Zuppardos immigrated from Camporeale, Sicily, in the early 1900s.

Mama Brocato and her boys pose in the family's Ice Cream & Confectionary Parlor on Ursulines Street. Angelo Brocato founded the business in the French Quarter in 1905. Brocato's was one of New Orleans's first sit-down ice cream parlors. It maintains a nostalgic atmosphere with slowly turning ceiling fans and rows of apothecary jars containing colorful candies. Although the location has changed to Carrollton Avenue, the business is still run by Angelo's descendants.

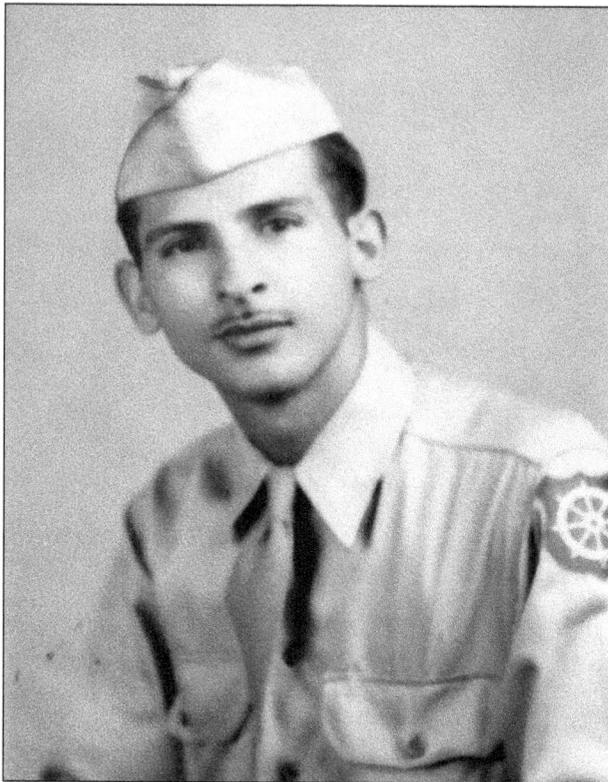

About 1 million of the 15 million people in the U.S. Military in World War II were Italian Americans. The war moved people around and impacted the community in many ways. New Jersey native Joe Maselli was stationed in New Orleans, where he met and married Antoinette Cammarata. For the past 60 years, they have been among the leading families of New Orleans.

| NEW ORLEANS | LOUISIANA | NL |

LOUISIANA—Motor Car Driving Rules: Speed Limit (not fixed). Gasoline Tax (State), 5c. Non-residents must obtain permit after 30 days. Use of spotlights permitted.

LOUISIANA—Law Governing Wine and Spirits: Sale with meal. out meals, yes. Room Service, ye sales: Hotels, yes.

NEW ORLEANS
Population, 458,762
Italian Population, 36,160

County (Parish) Seat. Situated between Lake Pontchartrain (an arm of the Gulf of Mexico) and the Mississippi River, 110 miles from the latter's mouth. Served by Ill.-Cen. Sou. Pac., Tex. & Pac., N. & M. V. L., & N., G. B. N., Gulf Coast Lines, Mo. Pac. La. & Ark., and Sou. R.Rs.; Teche Greyhound Lines; 90 steamship lines to all world ports; on Highways 90, 61, 11, 30, 31, 51, 71.
Principal Industries: Shipping, manufacturing, wash suits, sugar refining, vegetable oil refining, mineral oil refining, syrup canning, seafood packing, rice milling, cotton goods, candy, lumber, rope, furniture, pipe, gum, pulp wood, limestone, resin, corn, rice, cigars, cigarettes, tobacco, agriculture, iron and steel.

ADVERTISING AGENCIES
(Agenzie di Reclame)
Avegno, Robt.
334 Magazine_____RAymond 0971

ASSOCIATIONS (Associazioni)
Italian Chamber of Commerce

Federico Baking Co.
2000 Magazine_____JAckr
LaNasa A. S. Bakery, Inc.
6117 St. Claude_____FR
Liuzza Bros.
2001 Lapeyrouse_____
Lombardo, F., & Son
1210 Decatur_____
Messina, J.
2838 Third_____
Ruffino Baking Co., Inc.
625 St. Philip_____

BARBERS (Barbieri)
Italiano, Ernest
1108 Tulane_____
Italiano's, Frank, Barber Shop
1426 St. Chas._____R
Mascari Bros. Barber Shop
130 Royal_____
Mascari's, C., Barber Shop
111 St. Chas._____
Messina, Salvador
108 N. Rampart_____M.
Serio, Jean
227 Bourbon_____M

This page from a 1937 phone book puts the Italian population in New Orleans at 36,160, or 13 percent. The 2000 Census figure puts those with Italian ancestry in the corporate limits of New Orleans at 15,695, or 3.2 percent. On the other hand, the 2000 Census shows suburban Kenner with 9,057 Italian Americans, or 12.8 percent of the town's population.

Three

NEW ORLEANS'S
1891 NIGHTMARE
Eleven Italians Lynched

It is ironic that the most serious assault on Italian immigrants in the United States took place in cosmopolitan New Orleans. Yet racism ran high in all regions and social classes throughout the nation, and lynch law was ingrained in the culture of the South and West. Historian Richard Gambino has also stressed the local fears in the New Orleans business community that the Italians had become too successful and too numerous. The largest mass lynching in American history, this atrocity brought approval throughout the country and created animosity that almost triggered a war with Italy.

In his rise to the position of police chief, David Hennessy created many rivals and was involved in the killing of one of them. The chief had dealings with a host of unsavory elements in the city. On the foggy night of October 15, 1890, Hennessy was ambushed by gunmen on the street near his home. Hennessy died in the hospital the next day without revealing anything about his assailants. Mayor Joseph A. Shakespeare ordered police to "arrest every Italian you run across," and some 250 of New Orleans's 25,000–30,000 Italians were detained. The 19 who were indicted included Joseph Macheca and Charles Metranga, as well as Pietro Monasterio, Bastiano Incardona, Antonio Scaffidi, and Antonio Marchesi and his 14-year-old son Gaspare.

The trial started on February 16, 1891. The defendants were ably represented by Thomas J. Semmes and Lionel Adams. The prosecution raised the specter—perhaps for the first time in American history—of a mafia conspiracy, and Emmanuele Polizzi created an outburst with an incoherent confession of the murder. However, the prosecution presented little hard evidence against the indicted individuals, and no evidence was presented against Mantranga and Incardona. In fact, Judge Joshua Baker dismissed charges against the two. None of the all-male jury members had an Italian name.

On March 13, the jury handed down a verdict that found Macheca, the Marchesis, and Antonio Bagnetto not guilty and declared a mistrial for Polizzi, Monasterio, and Scaffidi. The judge ordered all the men remanded to the parish jail to await action on other charges against them. The next day, March 14, 1891, several thousand citizens crashed into the parish prison, led by W.S. Parkerson, John Wickliffe, Edger Farrar, and Walter Flower, and proceeded to shoot, hang, and club 11 Italians to death.

Public opinion around America generally endorsed the action of the mob, applauding the citizens' efforts to stop the mafia. Italian-American publications and organizations protested in vain. The Italian government was angered by the event, and rumors in America warned of a naval attack on America. President Harrison scrambled to condemn lynch law and defuse the conflict, eventually paying a $25,000 indemnity to be divided up among the families of the victims. Elements that had backed the lynch mob continued to have strong political support in the state for the next several decades.

The New-York Times

SHOT DOWN AT HIS DOOR

THE CHIEF OF THE NEW-ORLEANS POLICE BRUTALLY MURDERED.

A GANG OF REVENGEFUL SICILIANS SUPPOSED TO HAVE DONE THE WORK—THE DEAD MAN'S CAREER.

NEW-ORLEANS, Oct. 16.—The assassination of Chief of Police David C. Hennessey by a gang of Sicilians at his doorstep as he was about entering his house just before midnight last night has created a feeling of horror and indignation such as has not been manifested here for many years...

CHIEF HENNESSY AVENGED

ELEVEN OF HIS ITALIAN ASSASSINS LYNCHED BY A MOB.

AN UPRISING OF INDIGNANT CITIZENS IN NEW-ORLEANS—THE PRISON DOORS FORCED AND THE ITALIAN MURDERERS SHOT DOWN.

NEW-ORLEANS, March 14.—In every paper in the city this morning appeared the following call:

"All good citizens are invited to attend a mass meeting on Saturday, March 14, at 10 o'clock A. M., at Clay Statue, to take steps to remedy the failure of justice in the Hennessey case. Come prepared for action."

John C. Wickliffe, ... [list of names]

ALL QUIET AT NEW-ORLEANS

ITALIANS MAKE THREATS OF VENGE-ANCE BUT FRIGHTEN NOBODY.

NEW-ORLEANS, March 17.—The city remains very quiet...

WHAT DO THE ITALIANS WANT?

Of course, a formal remonstrance from the Italian Government against the lawless and irregular killing of certain Italians in New-Orleans is to be expected...

These *New York Times* clippings from October 17, 1890, March 15, 1891, and March 17–18, 1891 represent general American public opinion, depicting the acquitted victims of the lynch mob as "Italian assassins" and "Italian murderers." The March 15 article reprinted the call to mob action signed by John Wickliffe and 60 others. The March 17 article included one of the earliest references in the American media to the "mafia."

d, coming across the river, went to
er's. It was then about 11:55.
arly entered Fabacher's on the Cus-
ase street side. Witness saw a number
ons at the table adjoining. There was
of about seven, apparently of the
race.
ass did not know if he could recog-
of the seven.
saw some of the party by sight.
eca and Matranga were asked to stand
Adams, and Gen. Meyer said they
the party that night.
Adams then had Rocco Grachi, the two
s, Patorno and Sunzeri brought from
k. He recognized Patorno as among
mber. He was not sure about J'm
. He did not see Sunzeri and d'd not
er him. Witness was introduced to
e of the party and had a good look at
Witness' health was toasted and
rty of Italians wished him well
omised to work in his behalf. The
as well lighted. The party at the ad-
table had evidently commenced dining
witness saw them, judging from the
r of bottles on the table.
State had no questions to ask.
defense expected to prove that
I was in the party at Fabacher's but
o do so.)

FRED. MAUBERRET,
asurer of the Academy of Music. Has
that position twenty years. Knows
aca personally, and Matranga, John
, Jim Caruso, Chas. Patorno, Sunzeri,
t Garuso by sight. To the best of his
dge he saw Sunzeri and six others at
ademy the night of October 15th. Was
paid for them.
udge Luzenberg—I mean the night
ef was shot. "Fairies' Well" was the
layed. The theatre let out at 10:45
rrect—Was acting treasurer all of that

ARMAND VEAZEY
ler of the Academy, had been employed
nce Oct. 6. Remembered the night the
as shot. Knows Matrenga and Machæca
ne of the others. On that night Machæca
tranga were in the Academy. There
ur, five or six people with h'm. "Fairies
was being played that night.
ross-examination.

M. J. PONS,
ted with the theatres, was at the
ny on the night Dave Hennessey was
Witness identified Machæca and Ma-
as having been present at the the tre
ght.
five men were brought in
Witness remembered the faces
ree or four of them. Subsc-
Patorno, James Caruso and Sunzeri
ought into court again and witness
saw James Garuso, Salvadore Sunzeri
cco Geracht at the theatre that night.
s was not sure about Patorno and
. There were seven persons in the
Witness saw them go out after each
nance

FIXING THE JURY.

ANOTHER TALES JUROR WHO WAS OFFERED MONEY

To Get Accepted and Work in the Interest of the Defense—How He Became Frightened and Succeeded in Getting Off.

Here is another flagrant attempt on the part of the agents of the defense in the Hennessey case to defeat the ends of justice by bribing jurors.

The STATES yesterday printed the statement of a juror who had been approached through friends, and who had been offered $3,000 if he could obtain a place on the jury and cause either a mistrial or an acquittal. That publication created a sensation not only on the streets, but at the Criminal Court.

Sinister rumors of "packed" juries and talk of corruption have gone the rounds, but until yesterday it was not generally known that efforts had been made to influence in advance of the taking of testimony the verdict of the case.

The counsel for the State had their attention directed to the STATES' publication by representatives of the Times-Democrat and Judge Luzenberg intimated th t the matter would be presented to the Grand Jury at its next session if it was found that there were good grounds for these rumors.

A most positive attempt at jury bribing came to the attention of a STATES reporter this morning. The man whose verdict it was attempted to influence was one of the tales jurors who were summoned after the regular panel was exhausted. The person referred to resides not a great distance away from the court building, and a STATES reporter visited him this afternoon and held a conversation with him, which confirmed in every particular the information that had been privately furnished to the writer. It is thought best in the interest of the public good to withhold the name of this person for the present, but it is in the possession of the STATES and will be forthcoming if the State's attorneys or the grand jury should require it. Here is the conversation:

"You were one of the tales jurors summoned on the Hennessey case?" asked the reporter of the STATES.

"Yes, sir, I was," was the reply.

"Why did you not get on the jury?"

"Because I was challenged for cause at the State's suggestion."

"It is represented that you were approached after you were summoned and efforts made to influence your verdict if you were accepted?"

Porter Perkins in the leg, when the latter brought him a glass of ice water.

Toward 1 o'clock Polietz became very quiet and faithfully promised his counsel that when court opened he would take his seat with the other prisoners and behave himself.

WENT OFF WITH THE SHERIFF'S BUGGY.

During recess this afternoon a presumptuous young man took Sheriff Villere's buggy, which was standing in front of the court building, and drove off with it. The sheriff shortly after m'ssed it and was very much put out over its mysterious disappearance. He telephoned to the pound but could receive no information from that quarter. Couriers were sent out and the horse and buggy were found abandoned on Girod and Tchoupitoulas streets, where it had been left by the individual who had driven to his destination.

AN ACTRESS INHERITS WEALTH

Ray Douglas and Her Eventful Career.

NEW YORK, March 7.—[Associated Press.]— Theatrical people about town and a great many of the every day folks of New York were interested yesterday in the news printed in the Sun that Ray Douglass had come into a fortune of about a quarter of a million of dollars.

Miss Douglass is or was an actress. She is young and pretty and has a very interesting history, the making or which during the last three or four years she has come pretty conspicuously before the New York public.

Miss Douglass is a stage name, her real name is Mammie Thompson and she is known by that name now almost as well as by her theatrical name. But she is also entitled by marriage to the name of Montgomery. She comes of a Southern family of wealth. Her grandfather was Jacob Thompson, of the United States treasury, under President Buchanan and a member of the cabinet of the Confederate States. He died in 1885 and left a great part of his fortune in trust with his wife for his two granddaughters, Kate, now Mrs. Kirkman, a d Mammie, the Ray Douglas of New York. The grandmother died a short time ago and her will was admitted to probate last December.

Miss Douglass' fortune consists of a half interest in a hotel at Oxford mills, about $50,000 worth of jewelry and plate and other personal property, and $50,000 invested for her benefit.

Miss Douglass was liberally supplied with money by her grandmother, and it is not a fact as has been stated that she has been in want during the past winter. She lives in a cosy, prettily furnished flat and has everything she wished.

Miss Thompson fell in love with a wealthy young Southerner named Montgomery about three years ago. An elopement and marriage followed; there was a very brief courtship and a separation follwed an extremely short and stormy term of married life.

The honeymoon was hardly on the wane when Mrs. Montgomery disappeared from her husband, and for months she was lost to all

A headline in *The Daily States* on March 7, 1891 referred to "Fixing the Jury."

37

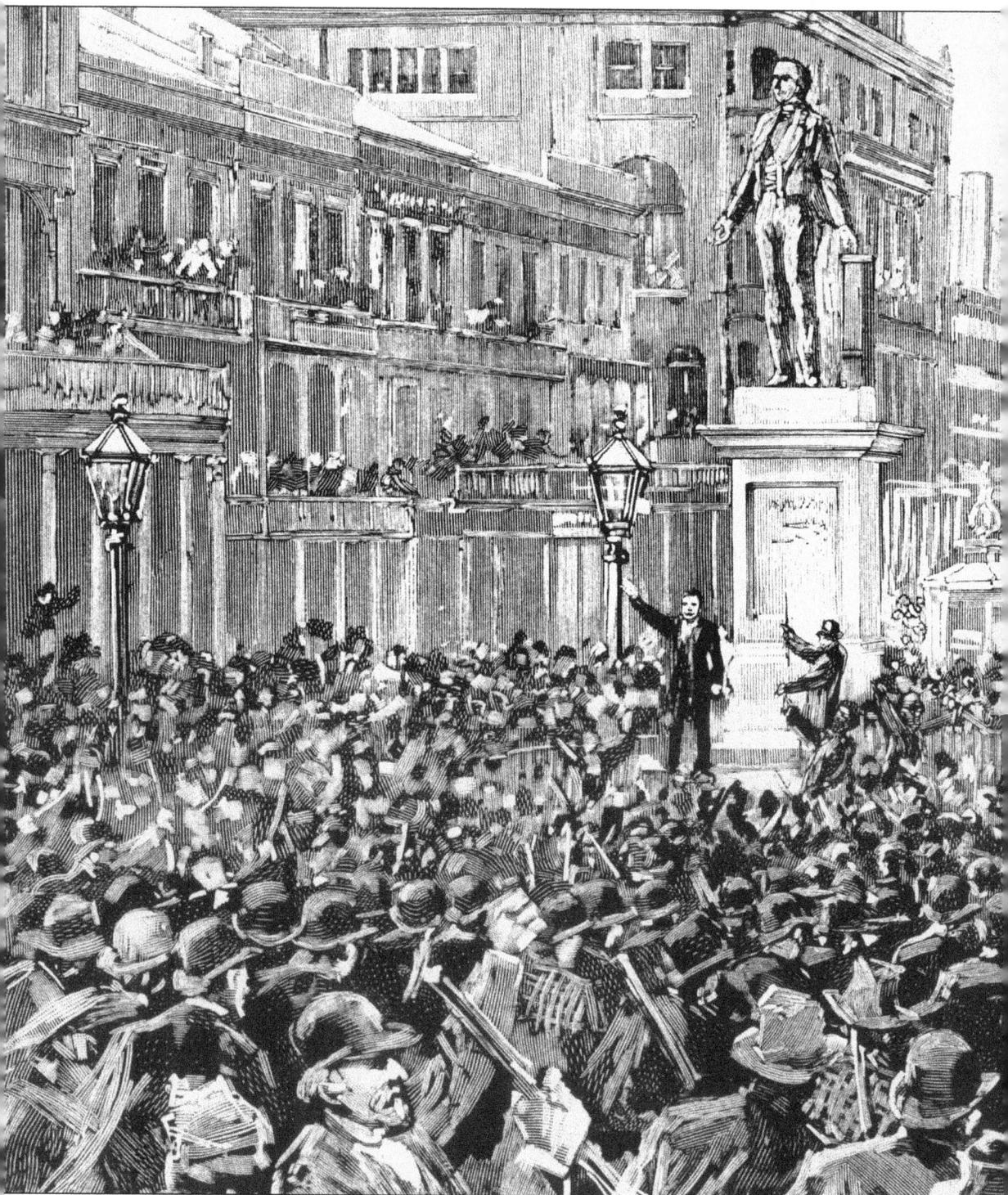

Responding to an appeal in the newspaper, an angry crowd of 10,000 gathered at the Henry Clay Statue on the March 14, 1891, as William S. Parkerson urged them to march on the prison after a jury failed to convict the Italians accused of murdering Police Chief Hennessy. Following

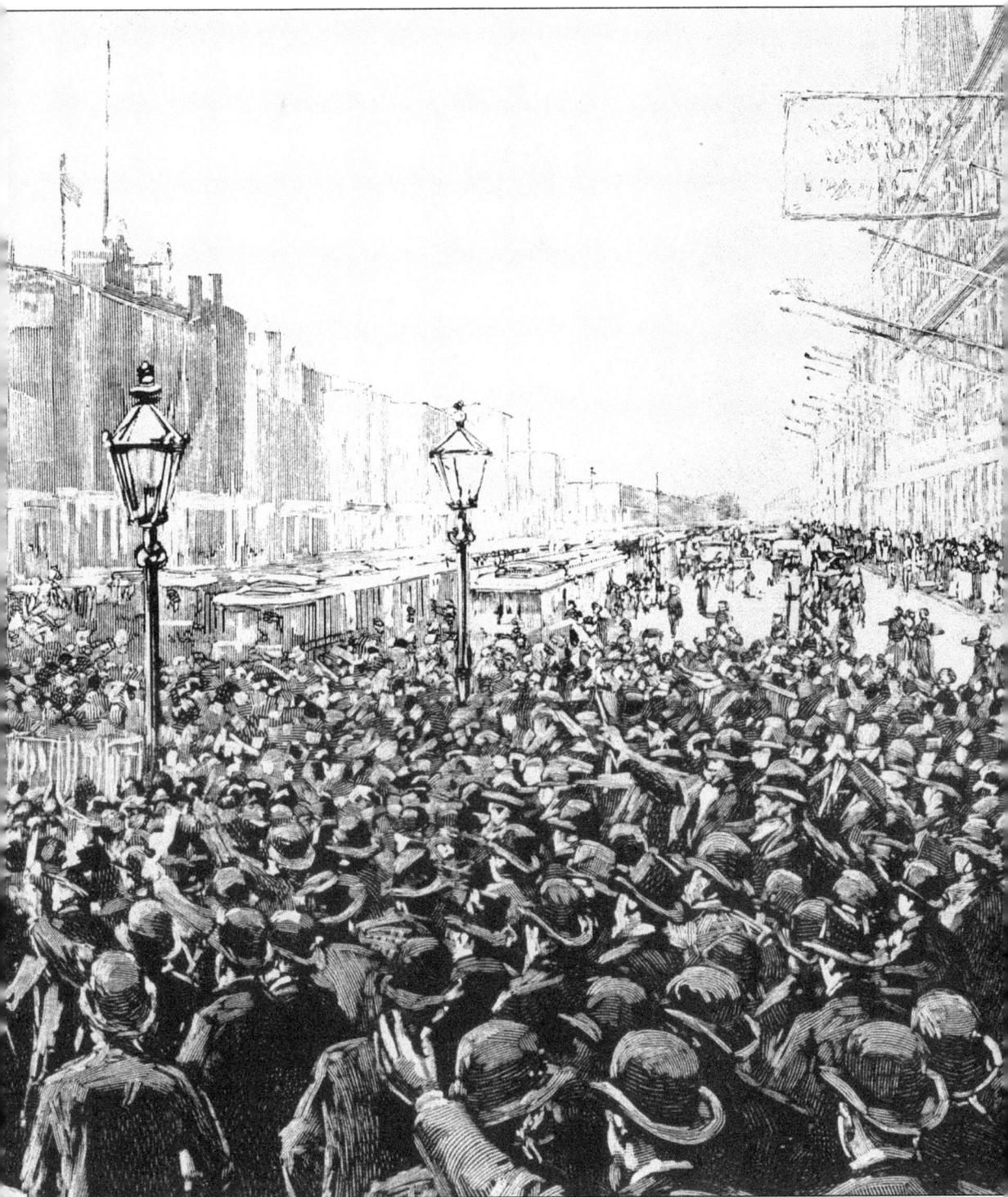

this gathering, the mob broke into the prison and murdered 11 Sicilians in the largest lynching in American history. (Reprinted from *Harpers Weekly*.)

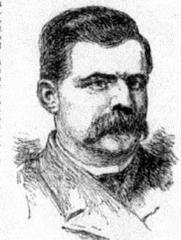

A *Harper's Weekly* drawing shows John C. Wickliffe, a leader of the mob that lynched 11 Italians on March 13, 1891.

On the day of the lynching, March 13, 1891, *The Daily States* referred to the lynching as "retribution." The paper estimated the size of the lynch mob at 5,000 "indignant men" who "executed" "eleven red-handed assassins."

Police Chief Assassinated!
Eleven Italians Lynched!

An Important New Look At One Of The Most Celebrated Incidents In New Orleans History And What It All Means Today

By James K. Glassman

At the age of 32, David C. Hennessy was one of the youngest police chiefs in the country. His toughness and resourcefulness—he captured some well-known criminals all by himself—had also made him perhaps the most famous chief in the nation as well.

At around 10 o'clock on the night of Oct. 15, 1890, Hennessy was walking home from work, through the French Quarter to his house at 275 Girod St. (He lived with his mother, as all stalwart police heroes should.)

Suddenly, a block or so before he got home, Hennessy was ambushed by five men. Richard Gambino describes the event in his new book, "Vendetta" (Doubleday, $7.95):

"There was a great explosion heard for blocks as they opened fire with shotguns, and perhaps also with rifles or pistols . . . Hennessy screamed in pain as the fusillade knocked him sideways against the cottage. Three heavy slugs had ripped into his abdominal area, tearing his stomach and intestines. One entered his chest, piercing the membrane around his heart; a fifth smashed his left elbow; a sixth broke his right leg, and his torso as well as both arms and both legs had been chewed by shotgun pellets."

But Hennessy did not die immediately. He was taken to Charity Hospital, where doctors and Hennessy himself thought he'd pull through. But he died at 9:06 the next morning—11 hours after the attack.

Immediately after he was shot, as Hennessy lay bleeding on Basin Street, his friend, Police Captain Billy O'Connor, who had left the chief only a few minutes before, ran up to him. "They gave it to me," Hennessy told O'Connor.

Then as O'Connor recounted later:

"Bending over the Chief I said to him: 'Who gave it to you Dave?' He replied, 'Put your ear down here.' As I bent down again, he whispered the word 'Dagoes.' "

I.

"Dagoes."

That one word, whispered by the dying Chief Hennessy to his friend O'Connor—and heard only by O'Connor (if the word was uttered at all)—that word "Dagoes" touched off what Gambino calls "the worst lynching in America, the mass murder of Italian-Americans in New Orleans in 1891."

Five months after Hennessy's murder, following a jury trial that failed to find the chief's accused murderers guilty, a band of what a grand jury later called "several thousand of the first, best and even most law-abiding of the citizens" of New Orleans, marched on Parish Prison, routed the accused from their cells and killed 11 of them—nine were shot in the prison, two were hanged on trees just outside it.

Until Gambino's book, which was just published a few months ago and which has gone largely unnoticed in New Orleans, historians wrote about the Hennessy murder and the lynching of his supposed killers, all Italians, in two ways:

1. As a colorful curiosity—bloody but entertaining, the stuff of which great New Orleans legends are made.

2. As a political scientist's dream—the most interesting vigilante case since "The Ox-Bow Incident." Here is John S. Kendall, writing in the Louisiana Historical Quarterly in 1939:

"The affair posed some issues which will long continue to be debated in manuals of political science and natural law . . . I believe that this is the only instance which American history affords where the judicial power was deliberately and openly taken back by those who claimed to have conferred it in the first place."

At the time of the lynching, the answer to the political science question seemed obvious. The slaughter of the Italians was condoned by every public official in New Orleans, by the New Orleans press, and by papers like the New York Times and the Washington Post.

Several months after the incident, Judge Robert Marr of New Orleans, writing in the prestigious American Legal Review, said of the mob that lynched the Italians on March 14, 1891:

"There is absolutely no room to doubt the sincerity and the rectitude of purpose of those who enacted the tragedy. Among the leaders there was present not one member of the rough element. It was a movement conceived by gentlemen, and carried out by gentlemen—men who were led by what they conceived a solemn and terrible duty, and who were willing, in furtherance of what they thought the public safety demanded, to undertake the performance and of a most painful and revolting task. Every exchange and commercial body in New Orleans, on March 14th, endorsed what had been done that morning."

Among the surnames of the men who signed an ad in the city's papers calling for the lynch mob to gather 86 years ago are many that still figure prominently in the social and business life of this city: Denegre, Walmsley, Pierson, Favrot, Labouisse, Hayne . . .

Gambino's book looks at the lynching in a very different way. Gambino is a professor at Queens College in New York and an author and spokesman for Italian-American causes. He's a pamphleteer, and his book is a political tract. It has to be read with those facts in mind.

But "Vendetta" is also very convincing. Gambino argues that the 11 Italians were lynched not because of what they allegedly did to the chief but because of the racial hatred that "American" Orleanians felt toward the immigrants and because of certain economic considerations—the killing of the 11, including the richest and most prominent Italian businessman in the city—effectively removed the commercial threat to New Orleans natives.

And more important than anything else, Gambino gives us a perspective, one that most non-Italians in New Orleans don't have, on what it was like to be a Sicilian immigrant in this city in the late 19th Century. It also makes us admire what Italian-Americans have done in New Orleans, how

continued on next page

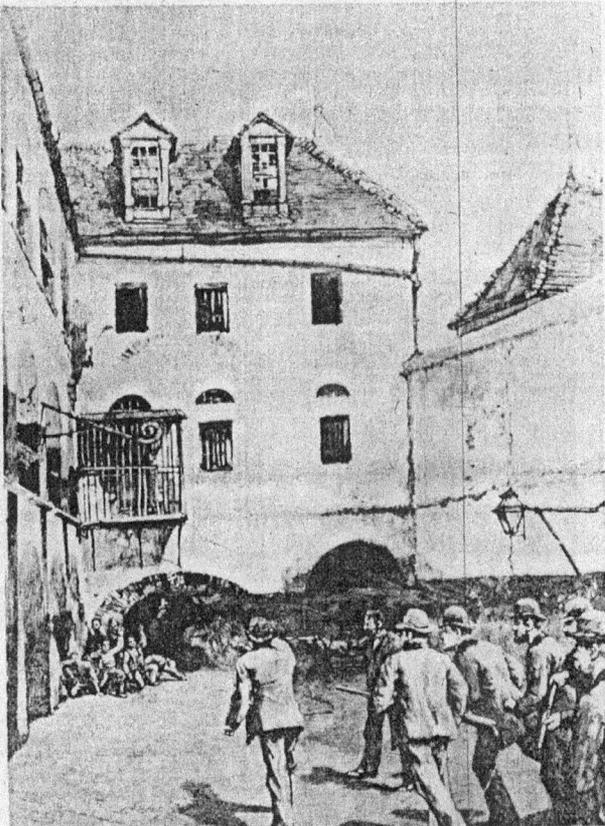

Richard Gambino on the lynching of the alleged murderers of Chief Hennessy in 1891: "The Italians clustered together at one end of the yard (of Parish Prison) and the squad opened fire from about twenty feet away. More than a hundred rifle shots and shotgun blasts were fired into the six men, tearing their bodies apart." The illustration is from Harper's Weekly, March 28, 1891. It is reproduced in Gambino's excellent new book, "Vendetta: A true story of the worst lynching in America, the mass murder of Italian-Americans in New Orleans in 1891, the vicious motivations behind it, and the tragic repercussions that linger to this day" (Doubleday, $7.95).

This article highlights the account of the lynching covered in Richard Gambino's book *Vendetta*.

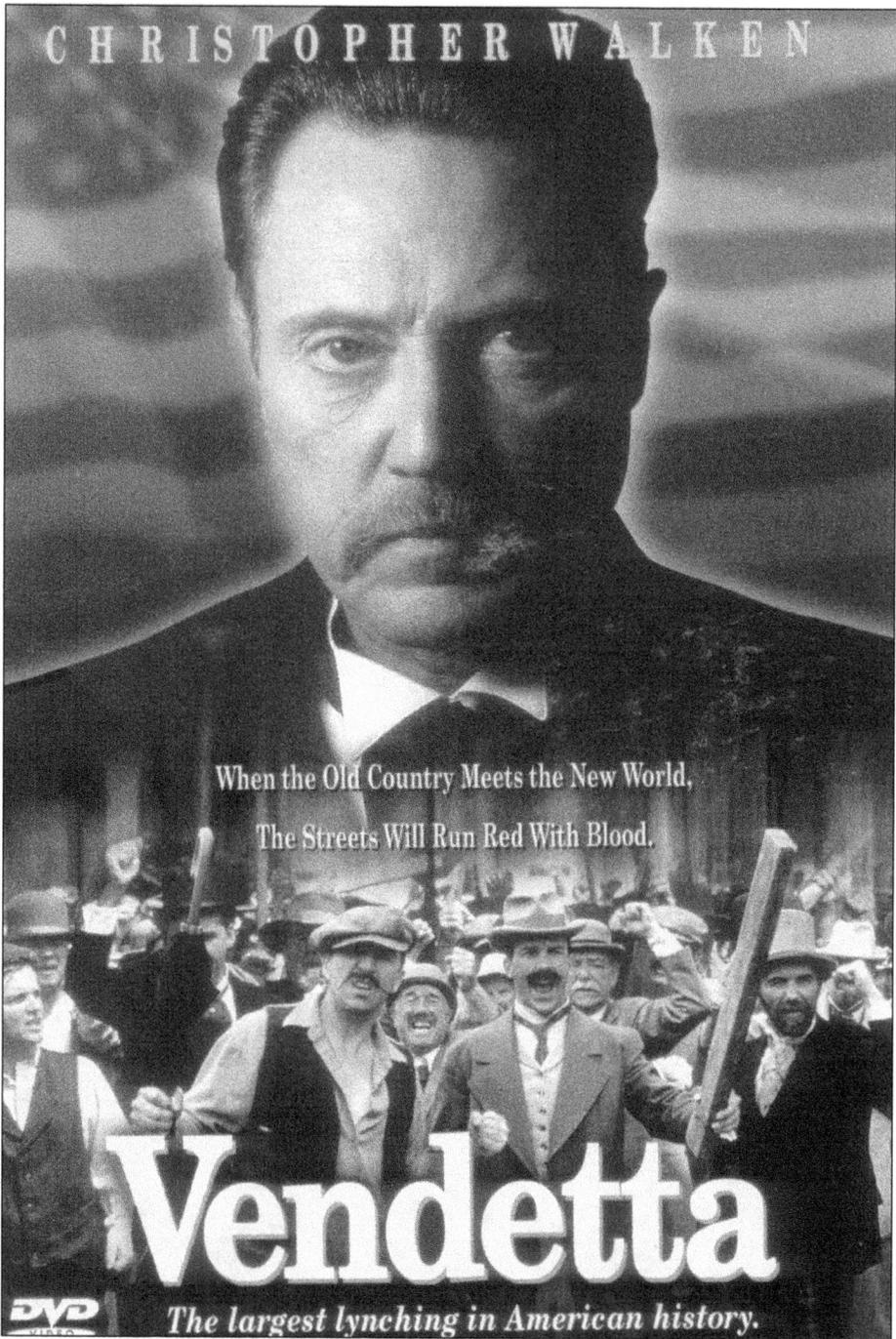

CHRISTOPHER WALKEN

When the Old Country Meets the New World,

The Streets Will Run Red With Blood.

Vendetta

The largest lynching in American history.

A little more than a century after the lynching, an HBO movie based on Richard Gambino's *Vendetta* recreated the story, starring Christopher Walken, in a 1999 production directed by Nicholas Meyer.

Four

A Friend in Need
Mutual Aid Societies

In the days before Social Security and health insurance, local groups formed mutual benefit societies. Italians in New Orleans organized one of the first Italian Mutual Aid Societies in America, Società Italiana de Mutua Beneficenza, in July 1843. The organization provided burial insurance, access to a doctor on retainer by the society, and social activities. Members were obligated to attend members' funerals with the society's banner and badges in evidence. Usually the groups were paesani-based, with most of the members originating from the same village in Italy.

These societies also organized celebrations in honor of the patron saint of their hometown, and their clubhouse offered a place for members to gather and play cards. In 1857, the Società commissioned a mausoleum for its members. Other early organizations were the Dante Alighieri (Freemason) Club, founded in 1865, and the Tiro al Bersaglio (hit the target) rifle club and mutual benefit society in 1855.

The San Bartolomeo Apostolo Society, composed of immigrants from the island of Ustica, 35 miles north of Palermo, was founded in 1879. The Arbreshe (Albanians) from Contessa Entellina, a remote Sicilian village, were Byzantine Catholics and spoke their own language. In 1886 they formed the Società Italiana de Beneficenza Contessa Entellina. In addition to a burial crypt, the society provided access to the services of a pharmacist and a doctor. Networking opportunities were very attractive since the Vaccaros, of the Standard Fruit Company, were prominent members.

Immigrants from the coastal town of Cefalù formed the Società Italiana di Mutua Beneficenza Cefalutana in 1887 and this group cooperated with other societies to form the Italian Hall Association in 1908. This confederation purchased 1020 Esplanade Avenue for use as the "Italian Hall" in 1912. The Unione Italiana, with its distinctive coat of arms—two lions—at its entrance became the focal point of Italian cultural and social life in New Orleans for the next half-century.

In 1973, the first statewide American Italian Federation in the United States was formed bringing together all the Louisiana societies under one umbrella. Joseph Maselli, founder and president from 1973 until 1982, served a second term in 1992–1993. Membership grew to include organizations from Mississippi, Alabama, Georgia, Texas, and Florida, necessitating a name-change to American Italian Federation of the Southeast. Today the Federation has 29 member societies and two college groups.

Today in New Orleans, there are societies that welcome both men and women, and several all women societies, in addition to the traditional all-male groups. They promote Italian culture, the Italian language, and preservation of Italian heritage. Some of them include the American-Italian Renaissance Foundation, Contessa Entellina Society of New Orleans, East Jefferson Italian-American Society, Greater New Orleans Italian Cultural Society, Italian-American Bocce Club of New Orleans, Italian-American Marching Club of New Orleans, Italian-American Society of Jefferson, Italian-American Society of Jefferson Auxiliary, Louisiana Irish-Italian Society, National Italian-American Bar Association–Louisiana Chapter, St. Lucy Society of New Orleans, San Bartolomeo Apostolo Society, and the Società Italiana di Mutua Beneficenza Cefalutana

Early Italian immigrants formed mutual-benefit societies in New Orleans to obtain health and burial insurance. J.B. Solari served as secretary of the *Società Italiana di Mutua Beneficenza*, founded in 1843 and believed to be the oldest such organization. This mausoleum, built in 1857 in St. Louis Cemetery Number 1, belongs to that group. While mutual-benefit societies in other cities provided their members' families with lump-sum death benefits, New Orleans' above-ground burial practices gave rise to community burial in the *Società*'s own mausoleum, and each member was allotted a crypt.

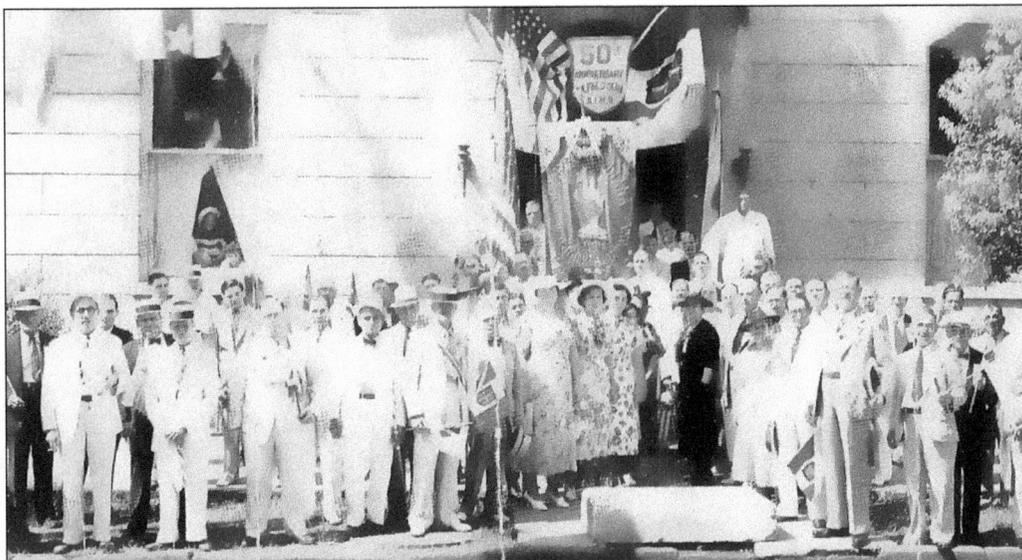

Community burial was a benefit unique to Italian mutual-benefit societies in New Orleans. Interred in the *Società Italiana di Mutua Beneficenza Cefalutana's* mausoleum are 170 souls. This tomb, which has 24 vaults, is located in St. Louis Cemetery Number 3. It was constructed in 1926. Prior to this, 64 members were interred in a leased vault from 1889 to 1926. Their remains were transferred into the new location and interred in the center vault.

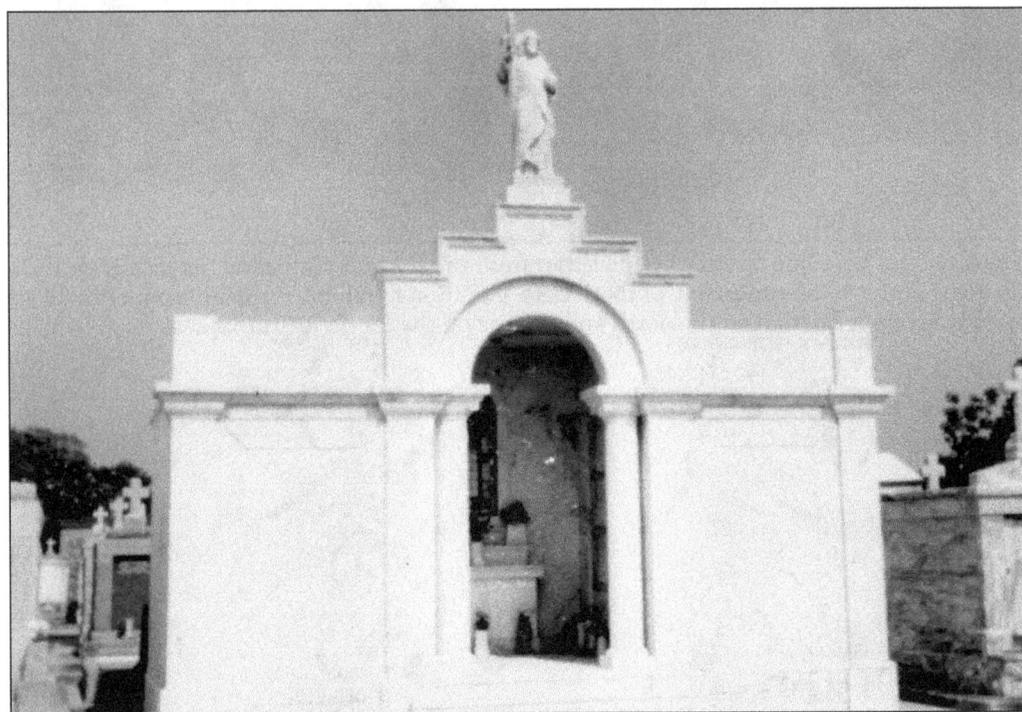

The interior features a stone altar and a stained glass window that depicts three fish meeting to form a triangle. On top of the mausoleum is a statue of *Gesu Salvatore, Patrono di Cefalù* (Jesus the Savior, Patron of Cefalù). (Photo and information courtesy of Salvadore J. Serio, SIMSC President.)

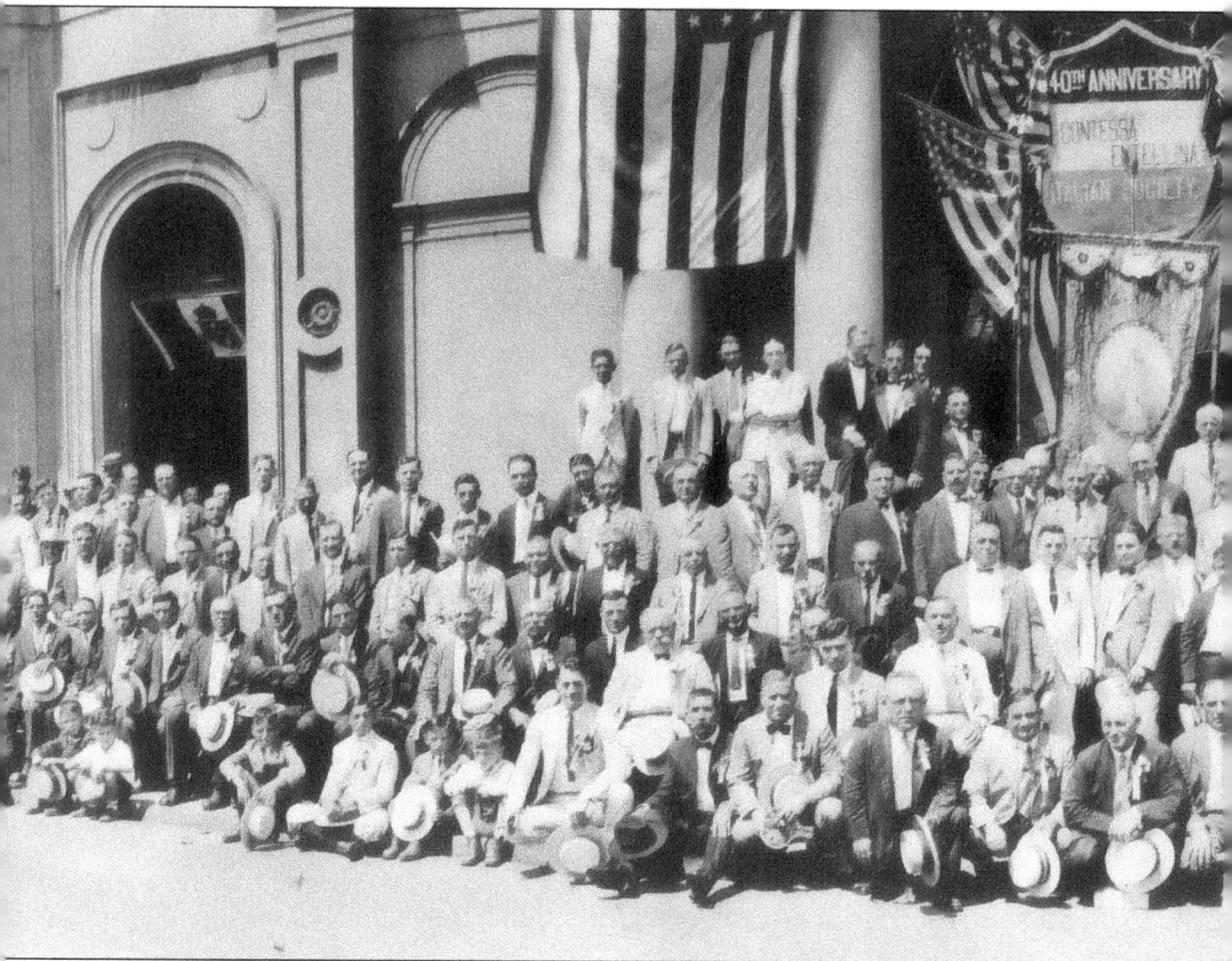

The Contessa Entellina Society assembled in front of St. Louis Cathedral September 8, 1926, to celebrate the 40th anniversary of the society. Contessa Entellina is a small mountain village midway between Palermo on the north and Sciacca on the south. Its inhabitants are Albanians

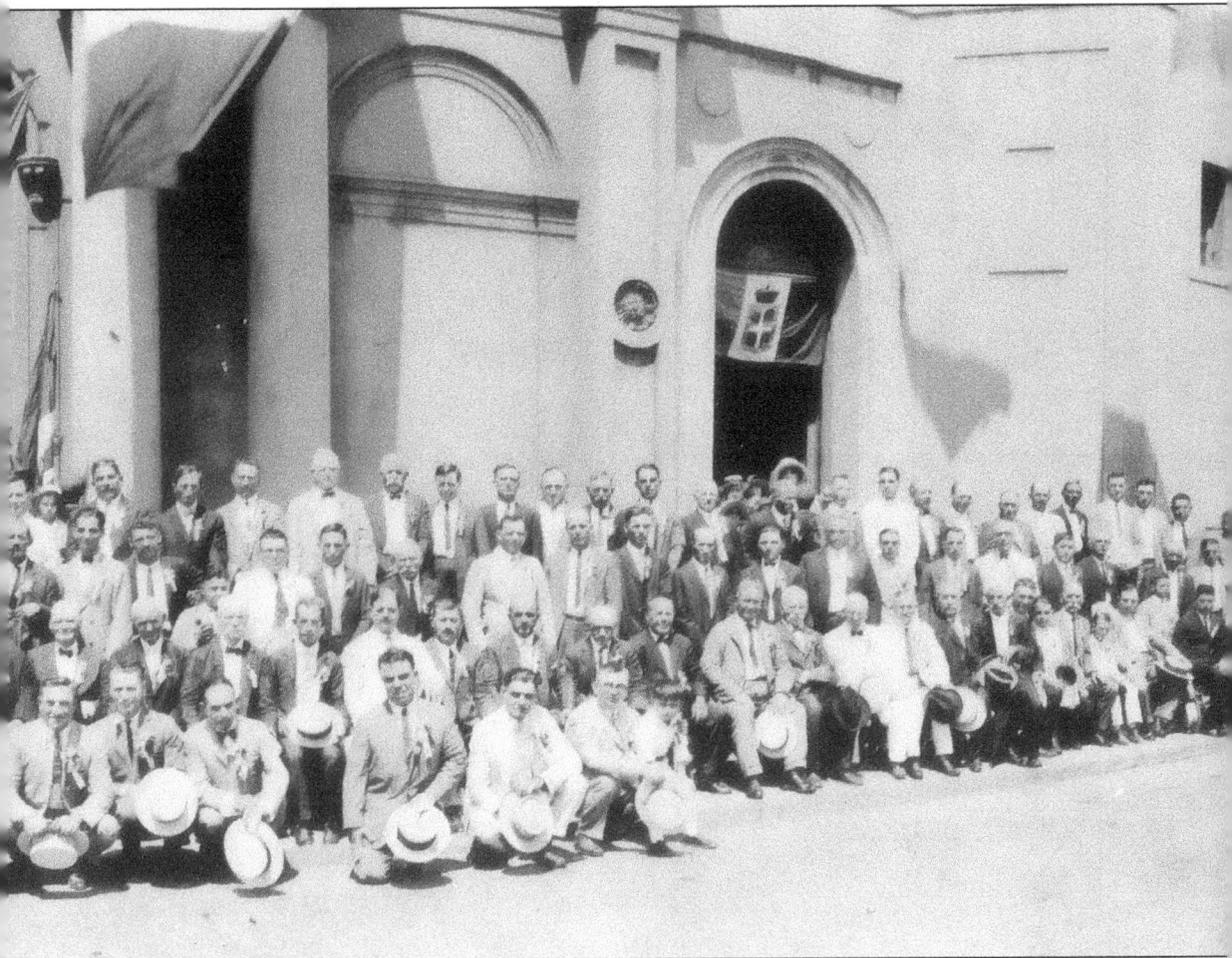

who fled to Sicily in the 1700s. Known as *Gheghi*, they spoke a language very different from standard Italian or Sicilian. Note also the Contessa Entellina Band, which was organized prior to 1924.

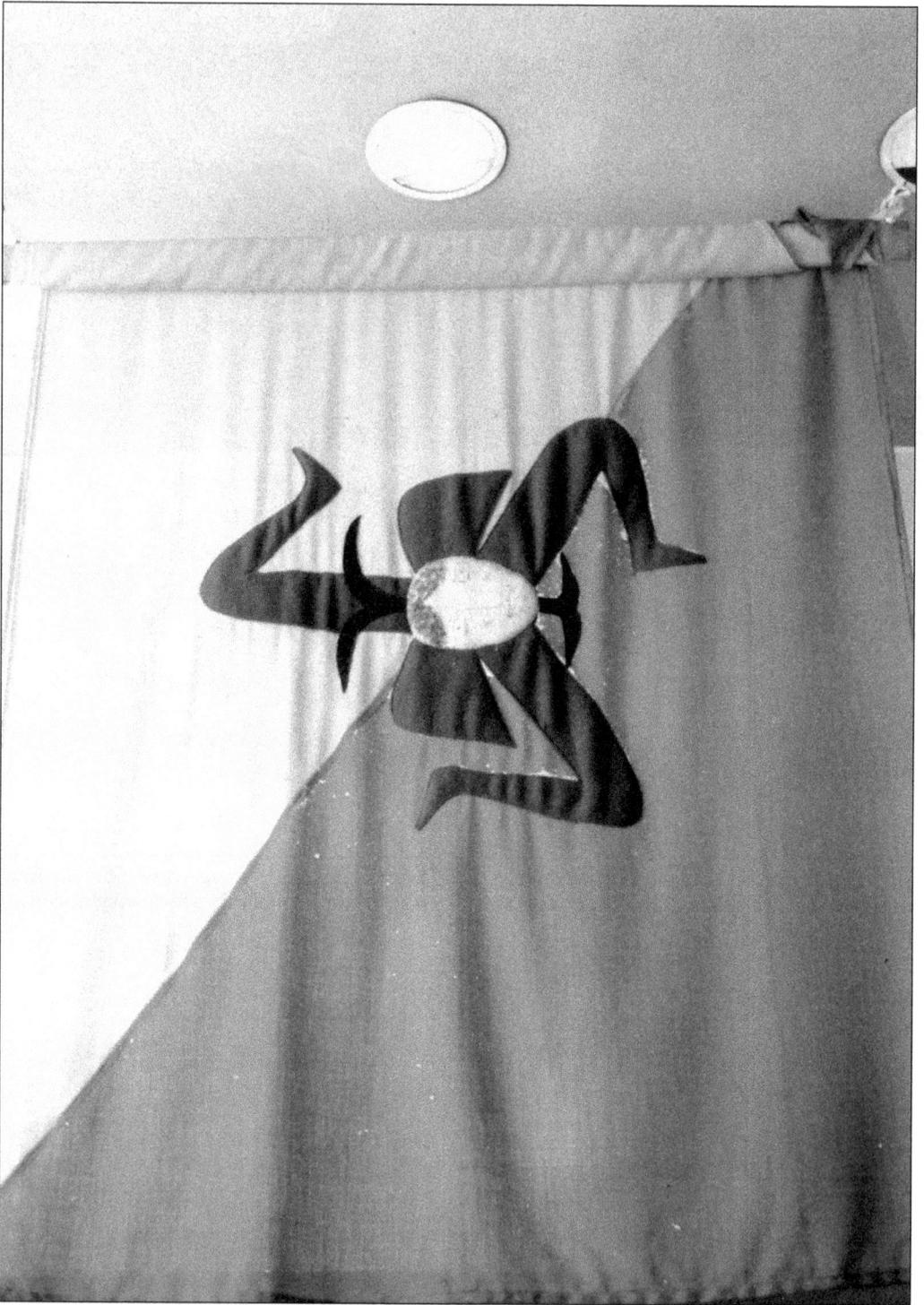

The word *Trinacria* means triangle. The regional flag of Sicily bearing the *Trinacria*, the ancient symbol of Sicily, is representative of the island's triangular shape. The *Trinacria* was brought to America by the immigrants and used in their clubs and organizations.

D'ABBONAMENTO

ANNO.......$2.00

MESI.......$1.00

MENTI ANTICIPATI

LA VOCE COLONIALE

(THE COLONIAL VOICE)

Entered as Second Class Matter May 22, 1915, at the Post Office at New Orleans, Louisiana, under the Act of March 3, 1879.

...ne e Amministrazione: 1122 Decatur Street. Giornale Pubblicato negli Interessi delle Colonie Italiane.

XVI. NEW ORLEANS, LA. SABATO 11 GENNAIO, 1930.

LE NOZZE REGALI

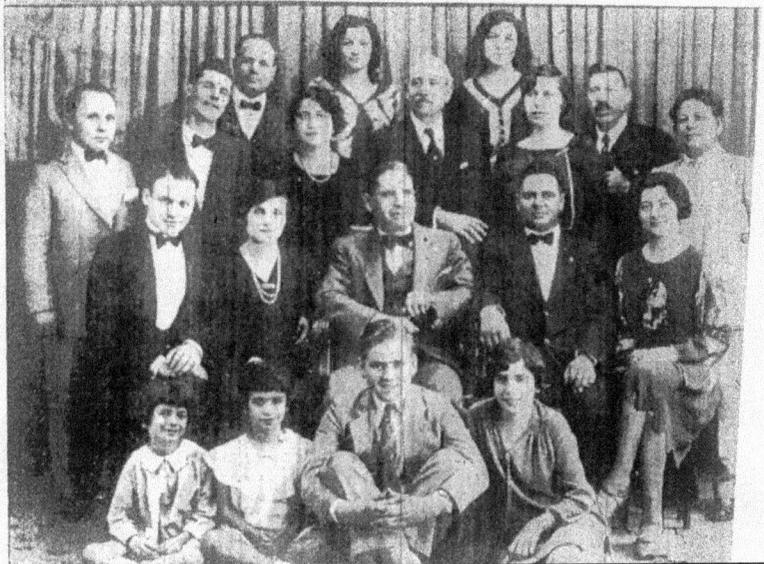

L'Italo-Americano (1894–1922) was an early Italian publication in New Orleans. *La Voce Coloniale*, founded in 1918, called itself the "official newspaper of the New Orleans' Italian Colony." This 1930 issue, under the editorship of Col. P. Montelepre, featured a photo of the Dante Alighiere Society. In later years Charles Cabibi served as editor. The paper added English-language sections before it folded in 1964. *La Voce* was printed at 1122 Decatur Street in the French Quarter. Cabibi was a member of the Italian Political Association, the *Società Italiana del Tiro al Bersaglio*, and M.B. *Madonna del Balzo*. Microfilm copies of *La Voce* were donated to AIRF by Charles Cabibi Jr. *La Voce* printed its last issue in March 1964.

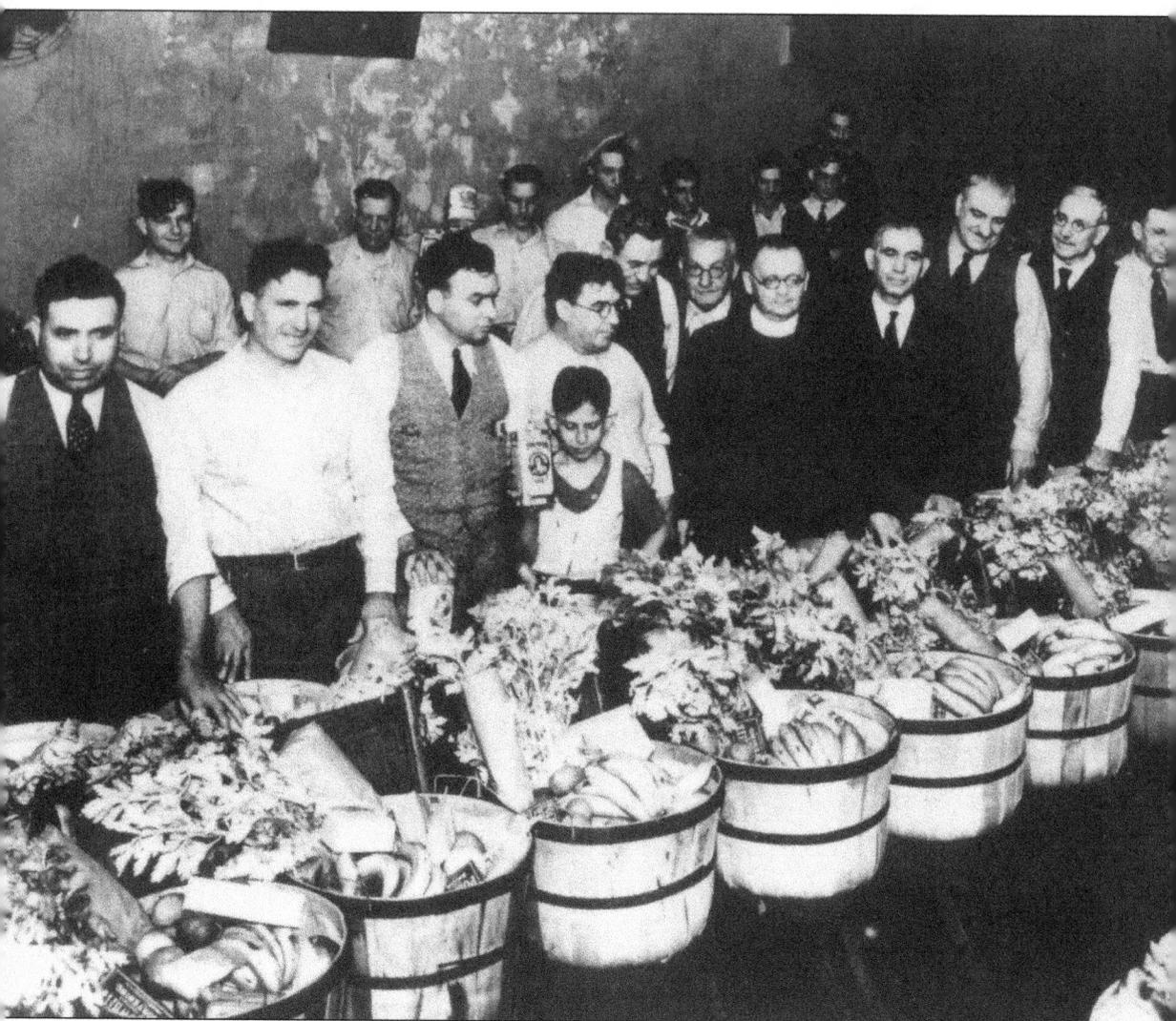

Four organizations belonging to the *Unione Italiana* (Italian Hall) in 1935 collected food for less fortunate members of the Italian community. The Union Hall on Esplanade Avenue was constructed in 1835 by noted Greek-revival architect James Gallier Sr. A confederation of Italian organizations bought the building in 1912 for use as a social hall. In 1920, the Italian Chamber of Commerce acquired and renovated the hall, creating an Italian Renaissance-type façade. In 1966 the building was converted to apartments, but the *Unione Italiana* inscription on the façade of the building is still visible today.

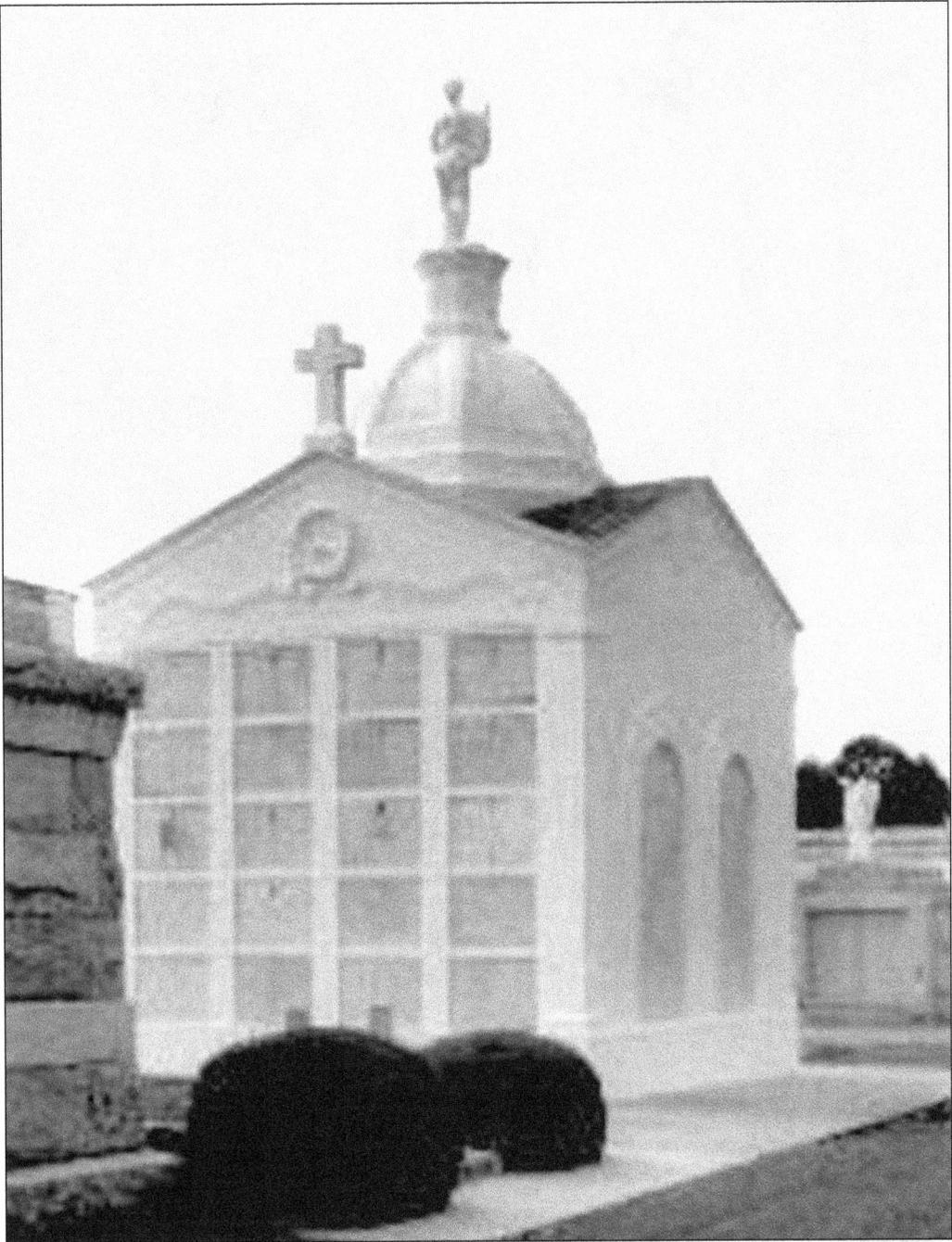

The tomb of the San Bartolomeo Apostolo Society of New Orleans had it's first occupant buried here in May, 1880—a young man of 17 years old. The San Bartolomeo Apostolo Society was organized March 23, 1879, and this year marks their 125th anniversary. The membership is mostly from the Island of Ustica. As early as 1850, the people of Ustica immigrated to American, most of them settling in New Orleans. The society was formed to welcome new arrivals into the community and offer them a safe haven. President Peter Bertucci is also celebrating—this is his 40th year as president of the organization.

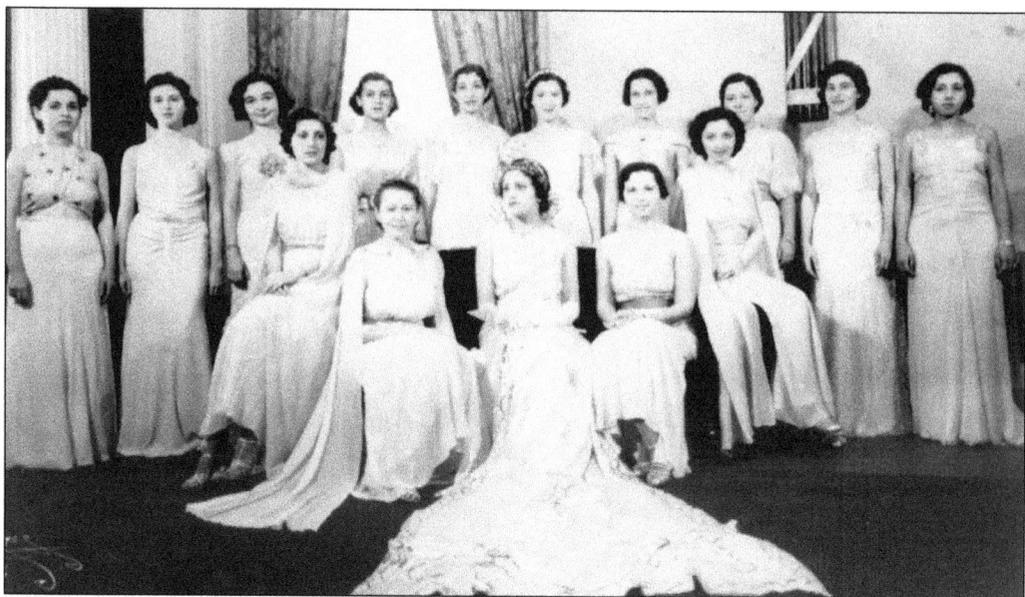

The Elenian Club was the first all-Italian ladies' club in New Orleans. The first meeting, held in 1934 at the Italian Hall, was conducted by president Nancy Zito. The first Elenian Club's *Ballo di Natale*, in February 1936, was the epitome of elegance. This event presented, from left to right, (front row) "Babe" Graziano, Lynn Roccaforte, queen Nancy Zito, Josie Greco, and Sarah Sputo; (back row) Elsie Romano, Elizabeth Crane, Mary Alice Danna, Angela LaFrance, Vita Giuffre, Claire LaRocca, Nancy Pecoraro, Rosemary Danna, Anna Palmisano, and Marie Mumfrey. Missing from photo is Margarite Loria. The organization is still active today and maintains a scholarship fund, does fund-raising events for needy charitable organizations, bakes and volunteers at St. Joseph Altars, and supports the American Italian Museum and Library.

Nancy Zito served as the first president of the Elenian Club from 1934 to 1937. She reigned as Queen of the First Elenian Ball in 1936. Zito spent much of her life in charitable activities to help children.

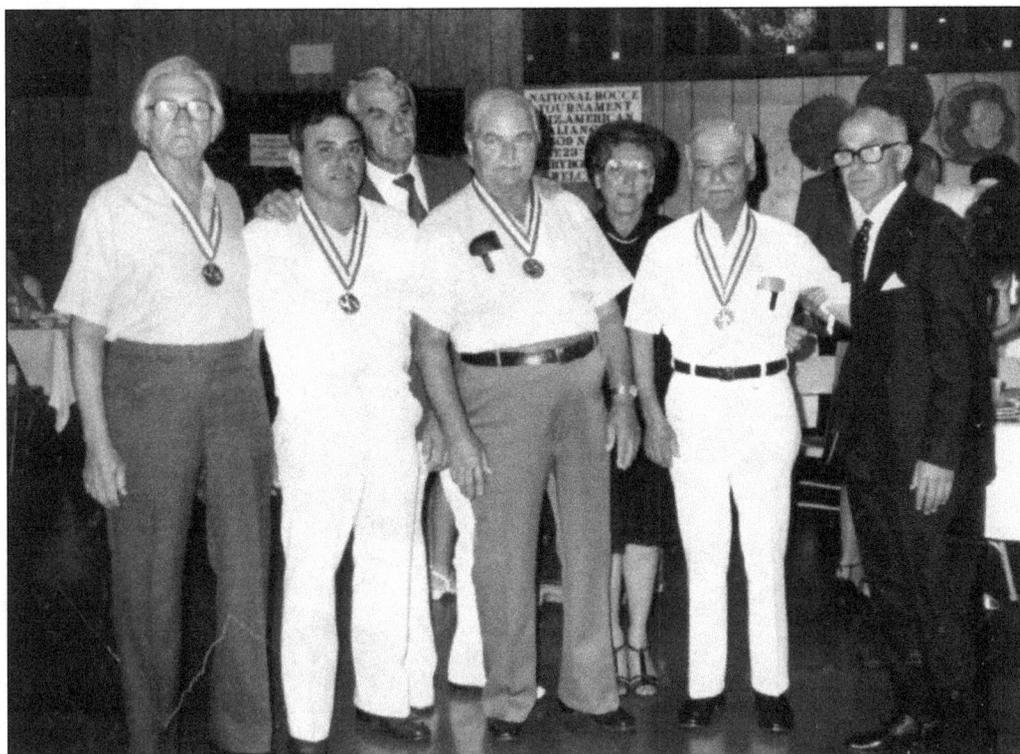

The Italian-American Society of Jefferson on the West Bank, founded in 1974, grew to include 250 men. They renewed pride in their ancestry and sponsored many activities, such as picnics, a St. Joseph Altar, *bocce* tournaments, and a Christmas dinner and dance, which brought their families together. A women's auxiliary was formed, and together, after years of fund-raising events, the group built its own clubhouse in 1996.

Officers and board members of the Italian American Society of Jefferson Auxiliary work closely with the men's organization. However, they each have separate meetings and events, and share the club house. From left to right are Felica Usner, Debra Alleman, Carol Folse, Genevieve Harris, Katherine Starck, Lucia Miceli, Santa Saladino, and Francis East.

53

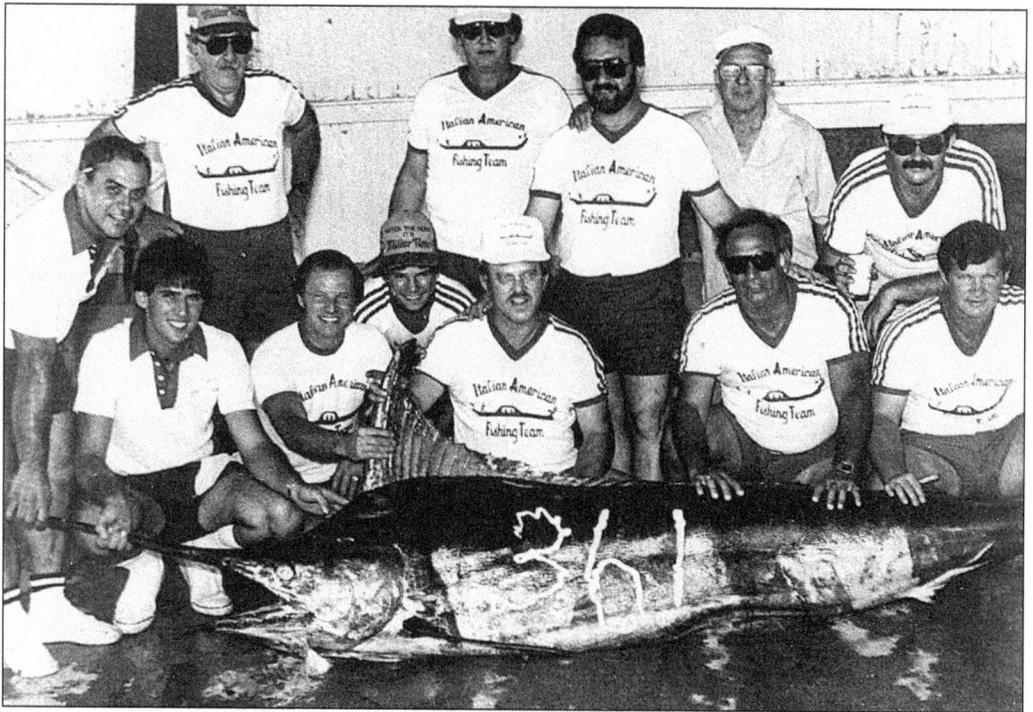

The Italian-American Fishing Rodeo committee held annual fishing competitions for adults and children. This family outing raised funds for various charities in the New Orleans area. It was organized in the late 1970s but was dissolved after a few years.

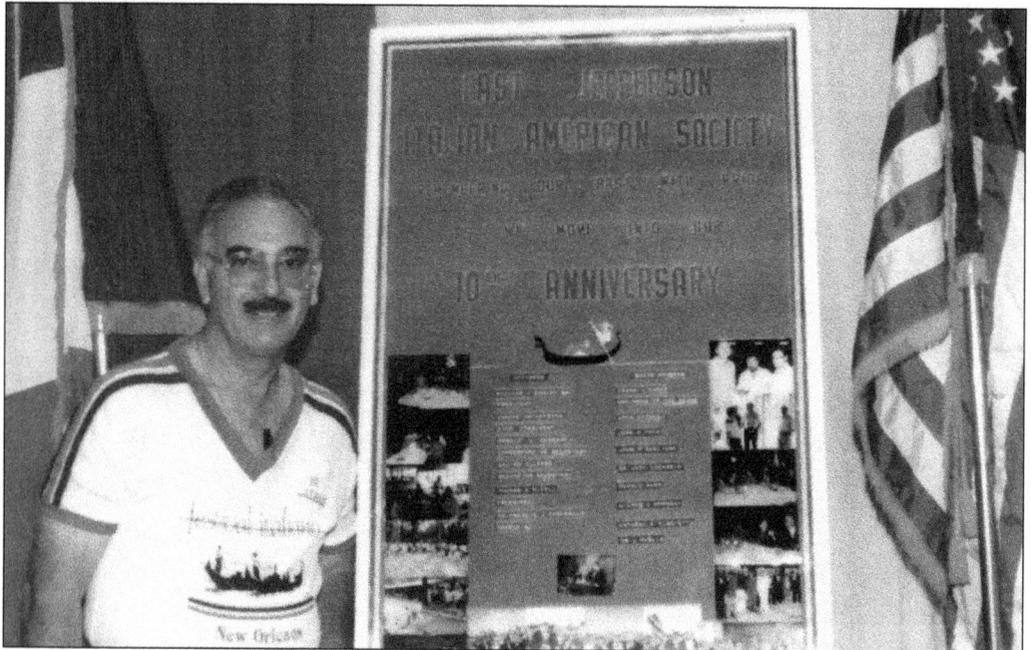

The East Jefferson Italian-American Society was formed in 1977 and installed its officers in February 1978. The first president of the society was Joseph Armenio. Thomas Miceli, a past president of the organization, is shown with the society's 10th anniversary poster in 1987.

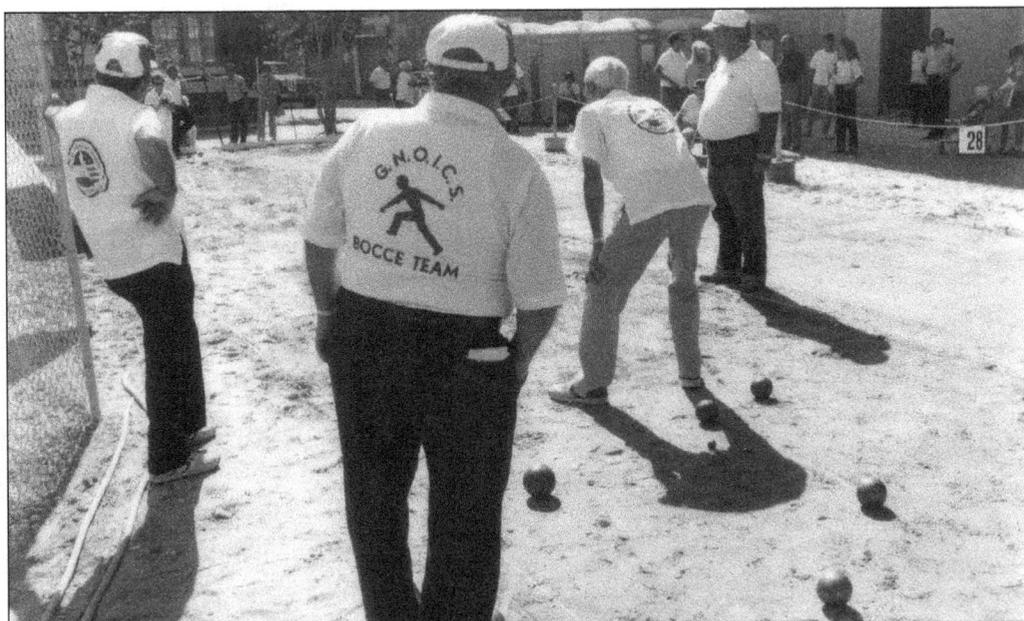

The GNOICS (Greater New Orleans Italian Cultural Society) *bocce* team participates in a national tournament at the Bocce Club facility in Metairie in the 1980s. A bowling game with roots in ancient Rome, the sport maintains popularity among Italian-American men (and women), who have formed a National Bocce Federation. In the city, *bocce* reigns supreme at the Italian-American Bocce Club on Severn Avenue.

Members of the Italian Open Committee congratulate a winner. From left to right are Louis Capagnano; Vincent Caruso, the founder of the Italian Golf Open; and Jerry Camiola. Seated are an unidentified lady and Joe Gemelli. The Italian Golf Open is sponsored by the Greater New Orleans Italian Cultural Society each year and is their biggest fund-raiser for the many charities they support.

The Italian-American Marching Club holds its St. Joseph Parade each year in March. Chairman Judge Anthony Russo organizes the 1,000 tuxedo-clad men, throwing lucky beans and handing out flowers. The parade also features floats, carriages, lovely maids, and a miniature St. Joseph Altar float with a large portrait of St. Joseph painted by noted artist Faye Palao. They parade each year on the Saturday before St. Joseph Day (March 19). Like all New Orleans parades, it includes plenty of live bands. The organization was founded by James LaCava and Joseph F. Cardenia in 1970 and has grown exponentially.

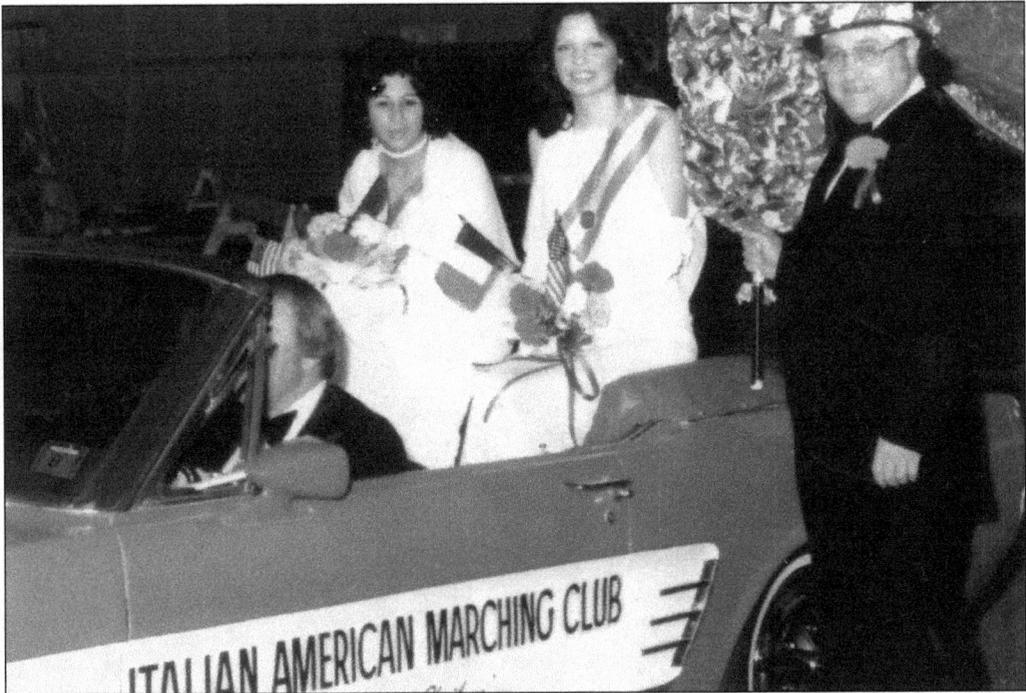

The four-hour St. Joseph Parade is sponsored by the Italian-American Marching Club each year during St. Joseph week. It features a St. Joseph Altar float, maids in Mustang convertibles, and 1,000 tuxedo-clad marchers throwing the lucky fava beans, flowers, and kisses. Some marchers have begun to carry flower canes in the colors of the Italian flag, and they exchange flowers for kisses from women along their route.

Salvatore Panzeca's maternal grandparents, the Pisciottas, emigrated from Bisaquino to Birmingham, Alabama, and his paternal grandparents moved from Caccamo to St. James Parish. In addition to sitting as juvenile judge ad hoc and practicing law with the firm Panzeca & D'Angelo, he is currently serving a second eight-year term as president of the American Italian Federation of the Southeast (AIFSE). Founded in 1971, AIFSE was the first state federation of Italian clubs formed in the United States; it later grew to include Alabama, Georgia, Florida, Mississippi, and Texas.

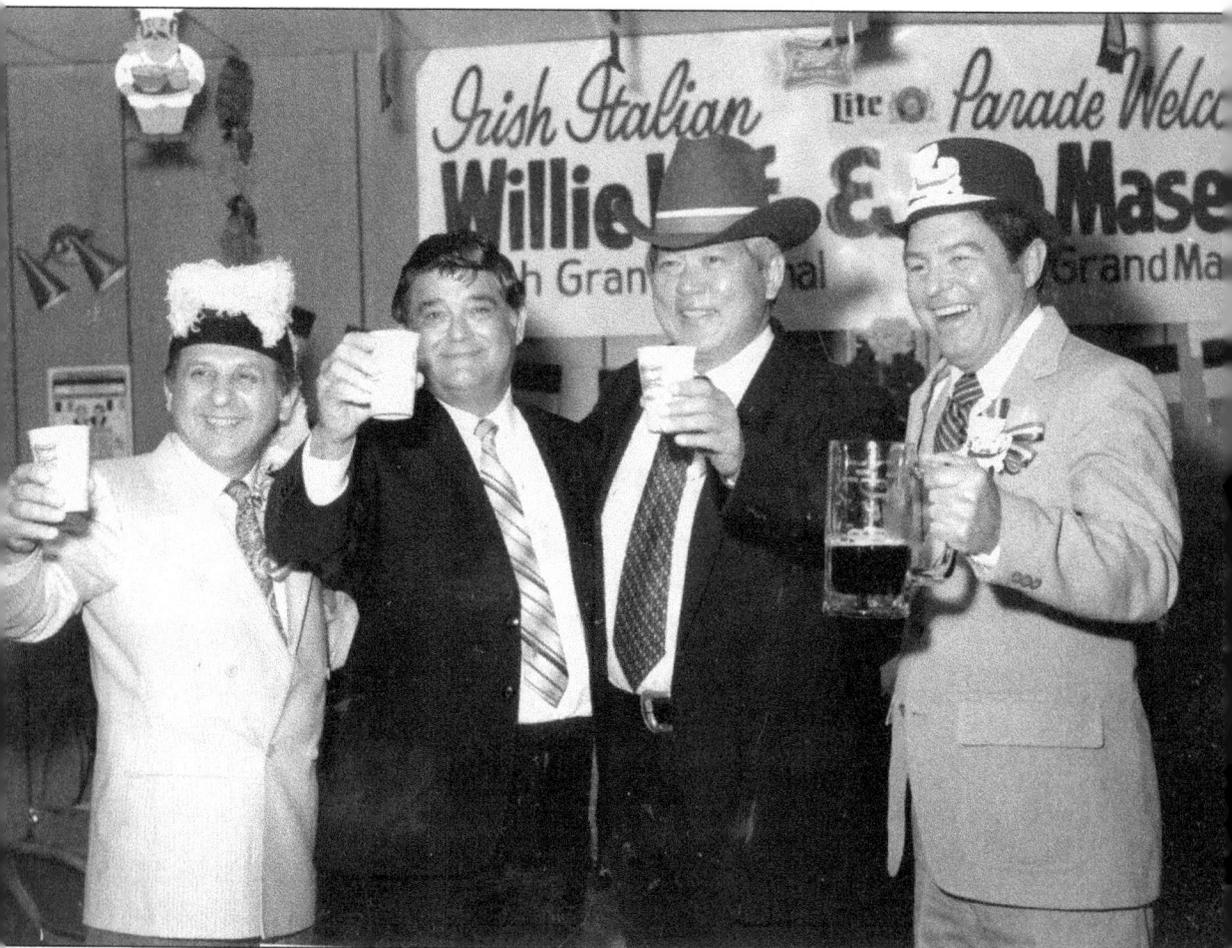

St. Patrick and St. Joseph team up. The first Louisiana Irish-Italian Parade was organized in 1983 by Ed Renton, and the first grand-marshals were Joseph Maselli and Willie Hof. They paraded on March 20 that year and still parade each year in March. Ethnic coalition-building is an essential element of multicultural New Orleans. From left to right are Joe Maselli, Kenner Chief of Police Salvador Lentini, Sheriff Harry Lee, and Parade Chairman Willie Hof.

Five

A LATIN FLAVOR
Italian and Sicilian Catholicism

New Orleans, with its Catholic culture, was much more hospitable to Italian and Sicilian Catholicism than most Southern cities. In the 1890s, St. Anthony of Padua served the Italian community under Fr. J.A. Manoritta, and Mother Cabrini and her Sisters of the Sacred Heart ran a school in addition to the Italian orphanage they staffed on St. Philip Street. Also during that period, St. John the Baptist had an Italian congregation with an affiliated boys' school and a girls' school. In 1914, St. Mary's Church was officially rededicated for Italian immigrants under the pastorship of Fr. V.M. Scramuzza.

Each church institution came with its own set of festivals, fund-raisers, and special events that helped build a sense of community. Aside from formal institutional religion, Sicilian and Italian immigrants came equipped with their own set of popular religious practices and beliefs that provided spiritual and practical aid after their arrival in New Orleans.

Sicilian immigrants were especially devoted to St. Joseph and brought the tradition of the St. Joseph altar to New Orleans. Building an altar to St. Joseph in gratitude for answered prayers during a severe drought began as far back as the Middle Ages. Employing the "generosity of the poor," the beleaguered peasant farmers and fishermen prepared abundant tables (altars) in their homes and offered up to the poorer people the very food that had just been granted them by St. Joseph. According to some traditions, supplies to build the altar must be begged for. There must not be any expense or personal financial gain during this act of devotion to St. Joseph. It must be an act of personal sacrifice. The food source that helped the Sicilians survive famine, the fava bean, is an important symbol on the altar. Each person visiting the altar receives a symbolic blessed fava bean and a piece of blessed bread. There is never any meat on the altar table, just fish, vegetables, fruit, and many decorative breads.

The celebration begins with a blessing of the altar. Then a ceremony called Tupa Tupa (knock, knock) includes children in costumes who knock on three doors asking for food and shelter. They are refused at the first two doors, but at the third door the altar host welcomes them in for food and drink. This tradition tells us a great deal about the fabled hospitality that Sicilian Americans have brought with them from their homeland.

Among the other feasts is that of Santa Rosalia, affectionately referred to as La Santuzza (the little saint), who was renowned for her preservation of Sicilians from the plague of 1624. Other patron saints of Sicilian Americans in the New Orleans area are Shen-Meria Favara—Santissima Maria della Favara—whose feast is on September 8; Contessa Entellina; Gesù Salvatore, the patron of Cefalù, whose feast in early August has been observed by the Società Italiana di Mutua Beneficenza Cefalutana in New Orleans for over 100 years; and the San Bartolomeo Apostolo feast day, August 24, celebrated with a mass and dinner.

Certificate of Baptism

✝

Holy Ghost Church
HAMMOND, LOUISIANA

⤙ This is to Certify ⤚

That _Bernadina Schiro_

Child of _Louiggi Schiro_

and _Maria Pecorara_

born in _Hammond_ _La_
 (CITY) (STATE)

on the _1st_ day of _May_ 19 _13_

was

Baptized

on the _24_ day of _May_ 19 _13_

According to the Rite of the Roman Catholic Church

by the Rev. _William Martin OP_

the Sponsors being { _Demetruis Loicano_
 { _Michelina Camolo_

as appears from the Baptismal Register of this Church.

Dated _7/20/62_

Rev. D. P. Brady OP
Pastor

Bernardina Schiro's 1913 baptism certificate shows that she was born on May 1, 1913, and christened at Holy Ghost Church on May 24, 1913. Her sponsors were Demetrious Loicano and Michelina Camolo.

60

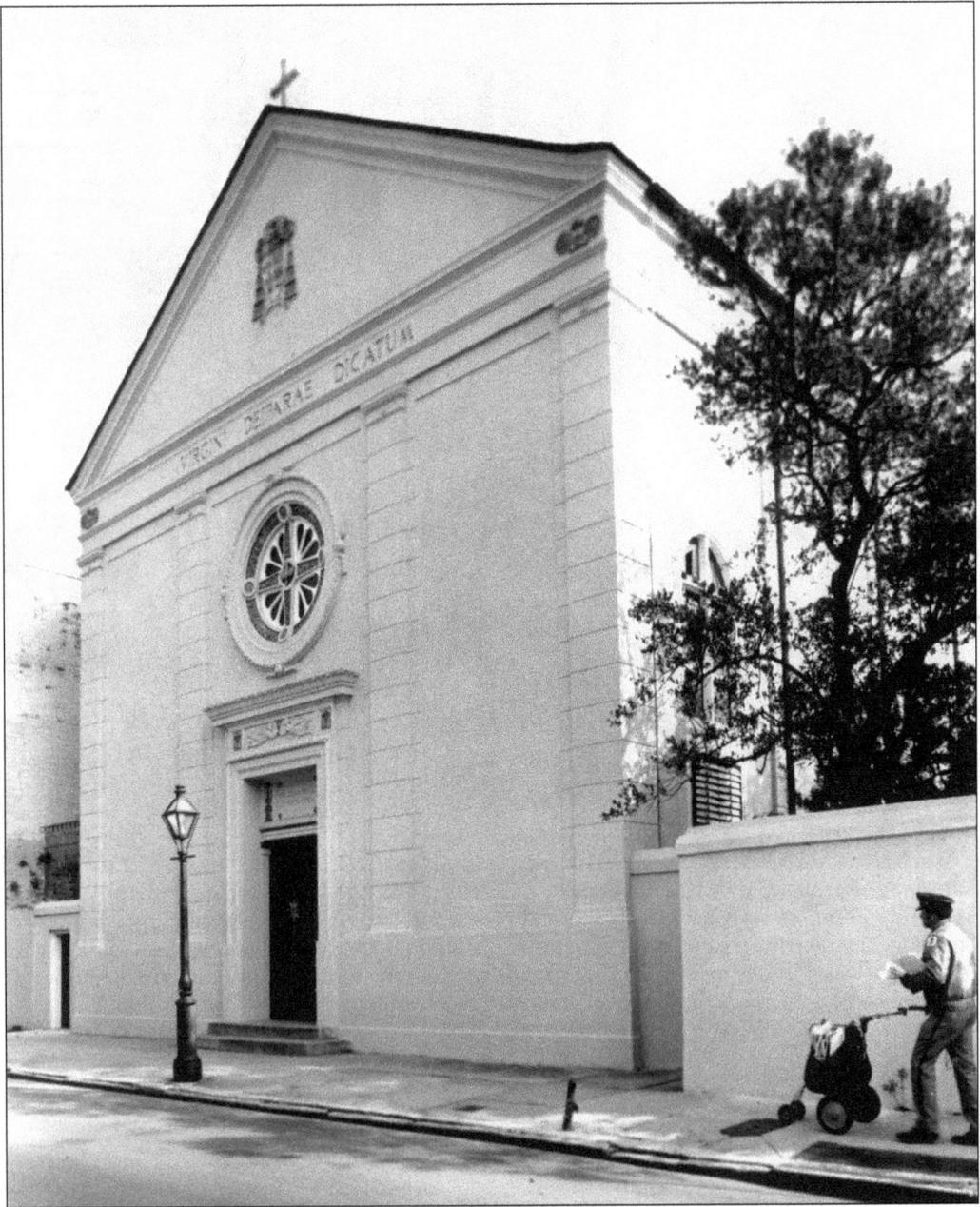

St. Mary's Church was built in 1845 on the site of the original Ursuline convent in the *Vieux Carré*. Most other churches have only one crucifix to kiss; St. Mary's had three. During its first 50 years of existence, St. Mary's was claimed by the Creoles and German immigrants; however, by the turn of the century it had become Italian. In 1921, it was officially named a National Italian Parish, but in 1975 that designation was temporarily removed because the number of Italian parishioners was dwindling. Its status has since been restored and is again known as Italian.

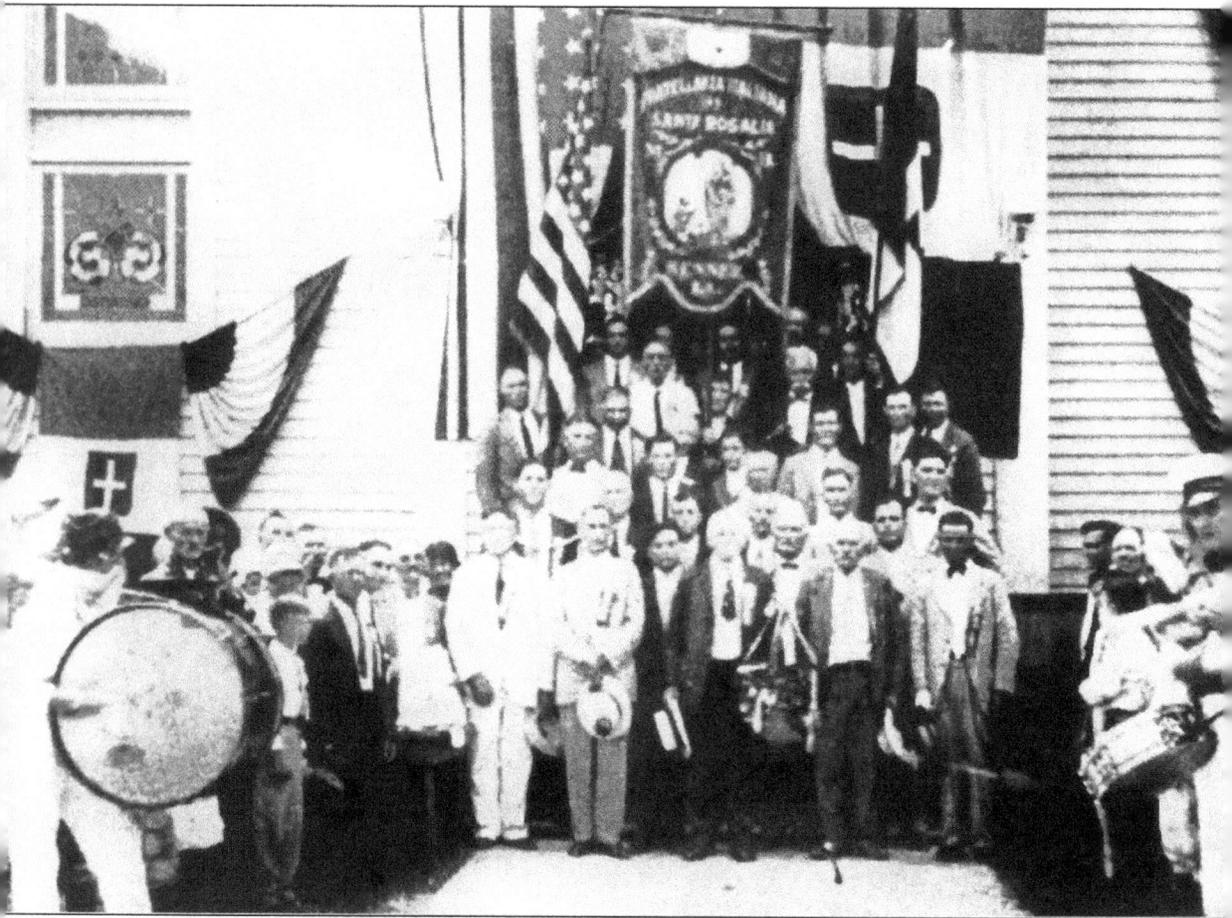

Fratellanza Italiana, Santa Rosalia Society of Kenner, and the New Orleans Italian-American Marching Band are seen here in the annual procession of 1921. Santa Rosalia, nicknamed *"la Santuzza,"* is the patron saint of S. Stefano di Quisquina, who is credited with saving Palermo from the Black Plague in 1624. During an anthrax outbreak among cattle in rural Kenner in 1899, Sicilian immigrants prayed to *la Santuzza* for deliverance.

Santa Maria del Balzo Society, with the *Banda di Roma* musicians, hosts a ball at the Italian Union Hall in New Orleans *c.* 1925. Santa Maria del Balzo is a much-venerated saint among immigrants from Bisacquino in the province of Palermo.

Paul Frank Schiro's confirmation, c. 1927, is seen here. Normal practice was for there to be two sets of godparents, one for baptism and another for confirmation. This strengthened and multiplied the number of kinship relations among Italians.

Guatemalan archbishop Juliano Raimando Rivera visits New Orleans in 1929. He is flanked by Msgr. Raymond Carra and Josephine Amato Carra. Others in the photo include, from left to right in the back row, Vincenza Carra, George Grieshaber, Jennie Carra Grieshaber, and unidentified. New Orleans's geographic location opens it to more interaction with Central America than any other American city except Miami.

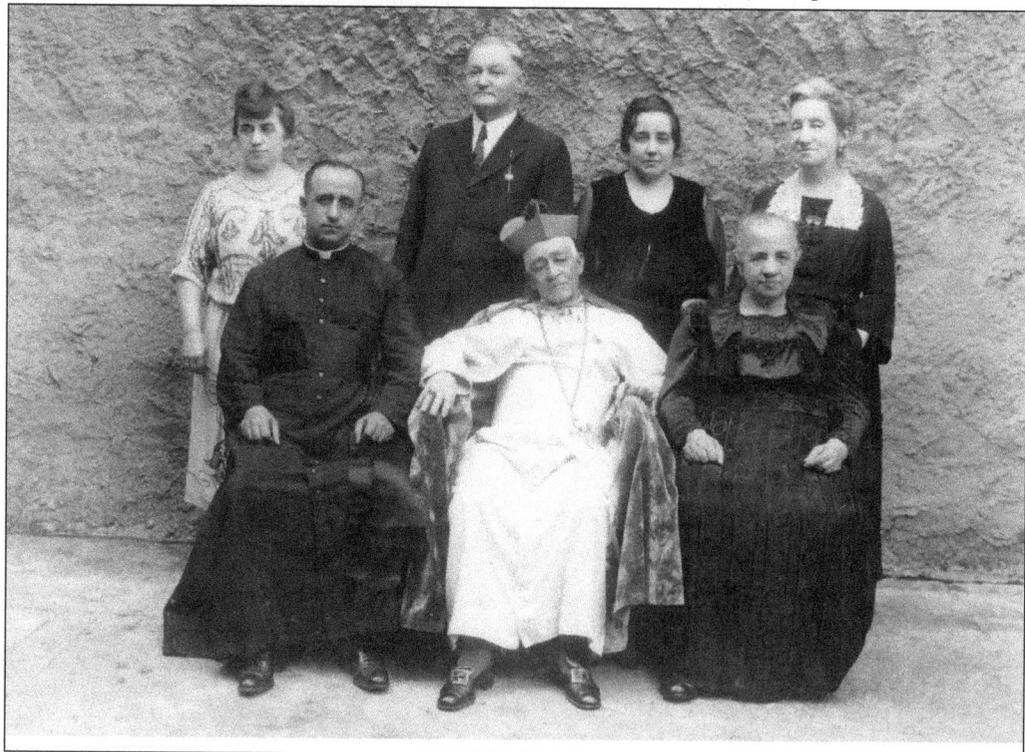

Lena Randazzo's confirmation photo was taken in 1931. She is the daughter of Sam and Petrina Livaccari Randazzo, who were emigrants from Palermo. A St. Bernard graduate, she married Sidney Torres Jr. and began working in the clerk of court's office in 1940. After her husband's death in 1988, she was appointed clerk of court and has been elected to that position ever since. As of this writing, at age 85, she can still be found at her office every day.

One of the most important events in one's life is the day they marry. Italian families plan for their daughter's weddings years in advance. They prefer the traditional religious ceremony with all the trimmings and invite many, many friends and family members. Antoinette Cammarata, age 22, married Joseph Maselli at St. John the Baptist Catholic Church on September 9, 1946, and they have enjoyed 58 years of wedded bliss.

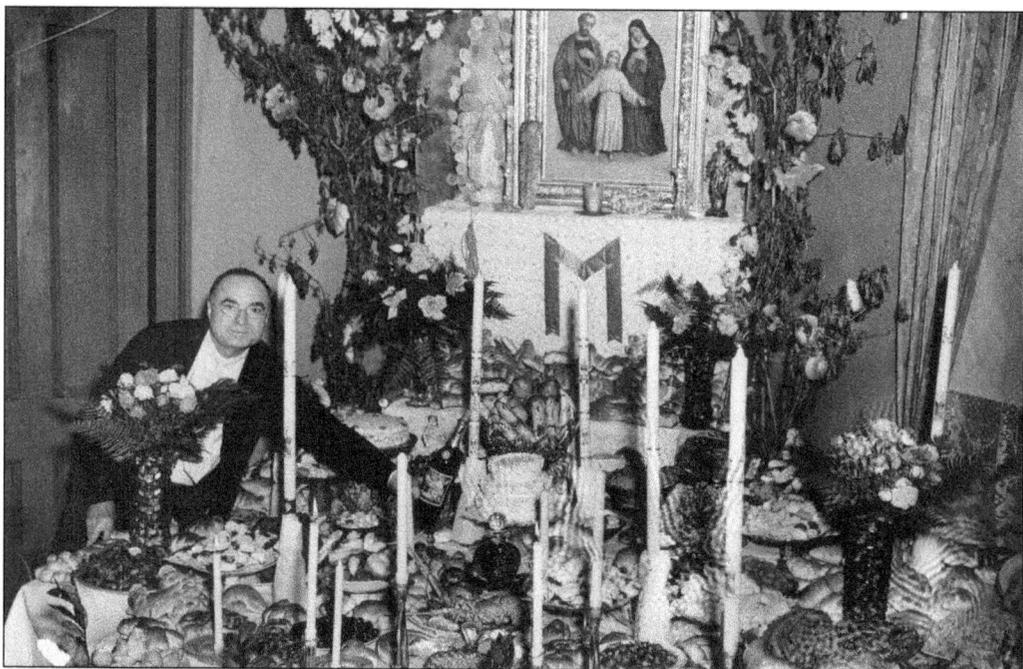

Vincent D'Angelo's 1935 St. Joseph's Day Altar represents a longstanding tradition among Sicilians that is fast becoming popular with non-Italian Catholics throughout America. The Irish, of course, put their major efforts into the celebration of St. Patrick's Day, which comes two days before the Feast of St. Joseph. In recent years in New Orleans, St. Joseph and St. Patrick are celebrated jointly at some events.

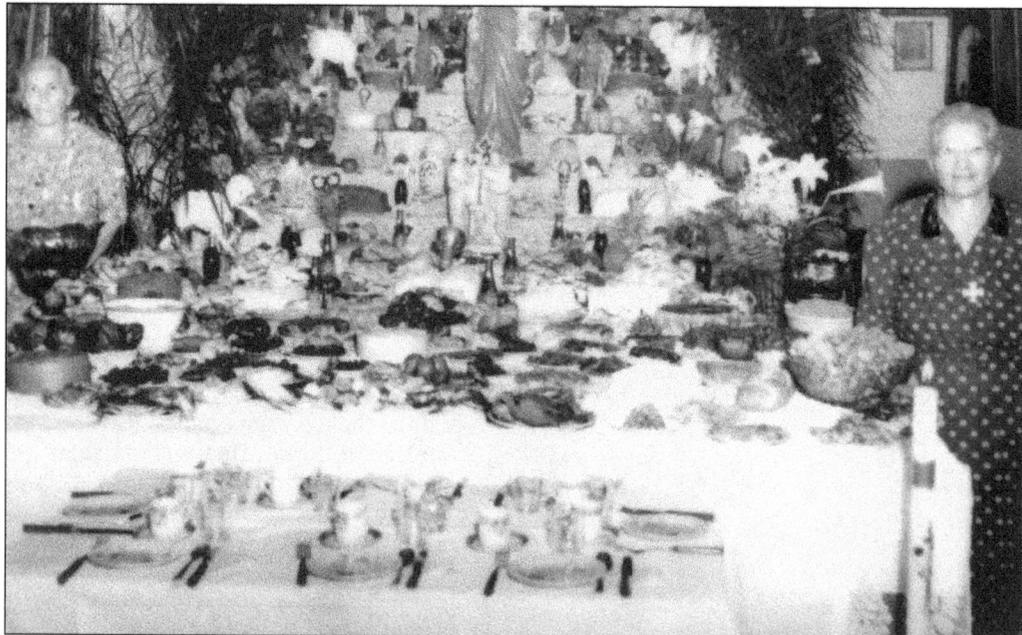

A typical St. Joseph Altar is seen in the home of Maria Pecoraro Schiro and Sarah M. Pecoraro c. 1940. Dozens of non-meat foods, statuettes of the Holy Family, St. Joseph, and Jesus are presented in a spectacular display of faith and devotion.

Affectionately known as "Father V," Rev. Vincent Verderame was ordained in 1939 and began his service at St. Mary's Italian Catholic Church. He spearheaded the building of the St. Mary's Gym where many professional boxers got their start. Father V coached championship basketball teams and promoted and developed outstanding amateur boxers. During that era, most Italian Americans were baptized, married, and buried at St. Mary's. In 1972, Father V was reassigned to the St. Louis Cathedral where he served until 1983.

The Mike Cusimano-Sarah Verderame wedding, at St. Mary's Italian Church on October 30, 1940, was officiated by her brother Fr. Vincent "Father V" Verderame, O.M.I. It was one of the first weddings he performed after being ordained in 1939. "Father V" was later assigned O.M.I. of St. Louis Cathedral from 1972 until 1983. The altar boy at the wedding was Dr. Robert J. Cangelosi.

Members of the St. Lucy Society, Mrs. Rosalie Canal (left) and Mrs. Mary Cammarata were honored at the annual feast of St. Lucy, which is December 7. The organization was formed in 1927 by Mrs. Cammarata and Angelina Accardo, Mrs. Canal's sister. It was originally known as *La Società di Santa Lucia di New Orleans*, and was devoted to a martyred saint of Siracusa, Sicily. Members visit the sick and elderly and give donations to the Eye Foundation of New Orleans.

Pictured above are ladies preparing for the St. Rosalie procession. The feast of Santa Rosalia, renowned for her preservation of Sicilians from the plague of 1624, is still honored today. Santa Rosalia's feast is in the first week of June in Santo Stefano Quisquina, Sicily, and is observed in September in Kenner by Sicilian immigrant families.

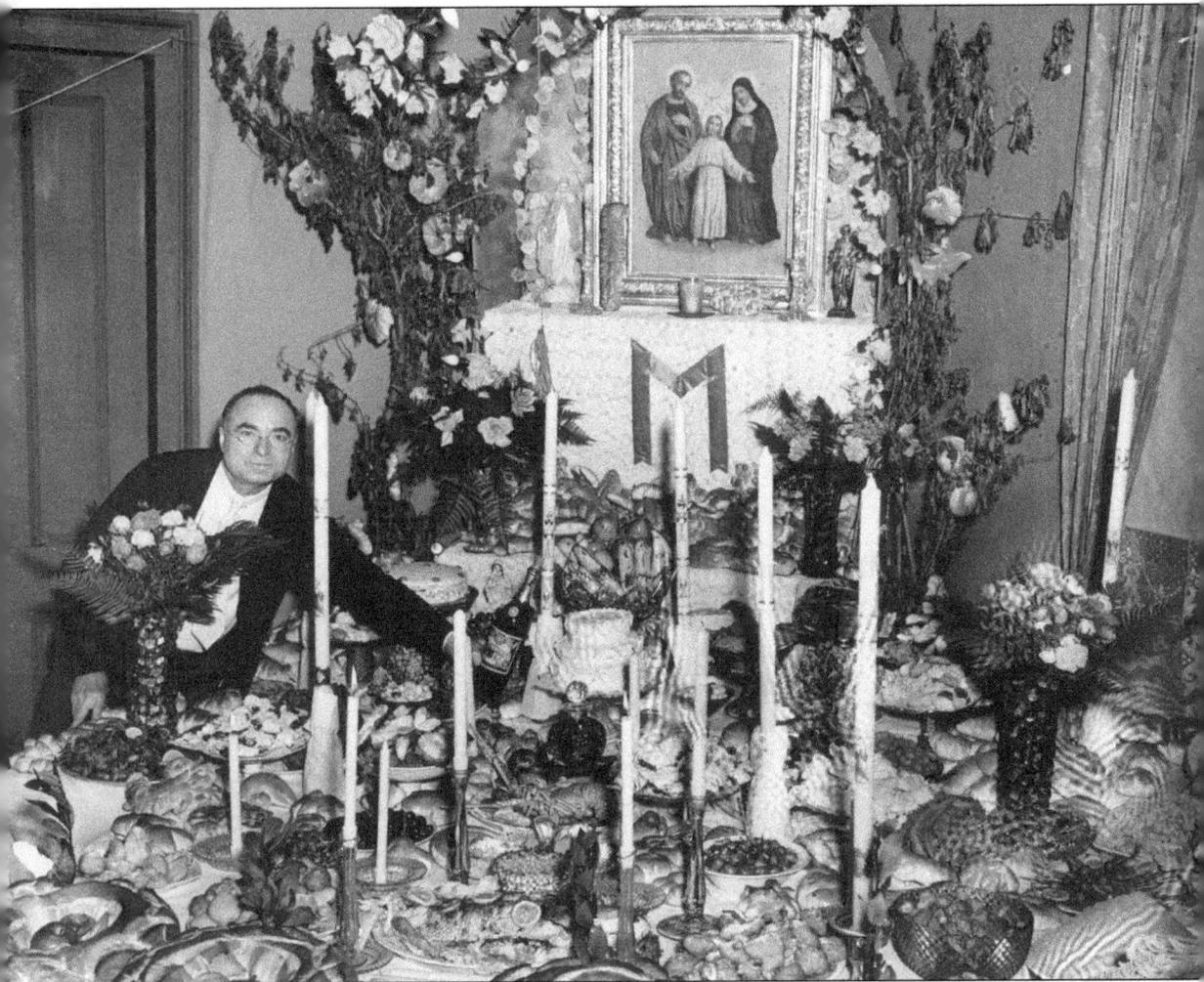

A typical St. Joseph Altar in a traditional Italian Catholic family home is prepared to thank St. Joseph for past blessings. This one was in the home of Vincent D'Angelo c. 1935.

Lamana-Panno-Fallo invites you to a Reunion Mass at St. Mary's Church

Father Frank Montalbano, O.M.I. to officiate
Honoring all Italians and those who attended
St. Mary's Italian School
and St. Mary's Italian Church

Monday, September 12, 1994
11:00 a.m.
1116 Chartres Street

A Coffee & Biscotti Reception
will follow in the Courtyard

To R.S.V.P. or for more information call 831-9901

Free parking at Tharp-Sontheimer-Laudumiey, 1225 N. Rampart Street
Shuttle service running every 10 minutes beginning at 10 am.

This mass is first in a series of events honoring "Pride in our Italian Heritage"
sponsored by Lamana-Panno-Fallo.

This Lamana-Panno-Fallo reunion invitation celebrated the rededication of St. Mary's Church in 1994. The Archdiocese had renamed the old St. Mary's Italian Church a few years back and, after much discussion, decided to return the name of St. Mary to the landmark church. Historically, St. Mary's is the home church of the Italian colony in New Orleans.

Six

PRESENT AT THE CREATION
Italian Americans and the Birth of Jazz

It was a perfect match. Music was a staple of the culture of Italian and Sicilian settlers just as it was ingrained in the spirit of their new hometown. Italian Americans in New Orleans contributed greatly to America's music scene, including opera and jazz. New Orleans musicians included great opera artists such as Marguerite Piazza, as well as jazz pioneers like Nick LaRocca and the Original Dixieland Jazz Band (ODJB), who made the very first jazz recording in 1917.

Dominic James "Nick" LaRocca, whose immigrant parents hailed from Salaparuta, Sicily, formed the five-piece Original Dixieland Jass Band in 1916 (jass was the original spelling but was changed later to jazz). The band traveled to Chicago and took the city by storm. They were so popular they were invited to play at Reisenweber's on the corner of Columbus Circle and Fifty-eighth Street in New York City. As the musical leader, Nick composed and arranged songs like "Tiger Rag" (The Louisiana State University's fight song), "Sensation Rag," and "Ostrich Walk." Nick and his first band played London and Glasgow before a great number of dignitaries. Members of the original band were Tony Sbarbaro, drums; Eddie Edwards, trombone; Larry Shields, clarinet; Nick LaRocca, cornet; and Henry Ragas, piano.

Other New Orleans Italian Americans who made important contributions to jazz and popular culture included Louis Prima, "Papa" Jac, Freddie and Frank Assunto of the Dukes of Dixieland, Joseph "Sharkey" Bonano, Tony Almerico, Sam Butera, Joseph "Wingy" Mannone, and Phil Zito. Prima was in the forefront of the "Italian trend" in the 1940s and 1950s that brought celebrities and music with Italian American themes to the consciousness of the American public in a big way.

During the late 19th and early 20th centuries, Italian artists and stone carvers produced numerous statues, tombs, and decorative building sculptures that adorn our city to this day. The eagles of Theodore Bottinelli and sculptures of Achille Perelli have received many accolades over the years. New Orleans was also the home of other famous artists such as Inez Lugano, architect Pietro Gualdi, and Franco Alessandrini, whose works can be found in the American Italian Renaissance Foundation's museum.

In the field of print journalism, Italian-American achievers in New Orleans included Augusto Miceli, newspaper publisher Francis Cabibi, and Evans Casso. The success of Italian-American radio personalities also attests to the impact they had on the mass media.

N.J. Clesi was one of many Italian-American musicians and composers who brightened the music scene in New Orleans. With words and music by N.J. Clesi, this sheet music for "Won't You Please Say Yes?" was published in 1914, shortly before the jazz craze went national.

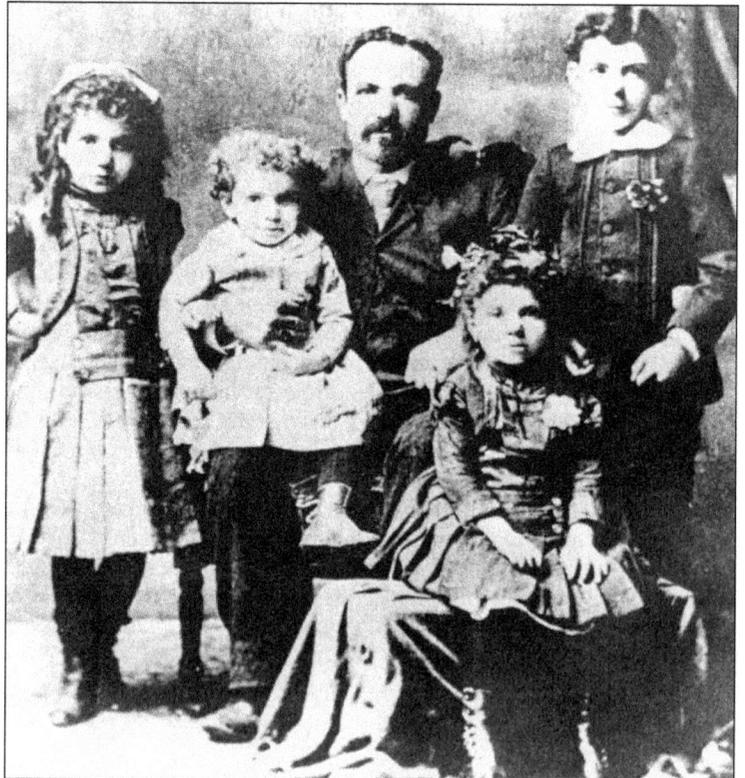

Dominic James "Nick" LaRocca sits on his papa's knee surrounded by siblings in this 1893 photo. Who could have predicted that he would record the first jazz record, "Livery Stable Blues" and "Dixie Jass Band One Step" for the Victor Talking Machine Company on February 26, 1917.

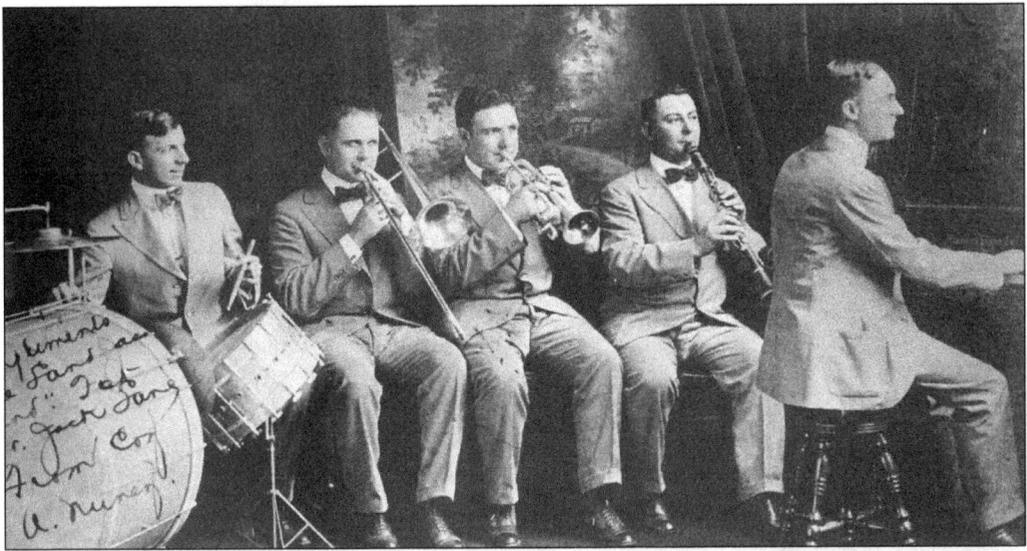

Original Dixieland Jazz Band members in 1916 are, from left to right, Tony Spargo, drums; Daddy Edwards, trombone; Nick LaRocca (1889–1961), trumpet; Yellow Nunez, clarinet; and Henry Ragas, piano. Nick LaRocca is credited with being the "father of popular jazz." As a budding young violinist, LaRocca covertly taught himself to play the cornet, playing in Papa Jack Laine's before his big break in 1916 brought him to Chicago with the group pictured above.

Nick LaRocca, pictured at home in 1960, was the composer and author of Louisiana State University's fight song, "Tiger Rag." Nick stands at his front door showing the musical notes of "Tiger Rag" etched into the doorframe. LaRocca donated his papers to Tulane University's Hogan Jazz Archive.

The Original Dixieland Jazz Band lives on led by Nick LaRocca's son Jimmy. Playing trumpet and doing vocals, Jimmy has put together a band of the finest New Orleans musicians, who understand and perform this style of music to perfection. The ODJB has performed for concerts and jazz festivals in Brazil, Japan, Sweden, Finland, and America. The ODJB is a regular at the New Orleans Jazz Fest.

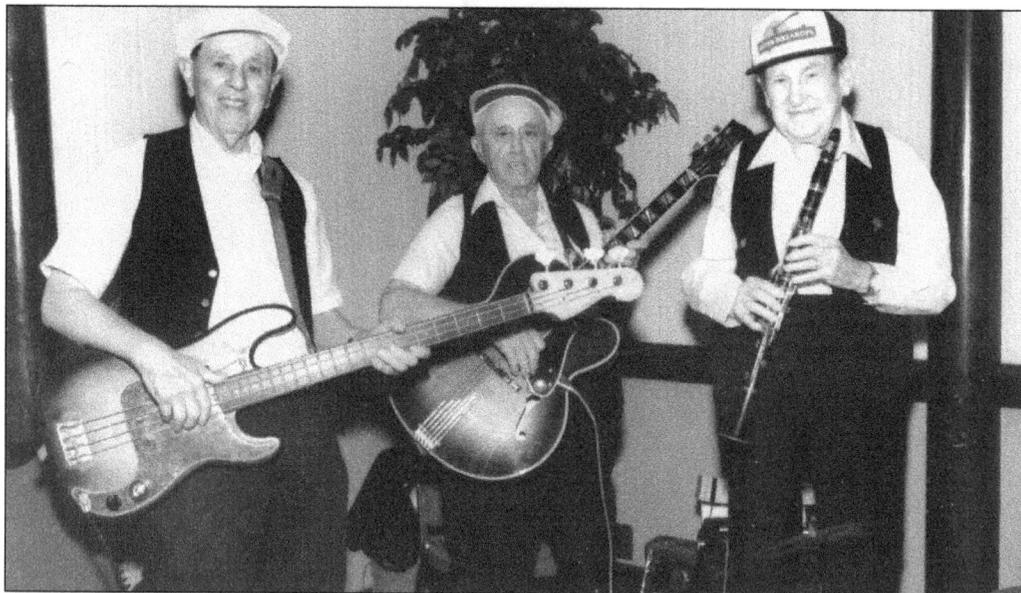

Frank Federico (at left), a guitarist, was very active in New Orleans jazz beginning in the 1920s. He played with several bands, including Louis Prima's, Tony Almerico's, and the Crescent City Joy Makers. Frank was with Louis Prima in the movie *Manhattan Melodrama*. His family hailed from Alia, Sicily.

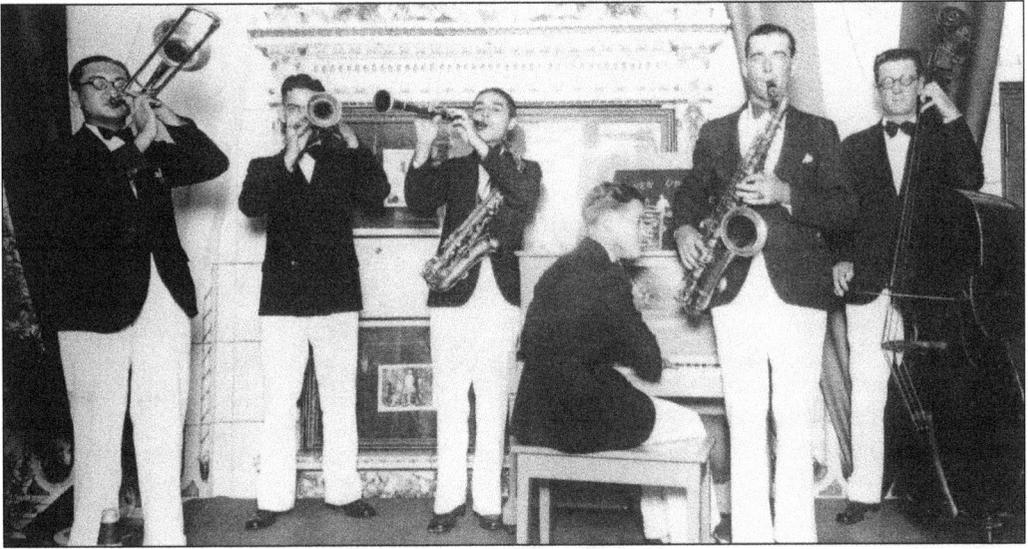

The Orpheum Theater band played inside for the shows and outside in the lobby to attract customers. This *c.* 1932 photo was taken in the lobby, and musicians are, from left to right, Jac Assunto, Howard Reed, Alfred Gallodoro, Howard Tift, Henry Raymond, and Charles Rittner. While inside the theater, the leader of the pit band was Emile Tosso. The theater was located at 125 University Place. Jimmy Dorsey claimed Gallodoro was one of the greatest sax players in America.

Royal Commander Band was just one of numerous orchestras and bands in the New Orleans area during the Jazz Age. Band members in this 1933 photo included O.J. Toups, piano; Cliff Curry, first sax; Russell Ortolano, tenor sax; Joe Fazzio, second trumpet; Joe Quaglino, third sax; Philip Quaglino, trombone; Phil Castang, guitar; V. Maggio, drums; and Angelo Quaglino, first trumpet.

Tony Almerico's band played the Parisian Room on Royal Street on November 12, 1936. Tony is a descendent of Pascal Almerico, from Agrigento. The band is, from left to right, Joseph Chetta, Pascal Almerico, and Felix Lipani. Tony Almerico is standing in center stage. Josie Almerico, Tony's sister, is the singer at the far right in crowd.

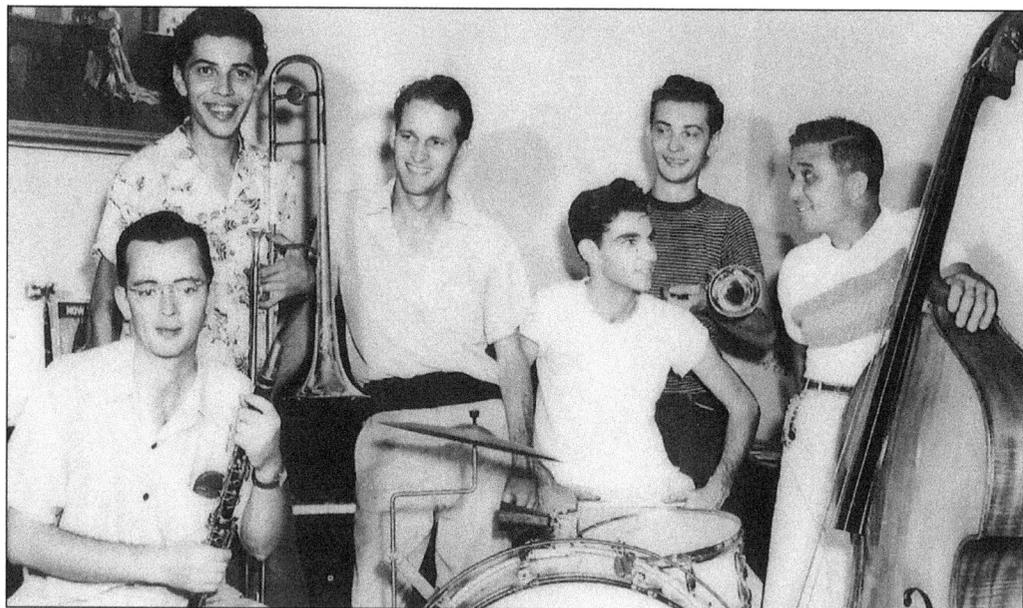

The Assunto family—Papa Jac, banjo and trombone; son Frank, trumpet; and Freddie, trombone—made up the original Dukes of Dixieland, one of the nation's big-name bands. Other New Orleanians who worked with the Dukes were Harry Shields, Tony Parenti, Raymond Burke, Pete Fountain, Stanley Mendelson, Arthur Seelig Jr., Willie Perkins, Buck Rogers, Roger Johnston, Tony Balderas, Henry Barthels, and Martin Abraham Jr. In the space of eight years they developed from teenage amateurs into one of the most popular Dixieland combos. The photo is c. 1950.

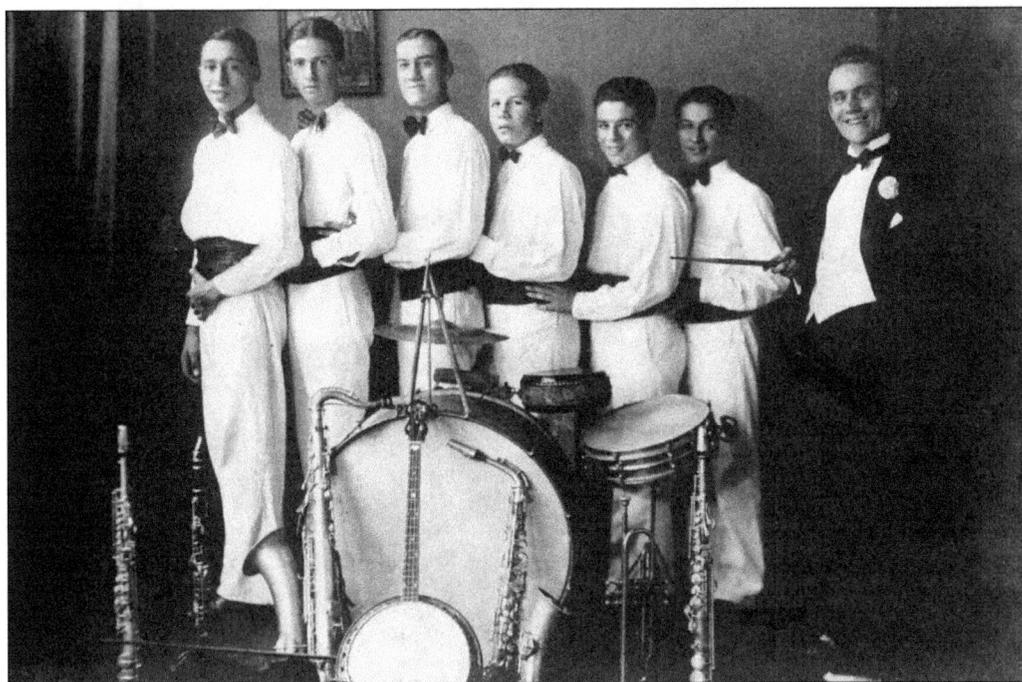

Louis Prima formed this band as a teenager, and by the time he was a senior at Warren Easton High School in the early 1920s, the group was playing regularly in the French Quarter. Louis is first on left. Proud of his heritage, Prima's persona and his material clearly identified him as an Italian American from New Orleans.

Louis Prima poses with his famous horn. After he left New Orleans for New York in 1934 he popularized swing music in such compositions as "Sing, Sing, Sing." His novelty songs like "Angelina," "Josephina, (Please Don't Leana on the Bell)," "Please No Squeeza Da Banana," "Bacciagaloop, Makes Love on the Stoop," and "Felicia No Capicia," raised consciousness of Italian-American life and language in the 1940s and 1950s. This "Italian trend" saw the rise of many popular entertainers.

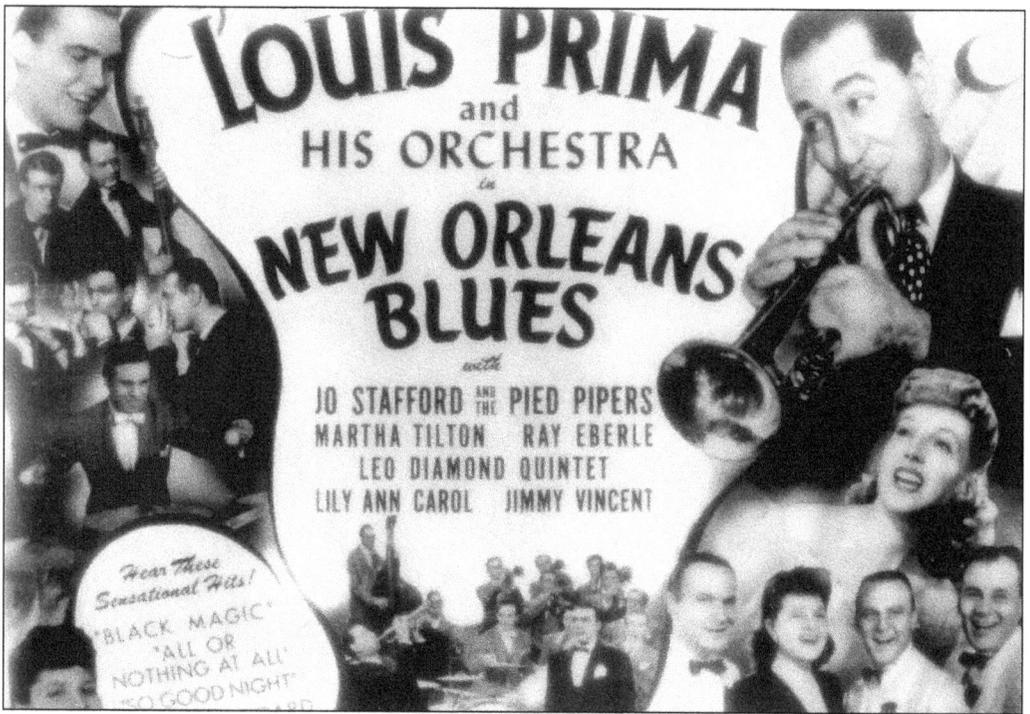

This 1941 film poster represents Louis Prima at the top of his game in the Big Band Era, working with Jo Stafford and the Pied Pipers. Since he grew up in the music world of the French Quarter, he must have been very comfortable performing in this short film with the title *New Orleans Blues.*

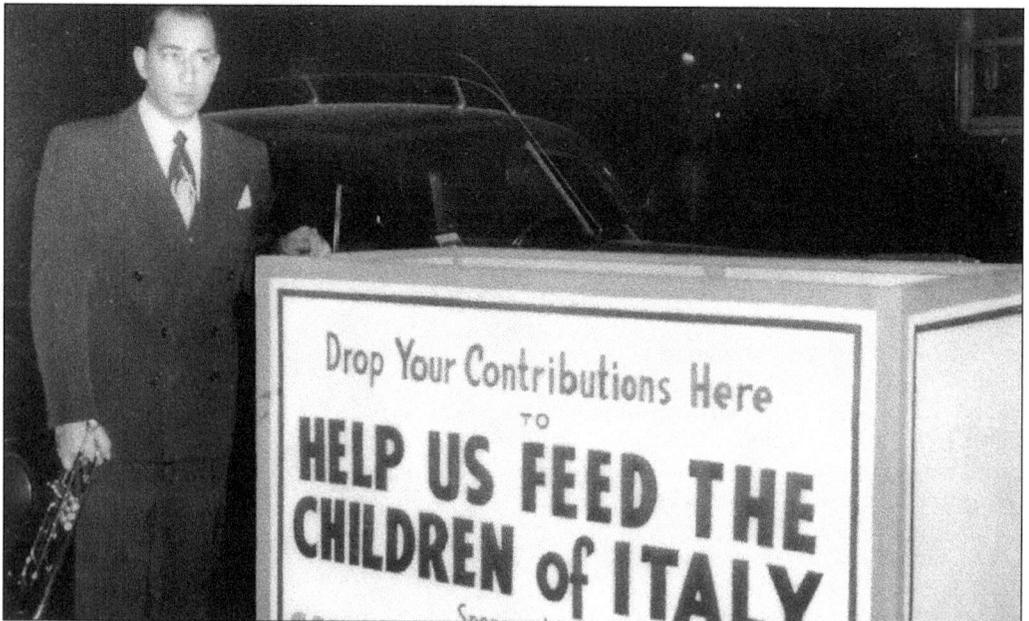

Louis Prima (1910–1978) pitched in with the Sons of Italy during the 1940s to help relieve the hunger and poverty that swept war-torn Italy. In his work and in his private life, there was never any doubt about Prima's ethnic identity.

Dominick Cammarata, Joe Accardo, Roy "BB" Anselmo Sr., Sam Anselmo, and the middle-weight contender, Jimmy "King" Anselmo watch the Louis Prima show at the Dream Room, a night club in the French Quarter on Bourbon Street, c. 1952. Boxing and jazz have been popular with all ethnic groups in New Orleans.

Louis Prima, Keely Smith, Sam Butera, and the Witnesses appeared at the Sahara Hotel in Las Vegas in 1956. Famous worldwide for his style of singing with Keely, who sang with a "poker face," Prima wrote many songs, had a series of smash hits, and won a Grammy in 1958. True to his musical background, his gravestone reads, "When the end comes I know, they'll say just a gigolo and life goes on without me." Louis is buried in New Orleans next to his parents, Angelina and Anthony Prima.

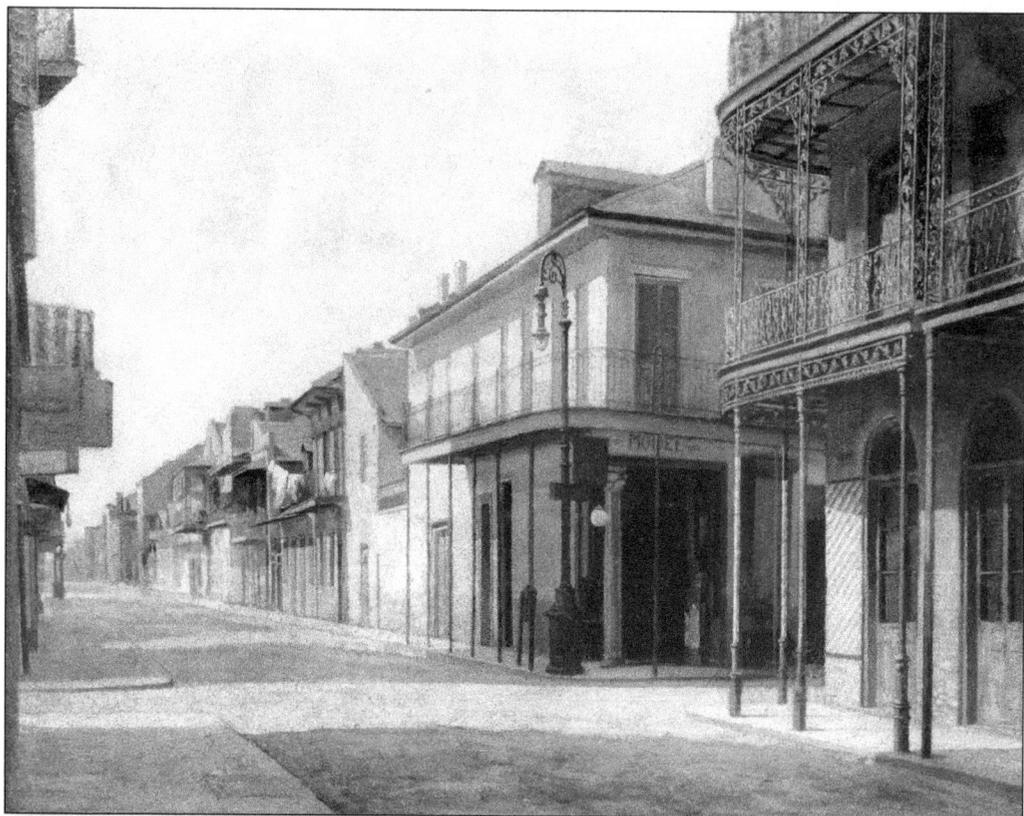

This oil painting of St. Peter and Royal Streets in the early 1900s by Achille Peretti, a muralist, landscape painter, and a miniature painter, depicts 700 and 701 Royal Street. An Italian immigrant who came to New Orleans in 1885, Peretti maintained a studio and home at 632 St. Peters Street. Though his early successes included masterful decorative work in the St. Vincent Church, he died in bitter poverty in 1924. His works appear in the Historic New Orleans Collection.

A native New Orleanian, Marguerite Piazza is a world-famous opera star and entertainer. When Italian Americans were refused membership in the Mardi Gras Carnival Krewes in the 1930s, they formed their own organization called the Virgilians. Marguerite was the first queen and Dr. Emile Bertucci the first king of the Virgilians. The group only paraded a few years, but their extravagant costumes and their assertiveness of behalf of Italian Americans are still remembered to this day.

Teodoro Bottinelli was one of New Orleans's most famous sculptors. He was chief sculptor of the largest carving on earth, the Confederate Memorial Carving on Stone Mountain in Georgia. Twenty of his eagles grace the Arlington Memorial Bridge in Washington, D.C. He settled in New Orleans in 1924, where many of his famous American eagles may be found—one is on the exterior of the American Italian Renaissance Foundation building. The City named a street in his honor.

Sculptor Teodoro Francesco Bottinelli, was one of New Orleans most famous artists. He was chief sculptor of the largest carving on earth— the Confederate Memorial. The colossal granite relief on Stone Mountain depicts Confederate leaders Jefferson Davis, Stonewall Jackson, and Robert E. Lee. He created the 20 eagles that grace the Arlington Memorial Bridge in Washington, D.C. Bottinelli settled in New Orleans in 1924 where many of his famous American eagles may be found. His descendants run a flower shop on a street named in his honor.

Mlle. Stella Bossi, the premier danseuse of New Orleans with the French Opera Company in 1901 and 1902, was one the many Italian artists to have an impact on the cultural life of New Orleans.

Known as "Queen of the Ivories," Inez Somonzini Lugano (1891–1983) painted miniature portraits and worked from her home on Andrew Street as an artist-illustrator. The National Italian Exhibition of Art in Italy in 1930 awarded her a silver medal, and the California Society of Miniature Painters honored her for her exquisite work.

Seven

ITALIAN AMERICANS IN GOVERNMENT
Mayors and More

During the years of the French and Spanish regimes in New Orleans, there was a constant trickle of Italians who usually arrived as members of the military, married, settled in the colony, and became valuable citizens. Most Sicilians came to America pursuing a better life for their families.

Though they had to battle prejudice and the political forces that led to the lynch mob in 1891, the Italian-Sicilian colony eventually found a prominent voice in both state and local politics. They ran for public office and won positions such as police chief, mayor, lieutenant governor, and State Supreme Court justice. One of the first Italians to hold a public office was Francesco Maria de Reggio, who in January 1781 was a member of New Orleans's town council, mayor, and a judge. Giuseppe A. Barelli served as secretary of the board of commerce and consul for Portugal and the Two Sicilies from 1838 until his death in 1858. During the Civil War, Italians joined forces to form the Garibaldi Legion, which served as a company in the Confederate Army. Dr. Felix Formento Jr. was a member of the Louisiana State Board of Health.

Robert Maestri, mayor of New Orleans from 1936 to 1945, was described by many as a financial wizard, and was given credit for reorganizing the city's financial structure to make it more efficient. Mayor Victor Schiro served from 1961 to 1970. Schiro and Police Superintendent Joseph I. Giarrusso restored public confidence in the police force, which was at a low ebb prior to their terms. Pascal F. Calogero Jr., elected to the Louisiana Supreme Court in 1972, was the first Italian American to become chief justice of Louisiana Supreme Court. There have been many officials with Sicilian and Italian ancestors from the New Orleans area including Mary L. Landrieu, U.S. Senator; Arthur Lentini and J. Chris Ullo, state senators; and John A. Alario Jr., Glen Ansardi, N.J. Damico, Mitch Landrieu (recently elected lieutenant governor), Steve Scalise, and Steven J. Windhorst served as state representatives.

This is a sample of Italian Americans who participate and serve in every imaginable aspect of New Orleans political life. Since Italians have been in New Orleans since the city's beginning, intermarriage with other ethnic groups has given us scores of men and women who are high achievers with Italian ancestry but without Italian names.

There has been only one Louisiana governor with Italian ancestors. Charles Foti, Sheriff of Orleans parish for many years, was recently elected state attorney general, the first Italian American to hold the post since Adolphe Coco in 1916. Since Italian ancestry for New Orleans Parish in 2000 was pegged at only 15,695 or 3.2 percent, and statewide at 195,561 or 4.4 percent, Italian Americans often seek political coalitions with other ethnicities, such as Irish Americans.

In this 1936 photo at the Governor's Mansion in Baton Rouge are, from left to right, Gov. Richard Leche, New Orleans mayor Robert Maestri, and Mrs. Earl Long. Jimmy (Brocato) Moran is standing on right. Maestri's good relations with state officials helped his efforts to cope with the problems of the Depression in New Orleans.

In 1936, Robert Maestri (1904–1992) became the first Italian American elected mayor of New Orleans in 1936. In his nine years, he improved relations between the city and the Long political organization, and he erased the city's debt in just three years. During the Great Depression, Maestri worked closely with the governor to create jobs and to secure millions in federal funds to employ New Orleanians in various WPA programs. His parents were Angelo and Francis Maestri. Francis was in the furniture business.

Mayor Victor Schiro served at a time (1961–1970) of social strife. He stood firm on school integration and enforced it through the police. Schiro, along with Police Superintendent Joseph I. Giarrusso, restored public confidence in the police force. Schiro widened and beautified Poydras Street, and, in 1965, announced plans for the Super Dome. Schiro secured federal help after Hurricane Betsy damaged the city in 1965. His motto "If it's good for New Orleans, I'm for it!" is still remembered today. Note that the plaque over Schiro's left shoulder is a memento from the City of Milan.

Joseph Yenni of Kenner was first elected alderman in 1965, then mayor in 1970. In 1980 Yenni was elected president of Jefferson Parish. Known as "Mr. Credibility," he was a coach and educator for 30 years and a naval communications officer in World War II.

Veronica di Carlo Wicker was the first Italian woman from Louisiana named to the federal bench. Appointed in 1977 by President Carter to federal magistrate, she was promoted to federal judge in 1979. Judge Wicker spent her entire career in federal district court in New Orleans, beginning as a clerk in Judge Lansing Mitchell's court in 1966. She was the wife of Judge Thomas C. Wicker.

Mayor Victor Schiro is pictured with Mr. and Mrs. Homer L. Hitt and Prof. Edward M. Socola on August 2, 1965. Homer Hitt was chancellor of University of New Orleans.

Bobby Freeman (at right), former lieutenant governor of Louisiana, has roots in Sicily—his mother was the former Rosa Borruano. He is seen here with Louisiana Supreme Court chief justice Pascal Calogero Jr. (at left), and E.C. "Chuck" Anselmo, past president of the American Italian Federation of the Southeast.

Deputy Sheriff Nicholas Beninate is pictured on the West Bank showing his stuff to the crowds at the Hercules Mardi Gras Parade in 1976. As a member of the Gretna Mounted Police, he and his horse Senator rode in the parade, Senator dressed royally with a silver saddle and Nick in uniform. The family came to America from the Province of Palermo, Sicily.

Charles Foti
Criminal Sheriff

#75

"Punch 75 for Foti!"—Charles Foti was first elected criminal sheriff of Orleans Parish in 1973. He was so highly regarded that he was re-elected to the position for the next two decades. In 2004 he was elected Louisiana attorney general. As sheriff, Foti initiated many programs to educate prisoners and redirect their lives. He also spearheaded the Christmas Toy Drive, the Thanksgiving Food Distribution for the elderly and the Young Marine Program.

Sen. Mary L. Landrieu has been referred to as "one of the Senate's foremost leaders on education" by her colleagues in the Senate. Her dedication to our armed services and her knowledge of defense issues is widely known. She is the state's junior senator, but a fiscal leader for the nation as a member of the powerful Senate Appropriations Committee. She follows in her father's footsteps (former Mayor Moon Landrieu) in the political arena. Mary's mother is Italian.

Joseph Giarrusso, Superintendent of Police, presents a donation to Sister Lillian McCormick. He began with the New Orleans Police Department in 1946 and served as superintendent from 1960 to 1970. After retiring from the force, he was elected councilman at large and served eight years. As part of his training, he attended the First Narcotics School in Washington, the FBI Academy, the Interpol School in Paris, and, in 1966, the Management Institute for Police Chiefs at Harvard University. Dr. Sal di Grado (left) looks on.

These Italian-American Pearl Harbor survivors were reunited at the christening of the *Pearl Harbor*, built for the Navy at Avondale Shipyard in New Orleans. An elaborate ceremony and reception paid homage to all those who served during the 1941 attack on Pearl Harbor. Pictured are, from left to right, John Zanca, Phil Serio, Joe Lumenti, and John Dibetta. Military service in World War II hastened the "Americanization" of the children and grandchildren of the immigrants.

Gasper J. Schiro, Gov. Ronald Reagan, and Harry Ladas attend Regular Democratic Organization at the Roosevelt Hotel in New Orleans in 1976. Reagan was very popular among New Orleans Italians.

Hon. Nancy Amato Konrad, judge of Jefferson Juvenile Court, has received many accolades for her work and is an officer of the Louisiana Council of Juvenile and Family Court Judges Association.

Pascal F. Calogero Jr., the first Italian-American chief justice of the Louisiana Supreme Court, was elected in 1972 and re-elected in 1974, 1988, and 1998. He became chief justice in 1990. Calogero served in the U.S. Army from 1954 to 1957. Calogero authored articles for law reviews and for the Louisiana Bar Journal and has received awards for his work. His family emigrated at the turn of the century from Messina, Sicily.

Judge Martha Sassone presents scholarship awards to two young students at the annual Louisiana American Italian Sports Hall of Fame Banquet. Judge Sassone was first elected to the 24th Judicial District Court in 1990, one of the first two women elected to that court. She was re-elected in 1996 and is currently in her 16th year on the bench. Martha Sassone is the daughter of Jack and Edith Sassone.

Judge Philip Ciaccio served on the 4th Circuit Court of Appeals in New Orleans for 16 years before his retirement in 1998. He was the recipient of many honors for his years on the bench and was given special recognition by the National Italian-American Bar Association's Louisiana Chapter. He married the former Mary Jane Bologna and they had 10 children—five boys and five girls.

Politics is a tradition for the Landrieu family. Mitch Landrieu, born to an Italian mother and French father, served as state representative for 15 years prior to his election as lieutenant governor in 2003. Mitch's father Moon Landrieu was mayor of New Orleans, and his sister Mary Landrieu was elected to the U.S. Senate in 1996. Mitch, shown here with wife Cheryl and their children, is known as a reform leader who fought tough battles in the legislature.

Eight

SPORTS AND ETHNICITY
The Road to Glory

America, especially the Old South, is sports crazy. Sport is unsurpassed for expressing the grace, fortitude, strength, and nobility of the human spirit. Games of sport are absolute arbiters of skill that transcend race, nation, age, and gender. Like members of other ethnic groups, Italian Americans in New Orleans benefited as a group and as individuals by excelling in sports.

Italian immigrants came to this country with a strong work ethic, a spirit of dedication, and attitude of self-fulfillment. The older generation of immigrants often did not understand their children's fascination with American sports. The younger generation transferred their parents' work ethnic into both work and play, and many of them excelled in sports. For this generation, sports became a means to escape the ghettos by using their God-given talents. Athletics, sportsmanship, and exemplary moral character were for years synonymous.

The American Italian Renaissance Foundation established the Louisiana American Italian Sports Hall of Fame to recognize the immigrants and their descendants, who, for generations, have participated and excelled in the field of sports. Since being organized by Joseph Maselli in 1986, many New Orleans champions have been enshrined at the Hall of Fame such as Zeke Bonura, American League baseball outfielder; Pete (Gulotta) Herman, bantamweight world champion 1917 to 1920; Tony Canzoneri featherweight and lightweight champion; Jimmy Perrin, featherweight world champion in 1940 (who waited 40 years for his belt); Vincent D'Antoni, national intercollegiate golf champion; and Francis "Hank" Lauricella, all-American football player. Many fighters, like Pete Herman, changed their last names from an Italian to an Irish surname, because in those days Irish boxers drew large crowds and were in great demand.

The full list in chronological order of those inducted into the Louisiana American Italian Sports Hall of Fame from 1986 to 2004 is as follows: Henry "Zeke" Bonura, Francis "Hank" Lauricella, James LaCava Perrin, Charles V. Cusimano, Ronald Maestri, Louis Messina, Anthony G. Sardisco, Johnny Altobello, Tony Canzoneri, Joe Gemelli, Pete (Gulotta) Herman, Willie Pastrano, Mike Calamari, Tom D'Angelo, Dom Fazzio, Sammy Grezaffi, Vincent D'Antoni, Michael J. Cusimano, Rich Mauti, Pal (Miorana) Moran, Vincent Caruso, Harold Cervini, Tyler Lafauci, Joseph "Oyster Joe" Martina, Warren Capone, Keith Graffagnini, August Lapara, Vincent Rizzo, Samuel Trombatore, Elmo Adolph, Stacey Gaudet Berry, Joseph Yenni, Ignazio "Nacho" Albergamo, John "Fats" D'Antonio, Jerry Pellegrini, Nickie Cammarata, Frank Misuraca, Anthony Reginelli, Vincent Verderame, Manuel Colletti, Buddy "D" Diliberto, Pete Giarrusso, Barry Butera, Martin Coscino, Rose Misuraca Scott, Dominic Alfred "Mickey" LaNasa, Charles Anthony "Chuck" Melito Jr., Sam A. Bella Jr., Frank Monica, Joseph "Jay" Ditta, Anthony "Joe" Galliano, Salvadore A. Bordlee, Frank J. Polozola, Sandra Mary Zulli, Dr. Nick J. Accardo Sr., Frank J. Cicero Sr., Louis James Giambelluca, Sam Paul Scelfo Sr., John Campora, Vince Manalla, Jodee Pulizzano, Randolph "Randy" J. Bordlee, and Chris Scelfo.

Pal Moran—real name Paul Francis Miorana—was one of Louisiana's first famous fighters. He fought seven world champions, including the great Benny Leonard three times, during a boxing career that lasted from 1912 to 1929. He was one of several New Orleans "ring greats" who never reached the top only because no lightweight champions of his time would risk their title against him. He was inducted into the Louisiana American Italian Sports Hall of Fame in 1990.

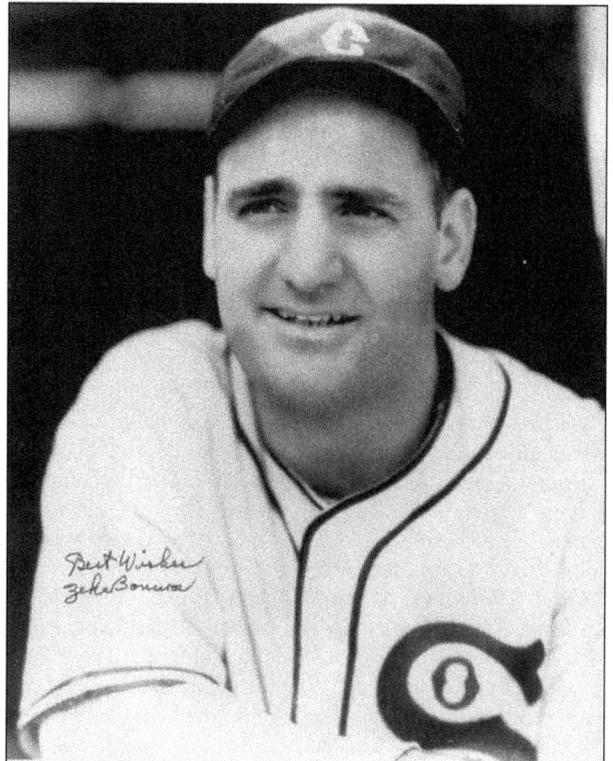

Henry John "Zeke" Bonura, as a 17-year-old member of the U.S. track team in San Francisco, broke the world record for the javelin in 1925. Zeke (1908–1987) was one of the many players from the Crescent City to make it into big-league baseball when he became the first-baseman for the Chicago White Sox in 1934. His career was cut short by World War II, when he was assigned to Special Services. He was presented the Legion of Merit by General Eisenhower.

The New Orleans White Sox lineup in 1929 included five players with Italian last names. The team was, from left to right (front row) Beach, Chalona, Hoerner, Passarieu, Powell, Antoine, and Federico; (back row) Carboni, Renauoin, Mangiapane, Smith, Clay, Viegas, Rizzo, and manager C. Fresh. Participation in sports, especially baseball, had an Americanizing influence on the children of immigrants.

This ticket to Jimmy (LaCava) Perrin's boxing match on May 29, 1939 cost $1.15. Perrin (1915–1997) fought 107 professional fights, (most of them in New Orleans, and won 94 of them. He was known as the "Conqueror of Champions," and himself held the world featherweight champion title. He was inducted into the Louisiana Athletic Hall of Fame, the Greater New Orleans Sports Hall of Fame, and the Louisiana American Italian Sports Hall of Fame.

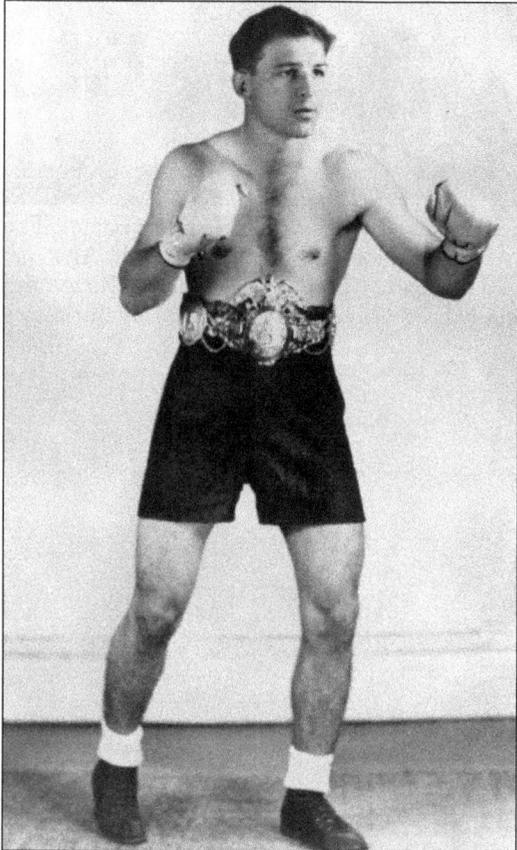

Pictured is Jimmy (LaCava) Perrin, featherweight champion of the world in 1940 after defeating champion Joey Archibald in a 10-round decision. His "hit and move" style avoided black eyes and bloody noses. He was left-handed and often said, "Why use two hands when you can win with one?" Perrin was a member of the 1932 U.S. Olympic boxing team. He was born James Raymond LaCava, but he began fighting professionally at 17 under his stepfather Ernie Perrin's name.

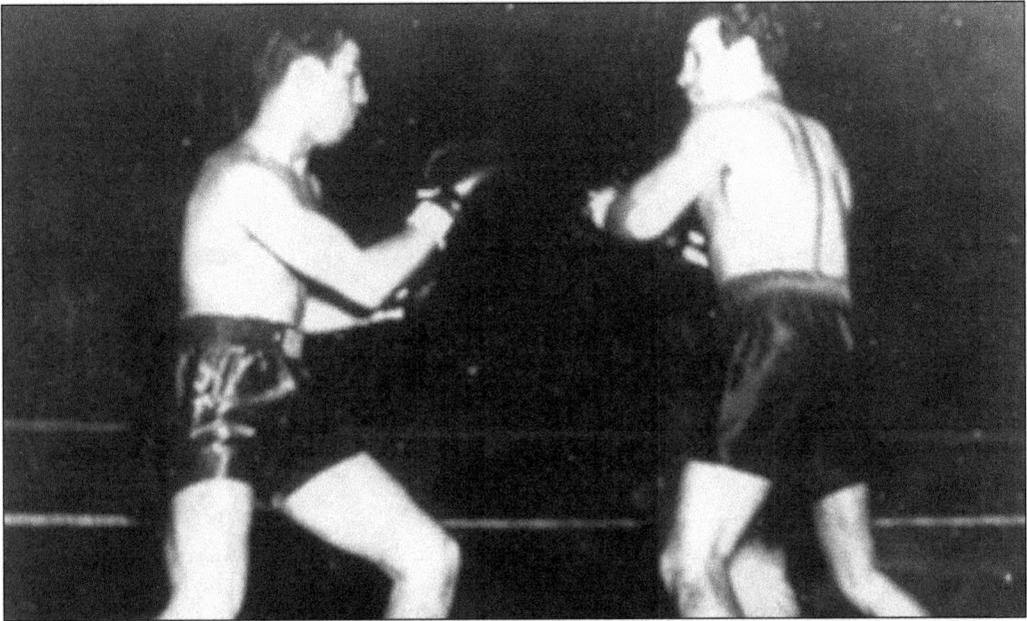

Tony Canzoneri, former featherweight and lightweight champion, battles with Nick Cammarata in the Municipal Auditorium on May 19, 1939. The match drew a crowd of 9,200 people, a record that held for almost 20 years. In that era, the city was a major venue for national-championship boxing matches, and a good number of the boxers were Italian American.

James Brocato, known as "Diamond Jim" Moran and seen with Governor Long, was born in the French Quarter. He was a shoeshine boy, newsboy, sportsman, professional boxer, and owner of Diamond Jim's Restaurant, home of the "diamond-studded meatball." He wore mink and diamonds everywhere and sported a diamond cigar holder, diamond glasses, and even a diamond in his tooth. He was an annual goodwill ambassador of New Orleans to the Kentucky Derby. The Diamond Jim Moran Collection was donated to the American Italian Renaissance Museum and Library by his son Anthony Moran Brocato.

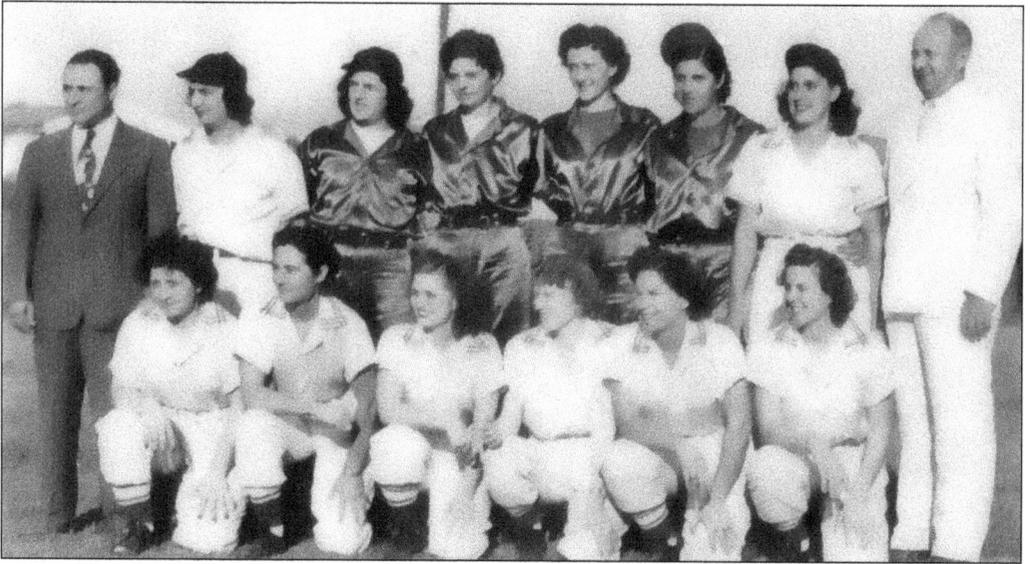

The Jax Girls were world champions in 1942, 1943, 1945, 1946, and 1947. The Italian-American Savonna sisters challenged both gender and ethnic stereotypes. Members of the team are, from left to right (front row) Eloise Steck, Evelyn Case, Kathleen White, Hazel Gill, Selma Meniecke, and Edith "Skipper" Daul; (back row) coach Heard Ragas, Freda "Toni" Savonna, Olympia Savonna, Lottie Jackson, Anna Strauska, Nina Korgan, Mary Pembo, and coach Dick Jones. Missing from photo are Dottie Pitts, Dottie Walker, and mascot Joyce Cook.

Augie Lapara, a successful golden-gloves boxer, fought and beat the U.S. featherweight champion Jackie Graves in November and again in December 1944. As a professional fighter, he had 50 fights and only lost 12 of them. Fifteen of his bouts took place in New Orleans.

Francis E. "Hank" Lauricella became an all-American with the Tennessee Volunteers and served in the Louisiana Senate and House of Representatives for 32 years between 1964 and 1996. He has been inducted into the Louisiana, Tennessee, and National Football Foundation Halls of Fame, and the Louisiana American Italian Sports Hall of Fame in 1986. As general partner and manager of the Lauricella Land Company, he continues to be among the movers and shakers of New Orleans.

Willie Pastrano (1935–1997), a light heavyweight champion from June 1,1963 to March 30, 1965, learned to box in the Whitey Esneault's gym on Elysian Fields in New Orleans. Many fighters have attempted to copy his boxing style, but most successful was Muhammad Ali, to whom Pastrano demonstrated his famous side-to-side footwork in a four-hour training session. He had a lifetime record of 63-13-8, with 14 knockouts.

John "Fats" D'Antoni played baseball for the Pelicans, was drafted by the Brooklyn Dodgers, and founded the Babe Ruth League in New Orleans.

The 1974 GNOICS Italian Golf Open, held at City Park, featured celebrities Joe DiMaggio (center) and opera star Marguerite Piazza. Dr. Nick Accardo Sr., president of the GNOICS, is at her side. Marguerite was the first female to be named the National Italian American of the Year by the organization.

William N. Clark Jr. is the great-grandson of Felix Benerito, a Sicilian immigrant, and Annie Renton. Will is a product of Jesuit High School in New Orleans. He set a San Francisco Giants club record by playing in 320 consecutive games. He moved to the Texas Rangers in 1993 and played with the Rangers, Baltimore, and St. Louis until his retirement in 2000. His lifetime batting average over 15 seasons was a remarkable .303.

Another high profile Italian American is Tulane University's football coach. Chris Scelfo began his collegiate career as a graduate assistant coaching the offensive line and tight ends at his alma mater, the University of Louisiana in Monroe. He came to Tulane as a proven offensive coach after two previous posts as assistant head coach (1996–1998) at the University of Georgia and at Marshall University as offensive coordinator and offensive line coach from 1990 to 1995.

John Volz (at left), former United States attorney, and Coroner Dr. Frank Minyard, attend the Louisiana American Italian Sports Hall of Fame Banquet with guests. Volz is a descendant of Italian immigrants—his mother was the former Mary Ortolano. The public has responded very favorably to the Sports Hall of Fame.

Joseph Gemelli, owner of Gemelli's Men's Wear, was the first president of the Saints Hall of Fame (1988–1989) and the first recipient of the New Orleans Fleur-De-Lis Award. He served on numerous committees in support of Italian-American activities, founded the Commercial Athletic League, was a charter member of the Greater New Orleans Cultural Society, co-chaired the 1987 New Orleans Jazz and Heritage Festival, and was a charter member of the Saints Touchdown Club. Gemelli was inducted into the Louisiana American Italian Sports Hall of Fame in 1988.

Success in sports has been an avenue of acceptance for all ethnic groups. The Louisiana American Italian Sports Hall of Fame Committee commemorates and honors the pioneers and achievers who helped win acceptance and respect for Italian Americans in the state. In this 1994 photo are, from left to right, (front row) Carlo DeMatteo, Dr. James J. DiLeo, Betty Bonura, Joseph Maselli, and Salvatore Panzeca; (back row) Vince Marinella, Leslie J. Bonano, Tony Melito, co-chairman Gary Alfonso, Michael J. Cusimano, Domenick Maselli, Johnny Foto, chairman Sam Scelfo Jr., Louis Capagnano, Dominick Grieshaber Jr., Joe Troia, and John Jay Grisaffi.

Tommy Lasorda and Frank Maselli attend the National Italian–American Sports Hall of Fame in Chicago. Tommy, although not a New Orleans native, has had close ties to our city and has donated his time and talents to the American Italian Renaissance Foundation. Frank Maselli is the son of Joe and Antoinette Cammarata Maselli.

Rose Misuraca Scott, president of the American Italian Renaissance Foundation, welcomes attendees to the Louisiana American Italian Sports Hall of Fame Banquet in 1997. At left are Ron Guidry, and Rick Cerone, both former New York baseball players. On the right is former ambassador Lindy Boggs, Joe Maselli, and Frank Maselli. Rose Misuraca Scott is one of three children of Angelo and Gaetana Misuraca, who emigrated from Vicari and Alia, Sicily in 1870s.

Nine

ITALIAN DESCENDANTS
"Discover America"

Italian and Sicilian families truly "discovered America" in New Orleans. The economic system allowed them to use their hard work, family solidarity, and entrepreneurial skills to come to America and to survive in a foreign country, enduring discrimination and the language barrier. We sometimes gloss over the sacrifices, family separation, and cultural trade-offs that the first generation had to make. Times were tough. Some Italian immigrants failed to make it in America, died in industrial accidents, or saw their children fall victims to disease. Most persevered however, bolstered by their devotion to their children and the better world that awaited them. They lived and worked as fruit and vegetable vendors in the French Quarter between 1875 and World War II, when the area was known as "Little Italy" or "Little Palermo."

It took several generations of hard work for most families to make progress, though a notable number of early entrepreneurs found success as they scrimped and saved to buy their businesses, such as the Monteleone Hotel, or Dr. Felix Formento's drug store, or the Vaccaro Brothers' Standard Fruit & Steamship Company.

If the 11 victims of the 1891 lynching were to return to New Orleans today, they would be astounded to find that many of the principal movers and shakers in the city are Sicilian-American. They might be pleased and satisfied to learn of the success that their descendants have had in accumulating real estate in the city and in reaching the highest ranks of the professions as doctors, lawyers, professors, engineers, artists, and business owners. No doubt they would be surprised at the number of their female descendants among those groups.

Italians in New Orleans have achieved a high degree of benessere (well-being) and they are among the leaders of their city. Like the descendants of Italian immigrants everywhere in the world, they must struggle with the meaning and role of their ethnicity in a multi-cultural world.

Central Grocery Store opened in 1905 and is the home of the first Muffaletto sandwich. Founder Sal Lupo invented the sandwich by adding his special olive salad to mortadella (Italian bologna), assorted cold cuts, and cheese on a round hard-crust bun. Descendants operate the store and continue to stock imported Italian food items. From left to right are Tommy, Frank, and Larry Tusa inside Central Grocery.

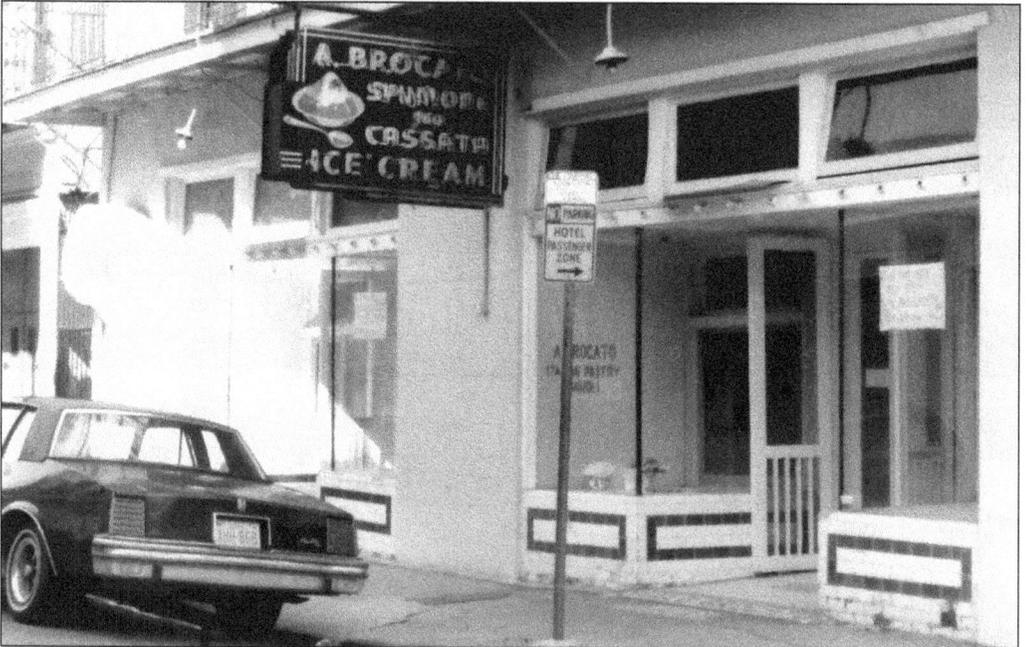

When Angelo Brocato and his sons opened his sweets emporium in the *Vieux Carré* in 1905, he served his homemade ice cream in thick slices on plates. Brocato made it in rectangular blocks and froze it in long metal pans immersed in ice and salt, a technique he learned in Palermo. He also made pastries, cookies, and cannoli. The shop was on Ursuline Street in the French Quarter. Today, the family continues to operate Brocato's in the mid-city area.

106

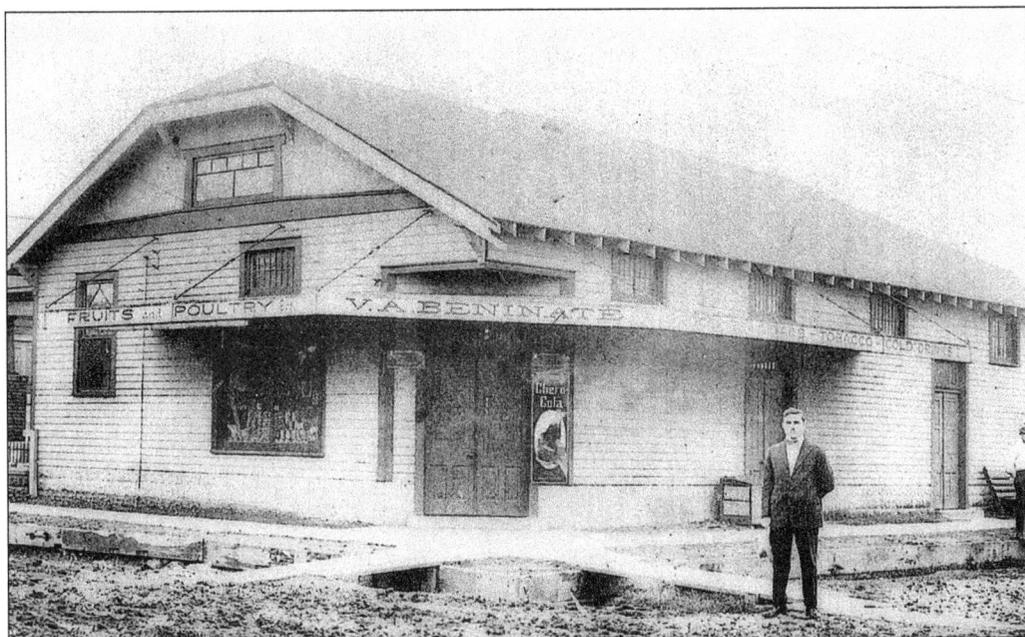

The V.A. Beninate Grocery Store at 901 Pelican Street in Algiers, Louisiana, was operated by Vincent and Antoinne Fallatte Beninate from 1920 until 1945. Apparently taken during a construction period, this photo reveals the variety of products offered by this small business including "Chero Cola." Vincent also owned the Plantation Country Club on Behrman Highway.

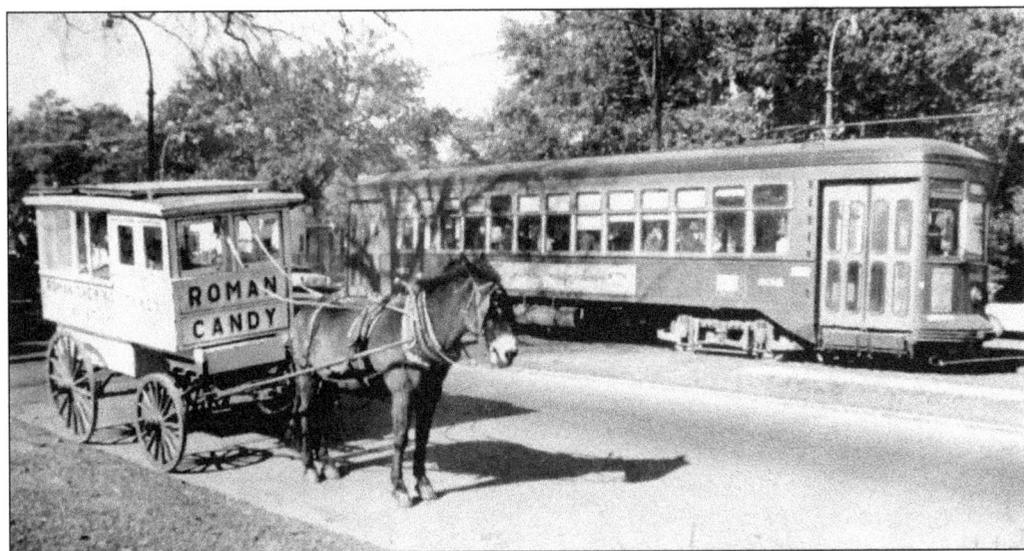

The Roman Chewing Candy Wagon, created in 1915 by Sam Cortese, still rolls down the streets of New Orleans today. Cortese was forced to leave school at age 9 following a streetcar accident that severed both his legs. By the time he was 12, he sold fruit and vegetables from a cart. His mother made Italian taffy, and whenever she had extra he sold it. It was such a hit that he built a special wagon to make the candy as he rode through the streets. Cortese's grandson Ron Kottermann took over the business in 1971 using the original wagon to sell the sweet treats.

This Progresso advertisement pitches the wide range of Progresso products from A to Z—antipasto to zucchini. Note also that one of the other locations of the company was Vineland, New Jersey, an area originally populated by Italian truck farmers that even today has a population that is 22 percent Italian. The Progresso Company was formed by the Uddo-Taormina Corporation of New Orleans.

Joseph Quaglino loads his delivery truck in 1942. His father Phillip opened the Quaglino Tobacco Company in 1922, and Joe began helping his dad at an early age. The Quaglinos originated in Corleone, Sicily, and first emigrated to New Orleans around 1889. The company is still in business today.

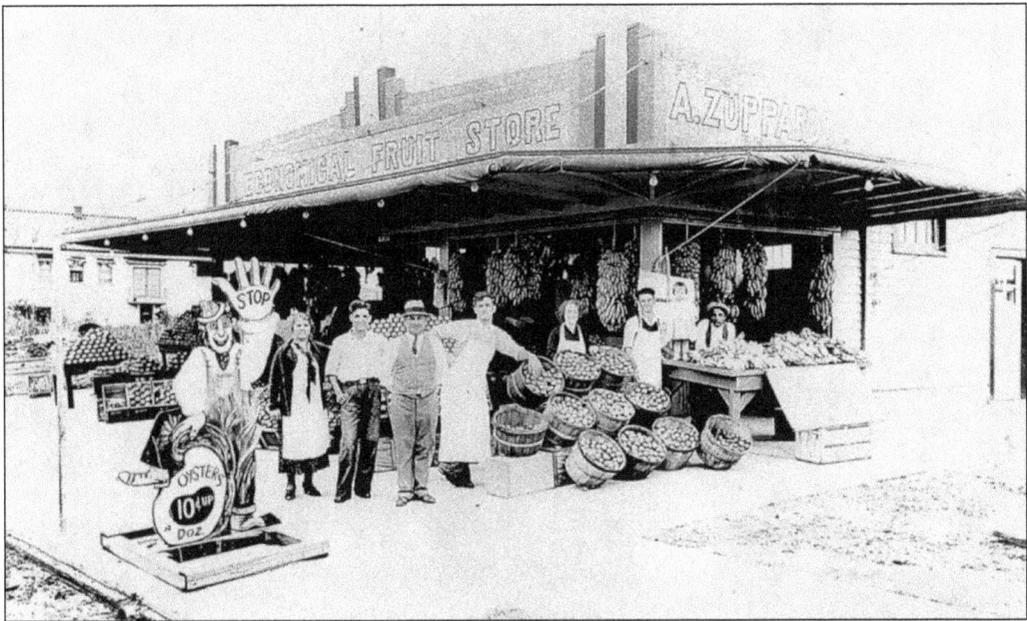

This 1934 Economical Fruit Store at Gentilly Boulevard and Elysian Fields evolved into today's Zuppardos Family Supermarkets. Peter Zuppardo, who came to America from Camporeale, Sicily, began selling bananas from Central American ships to truckers who distributed them nationwide. His wife Mary was the family bookkeeper. Pictured are Mary Zuppardo, son Joseph, husband Peter, and son Anthony. The clown-farmer figure offered oysters at 10¢ a dozen. These supermarkets are still thriving today run by Peter's descendants.

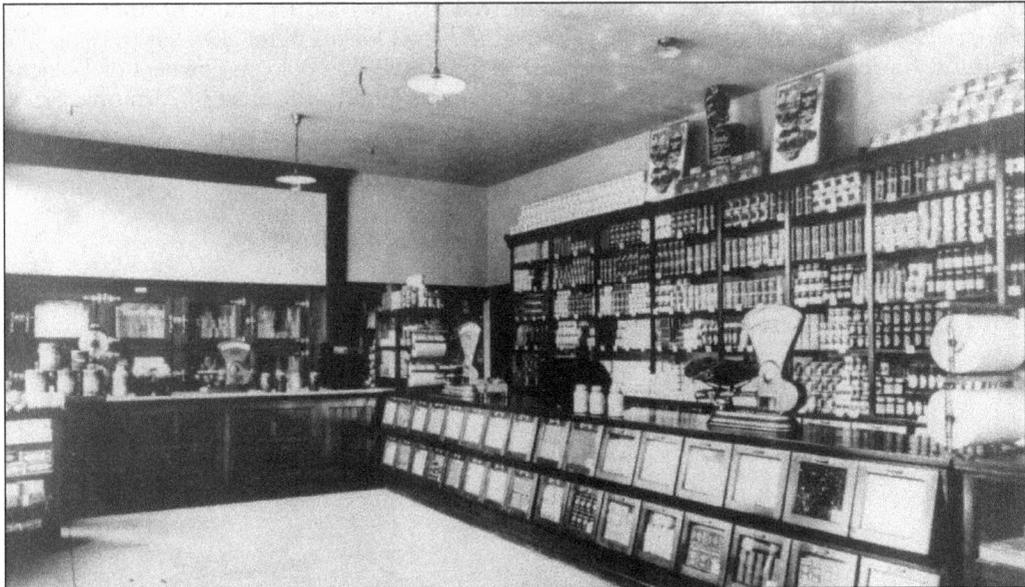

Prima's Full Weight Grocery and Delicatessen, located at Ursuline and North Dorgenois, was owned by Casper Prima, husband of Marie Tranchina and second cousin of the popular recording artist Louis Prima. Notice the bins along the counter, where customers could help themselves to goods. The Prima name is still embedded into the plaster of the facade of the building now serving as the space for medical and dental offices.

This solid freight carload of Taylor New York State Burgundy—believed to be the largest single order of premium Burgundy ever shipped—arrived just in time for the Christmas holiday rush, c. 1950. On hand for the shipment's arrival in New Orleans were, from left to right, J.D. Weining, Taylor divisional sales manager; Anthony J. and Sal Bologna, owners of Bologna Company; and Jack Williams, Taylor Wine. The Bologna family originated in Partanna, Sicily, and migrated in 1898.

Carlo Ditta Inc. is a family-owned concrete plant on the West Bank founded in 1934. Pictured above, Mrs. Felicia Trupiano Ditta and her children continued to operate the business after the death of Carlo in 1962. From left to right are Mrs. Rosalyn Weinstein, Jay Ditta (deceased), Mrs. Carlo Ditta, Mrs. Phyllis Woolfolk, and Mrs. Lillian Uhl. Carlo Ditta's family came to America in the early 1890s from Alia.

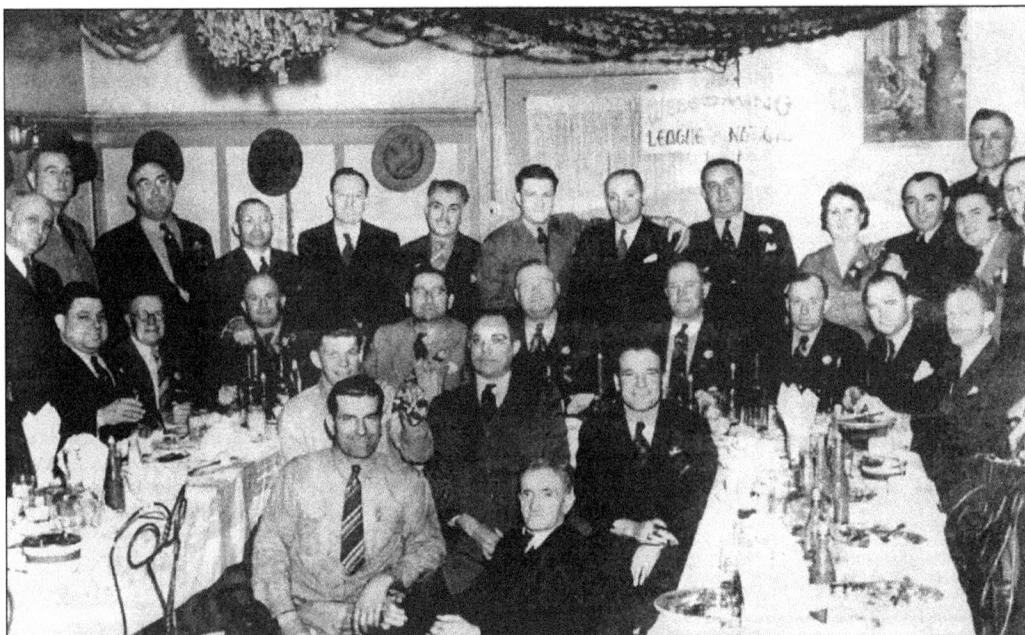

Charles Lamana, Peter Panno, and Joseph Fallo, founders of Lamana, Panno, Fallo Funeral Home, celebrate St. Patrick's Day in New Orleans in 1939. Since choice of funeral directors is strongly determined by ethnic considerations, Lamana, Panno, Fallo was patronized by a large number of Italian Americans. The enterprise continues at several locations under the management of the same families.

The Montelepre Memorial Hospital, founded in 1938 by Dr. Philip Montelepre, was the only hospital at the time privately held by one individual. Originally a 110-bed structure on the corner of Canal and North Lopez Streets, it grew into a two-story medical complex adjacent to the present facility, with an additional four-story wing. Paul Montelepre became the executive director after his father's death. Paul was also co-founder and director of Chalmette General Hospital and served on the boards of Progressive Bank, New Orleans Federal Savings & Loan, and the Azar Foundation.

Otto B. Candies Sr. was the founder and owner of Otto Candies LLC, one of the nation's leading marine transportation companies. Candies was the first to use ocean-going barges for deep-sea supply, and the first company to transport a complete production package from Houston to the North Sea. Candies also created an emergency response network to improve containment of environmental accidents. Candies's grandfather came to New Orleans in the early 1900s from northern Italy and first worked as a laborer.

Commodore Thomas J. Lupo, after serving his country in World War II, built a real-estate business in New Orleans. Known as "Lucky Loop" to his fellow officers during World War II, he holds the Navy's highest aviation combat medals, including the Distinguished Flying Cross. In 1958 he was selected by the Danforth Foundation of Harvard University as one of the 10 Outstanding Young Business Men in America.

112

John Jay Grisaffi of John Jay Salons International and the John Jay Beauty College presents a $100,000 profit-sharing check to Liusa Alvarez at her retirement. A famous hair stylist, educator, lecturer, and consultant, Grisaffi was the long-time president of Intercoiffure, which sets coiffure standards in over 40 countries. In his 46-year career, Grisaffi has received the International Lifetime Achievement Award from the North American Hairstylist, and Educator of the Century by the Intercoiffure World Congress in Germany.

Paul Campo is owner of the Mobile One Auto Sound company. He learned his business skills from his father, Tony "the Appliance Giant" Campo, founder of Campo Appliance Stores. Heavy advertising gave Tony Campo and all Italian American businessmen a high profile in the city's commercial circles.

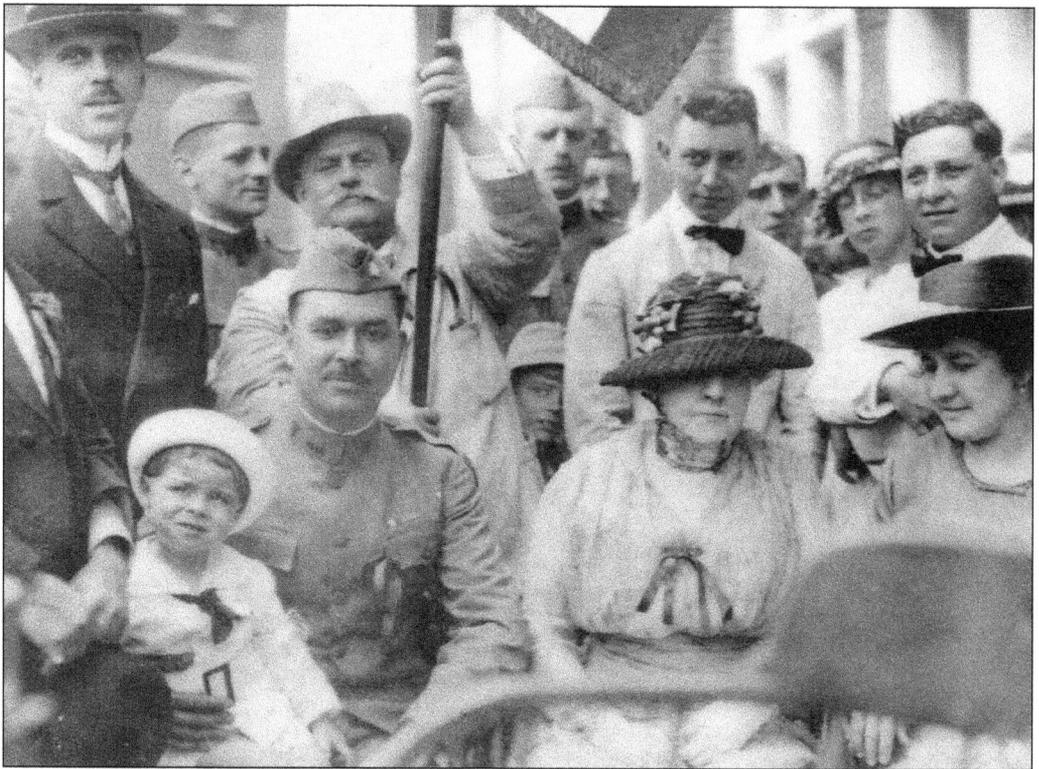

Lt. Col. Joseph A. Danna (1876–1954) served as professor of surgery at Loyola Post-Graduate School from 1914 to 1925 and professor of clinical surgery in the Graduate School of Medicine at Tulane University from 1926 to 1931. This photo was taken in 1919 upon the return of 102 American doctors who served with the Italian Army during World War I. Shown are, from left to right, (front row) Gesuardo A. Danna on Lt. Col. Joseph Danna's lap, philanthropist Eve Butterworth Dibert, and Antonia Danna; (back row) Charles A. Danna, Mrs. Hazel L. Danna, Nicholas A. Danna Sr., and holding the flag is Joseph Calamari.

Dr. John Adriani (1907–1988), from Bridgeport, Connecticut, received his degree in 1934 from Columbia University. Adriani pioneered the drive to professionalize anesthesiology. He was appointed director of anesthesiology at Charity Hospital in New Orleans in 1941 and served in at the hospital through the 1960s. He was director of the Research Department of Anesthesiology at LSU and a professor emeritus at LSU and Tulane.

Dr. Nick Joseph Accardo (1917–1990) was the foremost authority on the Noile's Total Knee Replacement surgery. He designed a method of anesthetizing upper limbs, authored scores of medical articles, and chaired many medical organizations. He was battalion surgeon in the U.S. Army and Louisiana's most decorated World War II veteran. For 40 years he practiced at Hotel Dieu Hospital and instructed Orthopedic Surgery at Tulane and LSU. He was awarded The Order of St. Louis by the Archdiocese.

A descendant of immigrants from Contessa Entellina and a graduate of Louisiana State University, Charles Cusimano was appointed by the governor in 1974 to serve on the LSU Board of Supervisors. Among his many leadership positions, Cusimano was chairman of the board for the Energy Corporation of America, director of the Equitable Petroleum Corporation, an active member of the New Orleans Chamber of Commerce, and a member of the Sugar Bowl Association. Cusimano played football for LSU in 1949–1950.

Joseph I. Giarrusso was the New Orleans Superintendent of Police (1960–1970) and a member of the New Orleans City Council from 1976 until 1993. He is one of a large number of Italian Americans on the police force.

The father of Joseph Maselli Sr., Frank Maselli served as deputy sheriff of Orleans Parish for four years. Here he is in the first uniform issued to their department in 1962. Italians have been very heavily represented in law enforcement in New Orleans.

Jerry Amato is chef and co-owner of Mother's Restaurant, established in 1938. He and brother John purchased the family-style restaurant, and it became so popular with both locals and tourists it had to be enlarged to accommodate the crowds. This 1999 photo was taken in front of Mother's on Poydras Street. The Amatos' ancestors are from Contessa Entellina, Sicily.

An example of today's women who venture into the world of business, Evelyn Conino operates a successful framing shop on Jefferson Highway.

John G. Amato accepted the Civic Award from event chairman Ron Maestri at the 1999 Sports Hall of Fame Banquet. Amato, an attorney, is secretary of the Contessa Entellina Society, where he has been a member for more than 45 years. He serves on the Board of Trustees of Loyola University, as treasurer for the American Italian Renaissance Foundation, the Board of Governors of Junior Achievement, and is president of the Virginia Rosanne Amato Foundation.

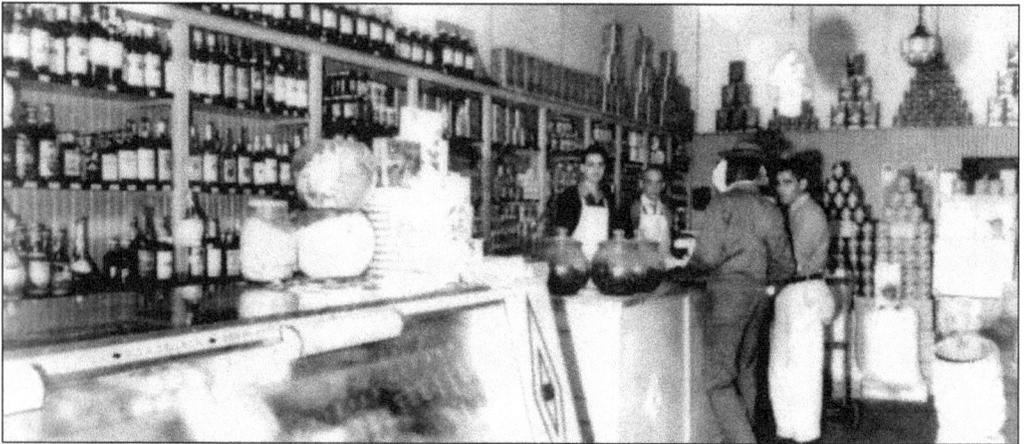

Near the turn of the century, Bartolomeo Perrone, a single, 22-year-old emigrant from Palermo, arrived in New Orleans. He worked in a warehouse, married Gaetana Bova in 1910, and became a father of four children. In 1924 he opened Progress Grocery and specialized in imported foods. Bartolomeo died in 1964, and his son John Perrone Sr. took over the store at 915 Decatur Street. Today, Perrone & Sons Inc., has become importers, wholesalers, and distributors of gourmet food products.

Local artists Faye Palao and Ines Somonzini Lugano compare notes at an art gallery in the French Quarter. Lugano is famous for her miniature portrait paintings done on ivory and her medical artist illustrations. She lived on Andrews Street. Palao is well known for large landscape paintings and for her work as an art instructor.

Joseph Maselli Sr. (at left), gathered in New York City in 1984 with his family, Joseph Jr. (attorney with Plauche, Maselli, & Parkerson), Jan Maselli Mann (first assistant U.S. District Attorney), Frank (successful real-estate developer), wife Antoinette, and Michael (consultant with CIPC Oppenheimer).

Pascal Calogero was the first Italian American to become chief justice of the Louisiana Supreme Court. The court is, from left to right, (front row) Catherine D. Kimball, Pascal Calogero, and Bernette J. Johnson; (back row) Jeanette T. Knoll, Jeffery P. Victory, Chet D. Traylor, and John L. Weimer.

"Mr. Radio" Harry Nigocia was WJBW's host of Midday Serenade. He was known as Mr. Radio from 1926 until 1957.

Joseph C. Canizaro, founder, president, and CEO of Columbus Properties, is an important symbol of the dominant status that Italian Americans maintain in real estate and development in New Orleans. Some of his most recognized developments include Canal Place, LL&E Tower, Texaco Center, First Bank Center, Lykes Center, and the Information Technology Center Office Complex at the University of New Orleans Research and Technology Park. He is a major sponsor of the American Italian Renaissance Foundation. Canizaro's family emigrated from Poggioreale, Sicily, around the turn of the century. His father was a physician.

Morning WWL talk show host Bob del Giorno also produces the Louisiana Sportsman Show, held in March each year in the Superdome. His paternal grandparents emigrated from Marsala in 1912, and his maternal grandparents came from Rome about the same time. Bob served in the Air Force, where he discovered his talent for broadcasting.

August Greco, son of Vincent Greco and father of Albert and Lynn Greco, demonstrated the enterprising spirit of many Italian Americans in hawking the *States-Item* newspaper from his post on Canal Street in the 1950s.

The Schiros are one of the most accomplished families of any ethnic group in New Orleans. The Schiros pictured here are Michael A. Schiro Sr., mayor Victor H. Schiro, Joseph G. Schiro, Dr. John P. Schiro, and Gasper J. Schiro at a St. Joseph's event at the Hilton Hotel on March 19, 1980.

Ten

PRESERVING THE CULTURE
The American Italian
Renaissance Foundation

As we move into the 21st century, the experience of Italian immigrants to New Orleans and America is fading fast and is in danger of being lost altogether. Intermarriage between ethnic groups, the flight from the old Italian neighborhoods and churches to the suburbs, the fading of familiarity with the Italian and Sicilian languages, the passing of the immigrant generation and their children—all these factors cause us to question whether future generations will have anything but the most superficial understanding of their origins.

We are now in a phase when Italian-American history and culture can only be transmitted and preserved by formal cultural institutions. Heroic efforts like those of Giovanni Schiavo to document and publish the history have been supplemented in New Orleans by the work of the American Italian Renaissance Foundation, established in 1979 by Joseph Maselli Sr. The result is the Italian-American Museum and activity center in the New Orleans.

In 1984, the foundation established a museum and research library in their building at 537 South Peters Street, next to the award-winning Piazza d'Italia. The institution staged a series of exhibits like Inez Lugano's collection of original oil paintings, miniatures, and sketches; the Diamond Jim Moran exhibit, complete with mink neckties and a diamond-studded cigar holder; a miniature St. Joseph's Altar covered with intricately designed baked goods and "lucky beans" for all who visit; opera singer Marguerite Piazza's Mardi Gras ball gown; and many other mementos from local Italian Americans and internationally renowned celebrities. The museum also houses the Louisiana American Italian Sports Hall of Fame, which honors the accomplishments of those who have excelled in the field of sports.

Outstanding features of the research library include family histories of Italian immigrants from the late 1800s, an excellent genealogy department, vertical files on several thousand Italian Americans, Italian-American newspapers from around the nation, an oral history tape collection, and the much-sought-after Giovanni Schiavo Collection. The latter was donated by Joseph C. Canizaro. During the Louisiana Purchase Bicentennial in 2003, the museum presented a special exhibit documenting the Italian-American contributions and influence on the discovery and founding of Louisiana through the present time. It attracted many out-of-town visitors and locals.

Most recently, Maselli spearheaded arrangements to renovate the Piazza d'Italia and negotiated a new management agreement with the neighboring Loew's Hotel. The museum and the piazza stand as symbols of the desire of Italians in New Orleans to honor their origins and their ancestors and to invite the respect of their fellow New Orleanians for the contributions that they have made to the Crescent City.

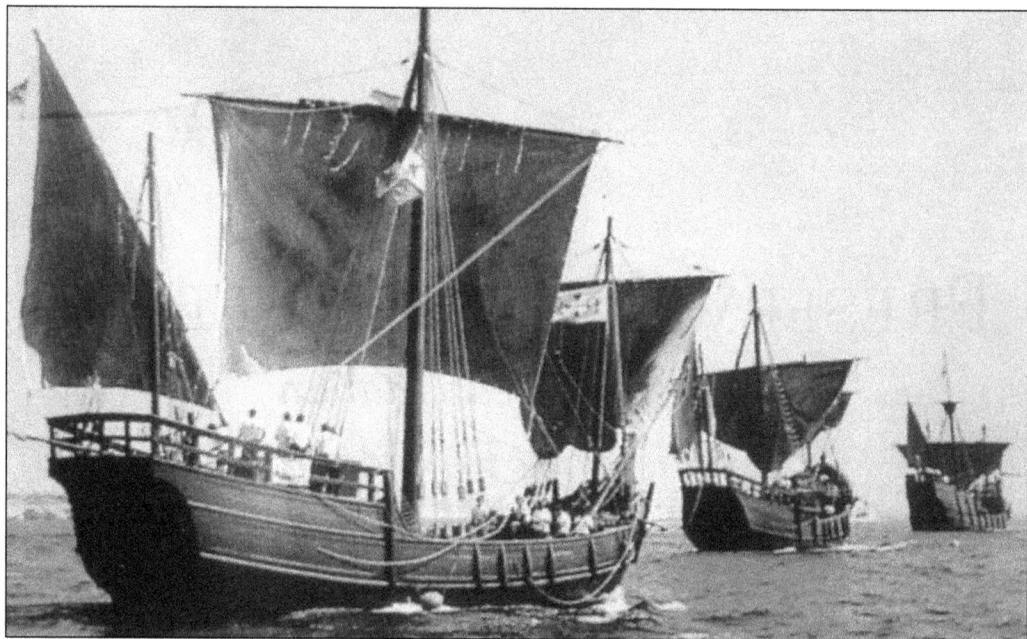

In 1992, these replicas of Columbus's ships traveled up the Mississippi River to New Orleans. Millions of visitors were able to see and board the small vessels. The public was amazed that anyone would attempt to cross the Atlantic Ocean in such small ships. The project was organized by Joe Maselli, chairman of the Louisiana Quincentenary Commission. Italian Americans, even more than Italians, have celebrated Columbus as a symbol of achievement.

Giovanni Ermenegildo Schiavo was the foremost pioneer in the field of Italian-American history. In his life-long, tireless research, he wrote 10 books documenting the presence of Italians in the history of America. Schiavo's books, research material, hand-written notes, and personal library books were purchased and donated to the American Italian Renaissance Foundation by Joseph C. Canizaro. The archive is a rich font of information about Italians in all parts of the nation.

Evans Casso authored *The Life of Napoleon Bonaparte* (1973) and *Staying in Step: A Continuing Italian Renaissance* (1984). He was also a feature writer of the *Italian-American Digest*, a tabloid newspaper founded by Joseph Maselli, which began publishing in 1973 and is still being published today. His works also appeared regularly in *Il Messaggero Della Louisiana* and *The American Citizen*.

Mike Palao, the American Italian Renaissance Foundation historian, had a radio talk show about the world of music. He was a collector and author who wrote articles for the *Italian-American Digest*. His book *St. Joseph Day in New Orleans*, published in 1979, sold out its first printing, but a limited number is still available in the American Italian Renaissance Foundation's gift shop.

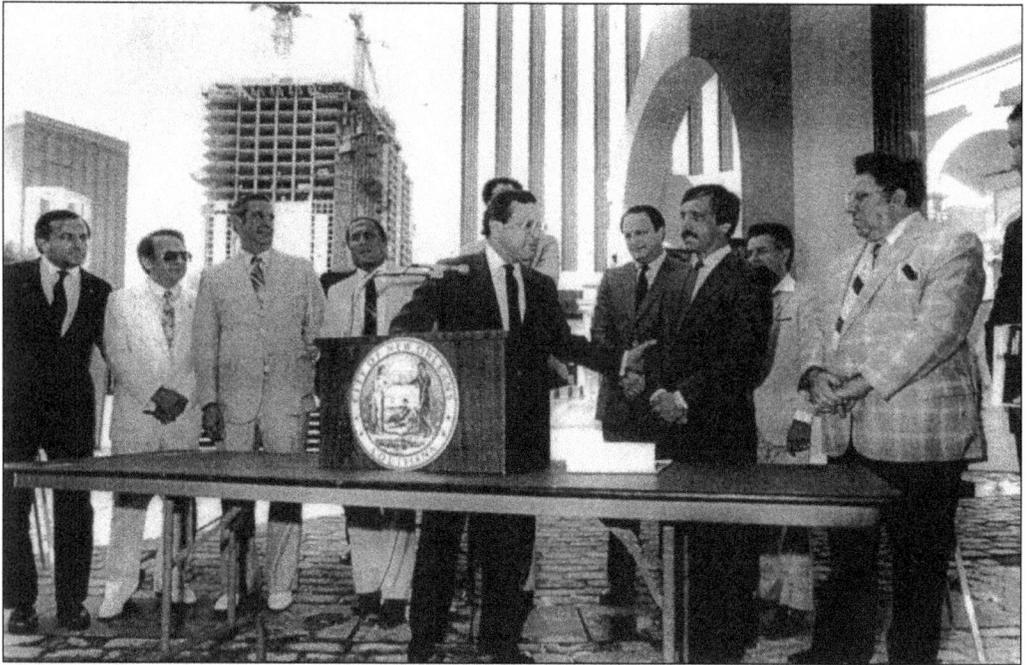

The Piazza d'Italia was dedicated in 1978. The area designated to honor Italian immigrants and their descendants was officially dedicated by Mayor Ernest M. "Dutch" Morial. The piazza was the brainchild of Joseph Maselli during Mayor Moon Landrieu's term in office. Mayor Landrieu wanted to erect a monument to the Italian Americans, and Joe Maselli recommended a piazza instead. Pictured from left to right are Joseph C. Canizaro, Joseph Maselli, Joseph I. Giarrusso, Tony Brocato, Mayor Morial, Albert Pappalardo, Steve Dwyer, Carlo DeMatteo, and Jerry Camiola.

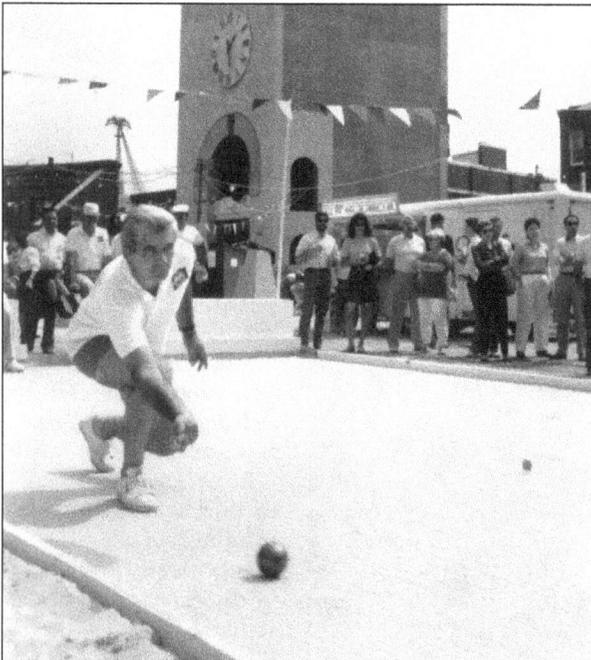

"Sunday Bocce" at the Eighth Annual Festa d'Italia was held in the Piazza d'Italia. This photo was taken for the New Orleans Extemporaneous Art Competition collection, which was an annual event with the Festa. While Italian-American culture in previous generations was transmitted by the neighborhood, church, and family, in our era formal institutions like the American Italian Renaissance Foundation have become the only hope that this culture can be preserved.

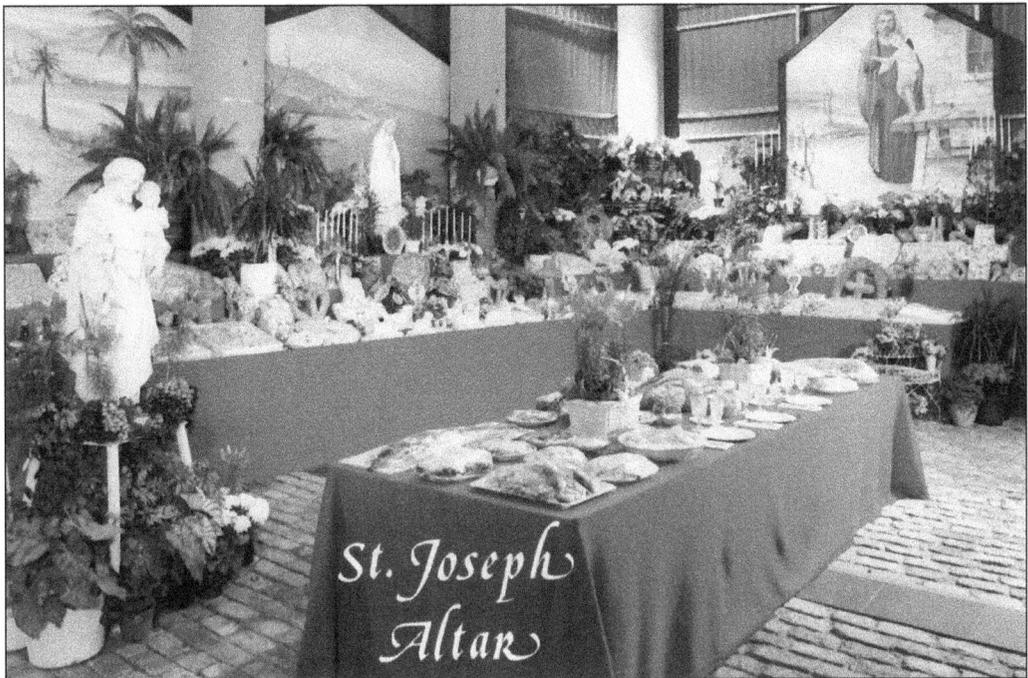

The city's largest outdoor St. Joseph's Altar is sponsored by the Greater New Orleans Italian Cultural Society. Founded in 1965, it has been erected annually in front of St. Joseph's Church and later in the Piazza d'Italia. On St. Joseph's Day an outdoor mass proceeds feeding of the poor in the piazza. The altar is visited by thousands each year, many from northern states.

New Orleans Italians did an outstanding job representing their ethnic group during the 1984 Louisiana World Exposition. TV personality Frank Davis and Frank Maselli share wine and music by Julie Council at the Italian Village. Organized and developed by Joseph Maselli Sr., the village also featured live entertainment nightly, authentic Italian food and gifts, and a mini-museum. It was one of the most popular exhibits at the exposition, and one of the few that did not lose money.

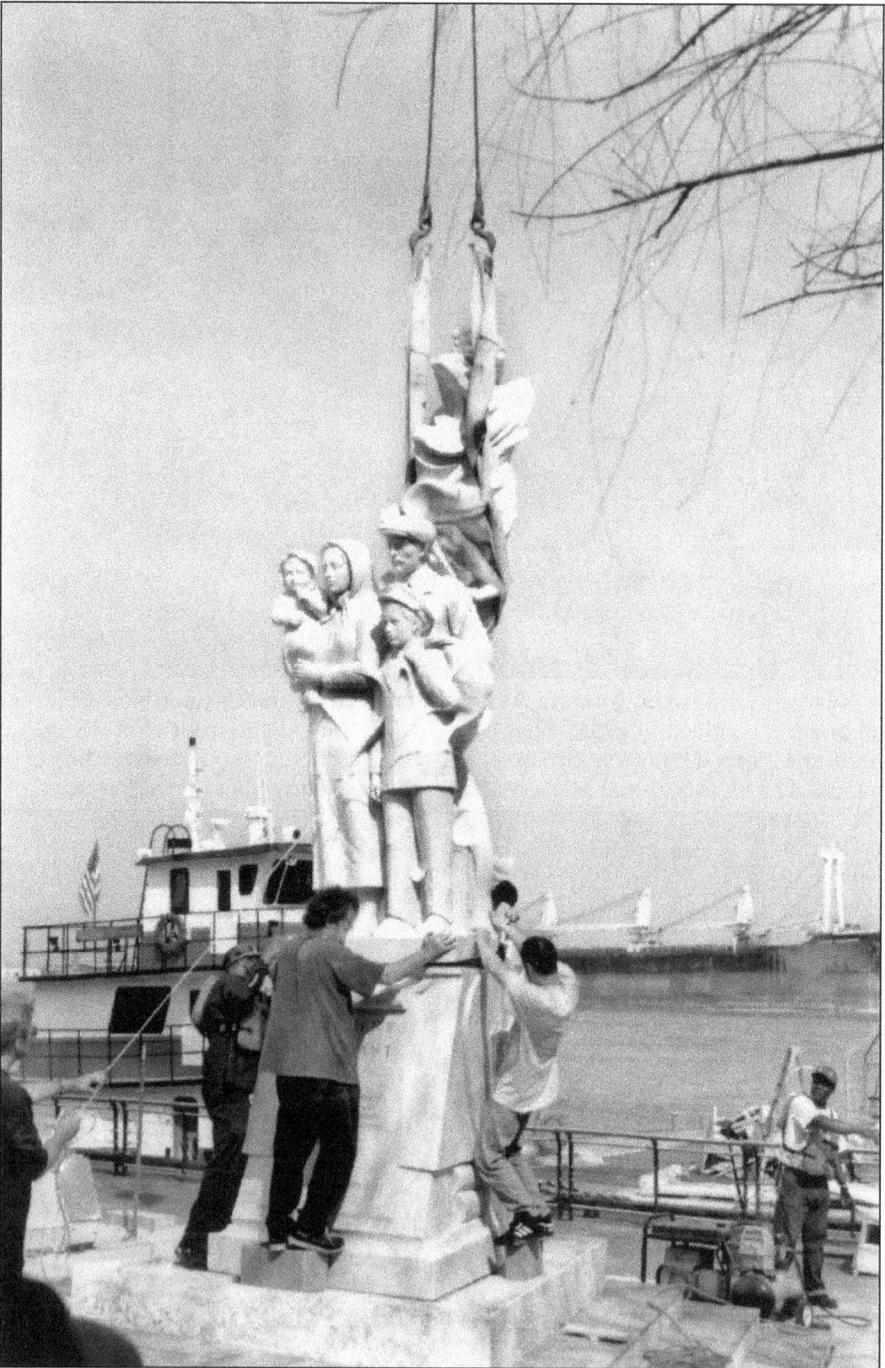

Workmen installed the *Monument to the Immigrant* by Franco Alessandrini in the French Quarter's Woldenberg Park in 1995. Sponsored by the Italian-American Marching Club, the sculpture celebrates the strong family life, determination, and hard work of immigrants to New Orleans.

www.ingramcontent.com/pod-product-compliance
Lightning Source LLC
Chambersburg PA
CBHW050638110426
42813CB00007B/1849